What Life Was Like.

AT EMPIRE'S END

Austro-Hungarian Empire
AD 1848 - 1918

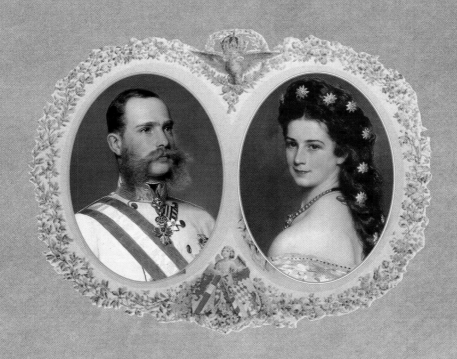

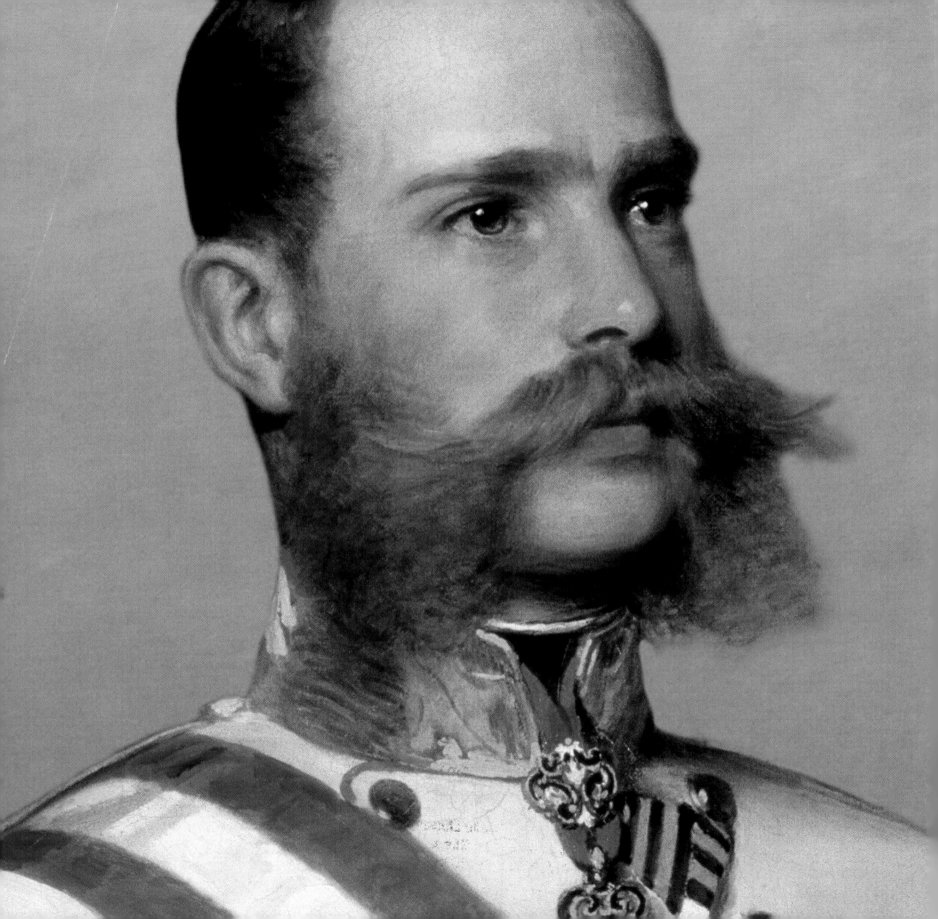

What Life Was Like

AT EMPIRE'S END

Austro-Hungarian Empire
AD 1848 – 1918

BY THE EDITORS OF TIME-LIFE BOOKS, ALEXANDRIA, VIRGINIA

CONTENTS

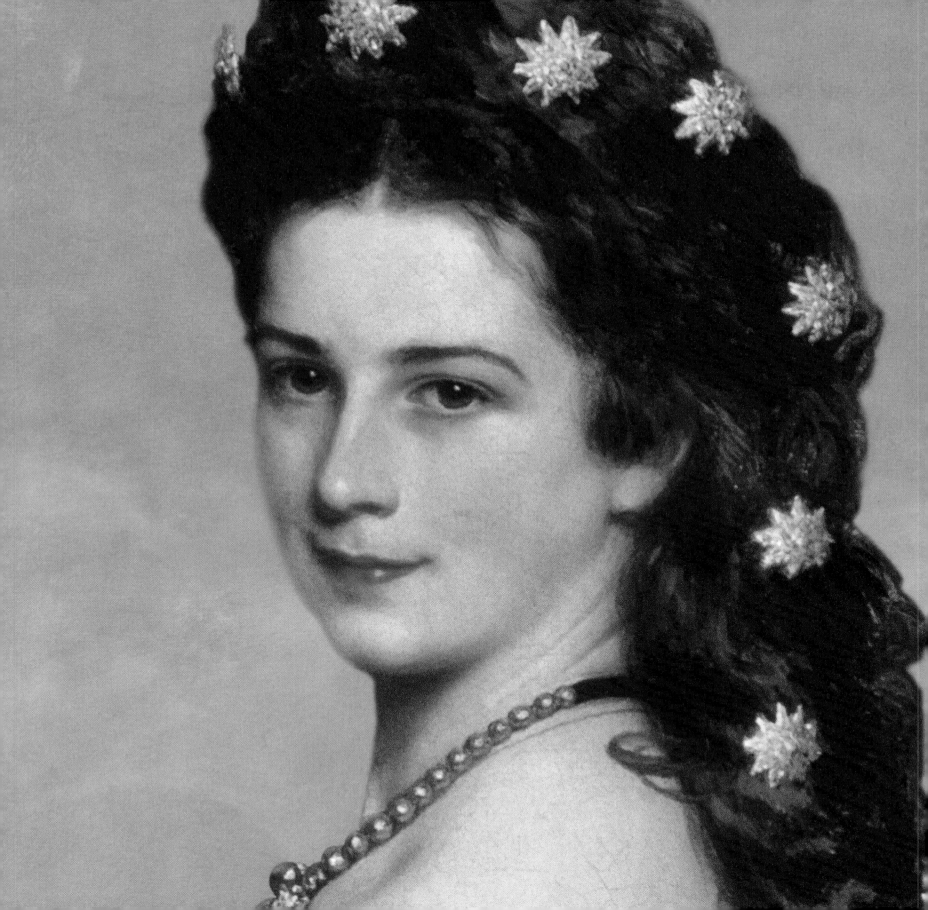

AT EMPIRE'S END

THE LAST WALTZ

In November 1806, Emperor Franz I stood on the balcony of the Church of the Nine Choirs of Angels in Vienna. For almost four centuries his Habsburg forebears had held the title of Holy Roman Emperor. But Europe had recently undergone great change: The armies of Napoleon Bonaparte had overrun much of the continent and, in November 1805, had entered Vienna itself. Addressing the crowd gathered beneath the church balcony, Franz announced the dissolution of Charlemagne's thousand-year-old Holy Roman Empire. Henceforth, Franz would be known only as hereditary emperor of Austria.

The alliance of Prussia, Russia, Britain, and Austria ultimately defeated Napoleon, and in 1814 the victors met to redraw the map of Europe. Under the guidance of Austrian foreign minister Klemens Metternich, the Congress of Vienna established Habsburg leadership of a new German Confederation, which replaced the old Holy Roman Empire, and reaffirmed the dynasty's control over the Austrian Empire's great multinational realm.

The Congress of Vienna secured the frontiers of the empire and confirmed Austria as one of Europe's great powers, but it did little to ease tensions within the Habsburg realm. Determined to preserve the monarchy, Metternich used strict censorship and a

1848
Revolution breaks out across much of Europe, including in the Habsburg empire; Franz Josef becomes emperor

1854
Marriage of Franz Josef and his cousin Elisabeth of Bavaria

1866
Austria at war with Prussia and Italy; Austria loses Venetia and is excluded from Germany

1867
Johann Strauss's *The Blue Danube* waltz is first performed; Franz Josef and Elisabeth are crowned king and queen of Hungary in Budapest

powerful secret police to stifle liberal reform movements and to keep a close watch on the empire's various subject peoples. The Hungarians remained fiercely independent, proud of their language, culture, and history. Similarly uncompromising were the Czechs of Bohemia and Moravia, the southern Slavs—Croats, Slovenes, and Serbs—and the Italians of Lombardy-Venetia.

In 1835 Franz I died and was succeeded by his son Ferdinand. Kindhearted but ineffectual, Ferdinand I was ill-equipped to counter demands for change in his empire and was content to leave everything to Metternich, now state chancellor. Finally, in March 1848, Viennese students joined citizens' organizations in petitioning the government for freedom of press, speech, and opinion and for the creation of a representative assembly. When the petition brought no response, the Viennese took to the streets. Soldiers clashed with the protesters, killing about 50. Barricades were thrown up, factories burned. That night, the hated Metternich resigned; the following day, censorship was lifted.

A more liberal government in Vienna instituted a series of reforms aimed at pacifying the revolutionaries. But insurrections began to break out elsewhere in the Habsburg empire, most worrisome of all in Hungary, where Magyar nationalists demanded an autonomous government. The Habsburgs knew the loss of Hungary would end the empire's status as a great

power. When Viennese sympathetic with the Hungarian rebels tried to prevent troops from marching on Budapest, a second revolution broke out in the capital. Emperor Ferdinand and his family had to leave the city and seek refuge in Moravia. On October 31, 1848, an imperial army forced its way into Vienna. In vain a citizens' militia tried to resist. Twenty-five people were executed. The empire was in crisis, and to meet the threat, the Habsburgs brought to the throne a new emperor, teenage Franz Josef I. Like his near contemporary Queen Victoria, he would command the destiny of his empire for more than 60 years and give his name to the era in which he lived.

In the chapters ahead, we will see what life was like during the long reign of Franz Josef, particularly in the imperial capital. Vienna, however, was not just a city of archdukes and archduchesses, of royal palaces and ancient cathedrals. It was also a city of poor immigrants and grim suburban tenements, of wealthy industrialists and nouveau riche Ringstrasse mansions. Franz Josef's Vienna was, in addition, a city at the height of its artistic creativity. Home to Johann Strauss and Stefan Zweig, Gustav Klimt and Sigmund Freud, *fin de siècle* Vienna boasted an unparalleled collection of thinkers, musicians, writers, and painters who made this period the city's golden age.

As if enchanted by the waltz, all classes of pleasure-loving

1889

Austrian socialists forge unified party; suicide of Crown Prince Rudolf at Mayerling

1897

Christian Socialist Karl Lueger becomes mayor of Vienna

1898

Assassination of Empress Elisabeth in Geneva

1907

Pressure from socialists causes parliament to institute universal suffrage in the western part of the empire

Viennese flocked to opera houses and coffeehouses, theaters and wine taverns, balls, bandstands, and the city's great public parks. But the end of the empire—and the end of their way of life— was near. When Franz Josef's heir, Franz Ferdinand, was assassinated by a Bosnian Serb in Sarajevo in June 1914, Austria held the Serbian government in Belgrade directly responsible. The punitive ultimatum delivered to Belgrade on July 23 was for the most part accepted. Even so, on July 28 Austria declared war on Serbia. When Russia sprang to Serbia's defense, all Europe took sides and the continent began its spiral into war.

"A war between Austria and Russia," Franz Ferdinand accurately predicted in 1913, "would end either with the overthrow of the Romanovs or with that of the Habsburgs, perhaps with both." Franz Josef would not live long enough to see it. Two years before the war ended, he died. He was 86 years old.

Archduke Karl succeeded his granduncle as emperor, but after the war, in 1918, the monarchy was abolished. By the time Karl died in exile four years later, the empire was partitioned into independent states: the small republic of "German" Austria; the republics of Poland and Czechoslovakia; the kingdoms of Romania, Italy, and Hungary; and a kingdom of Serbs, Croats, and Slovenes that, as Yugoslavia, would later experience the same internal strains as did the Habsburg empire from which it sprang.

The map at right shows the extent of the Austrian Empire at the time of Franz Josef's accession to the throne in 1848. Sprawling across much of central Europe, from the shores of the Adriatic to the edges of tsarist Russia and from the Swiss Alps to the borders of the Ottoman lands, the empire covered more than 250,000 square miles, making it the largest country in Europe after Russia. Within this great realm—this "prison of peoples," as one Viennese radical called it in the 1840s—lived Germans, Magyars, Italians, Czechs, Ruthenians, Romanians, Poles, Slovaks, Serbs, Croats, Slovenes, Jews, and Gypsies. While Germans predominated in Upper and Lower Austria and Italians in Lombardy-Venetia, most of the regions of the empire were mixed.

The Habsburgs had arrived in Vienna and the Austrian lands in the late 13th century. Only in the early 1500s, however, did they lay the foundation of their multinational empire, acquiring through dynastic marriage the kingdoms of Bohemia and Hungary-Croatia. Located at the heart of Europe, the empire played a pivotal role in the great upheavals of the continent. Between the years 1620 and 1720, the empire established itself as a powerful force: Acting on behalf of the Counter Reformation, it subdued the Protestants in Bohemia, where the reformed faith had quickly taken root; in addition, taking the lead as the easternmost outpost of Christendom, it turned back the advance of the Muslim Turks.

Austria's defeat at the hands of the Prussians at Königgrätz in 1866 ended Habsburg influence in the German Confederation, and in 1867 a compromise with Hungary divided the empire into the two equal spheres of the Austro-Hungarian Dual Monarchy. From this time on, the focus of Habsburg foreign policy shifted from central Europe to the Balkans, a region rife with the political and ethnic tensions that would eventually propel the continent into the horrors of World War I.

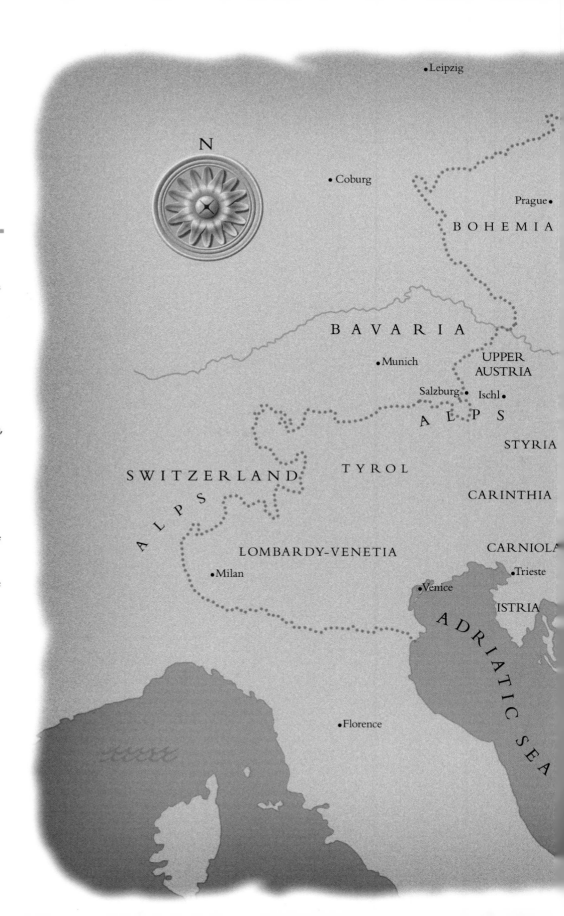

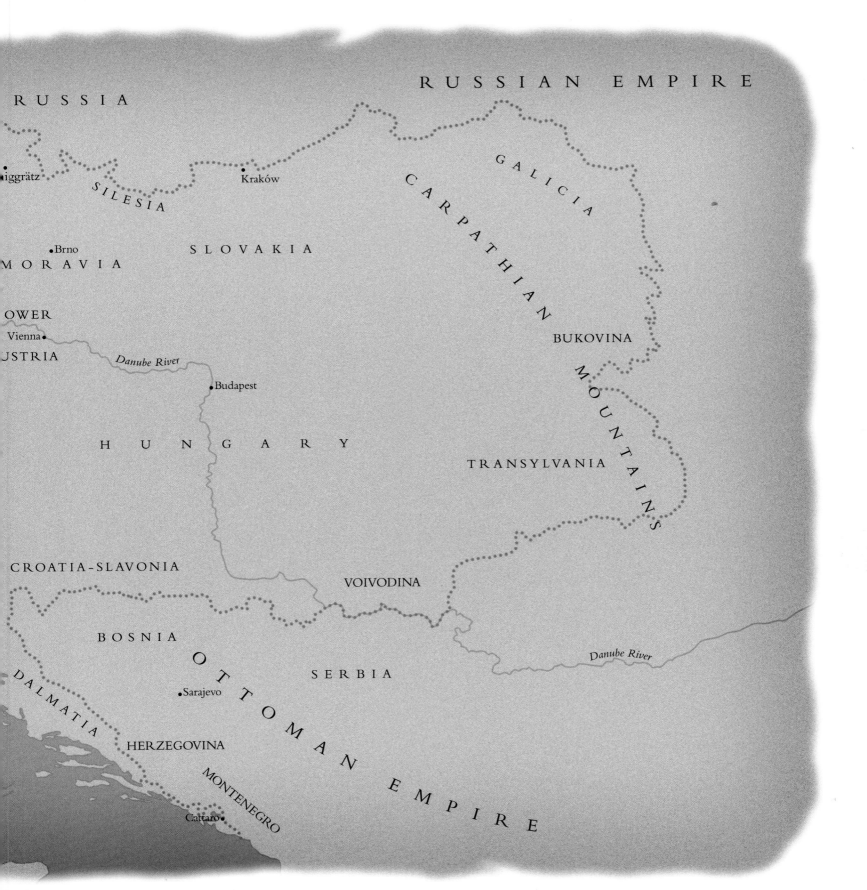

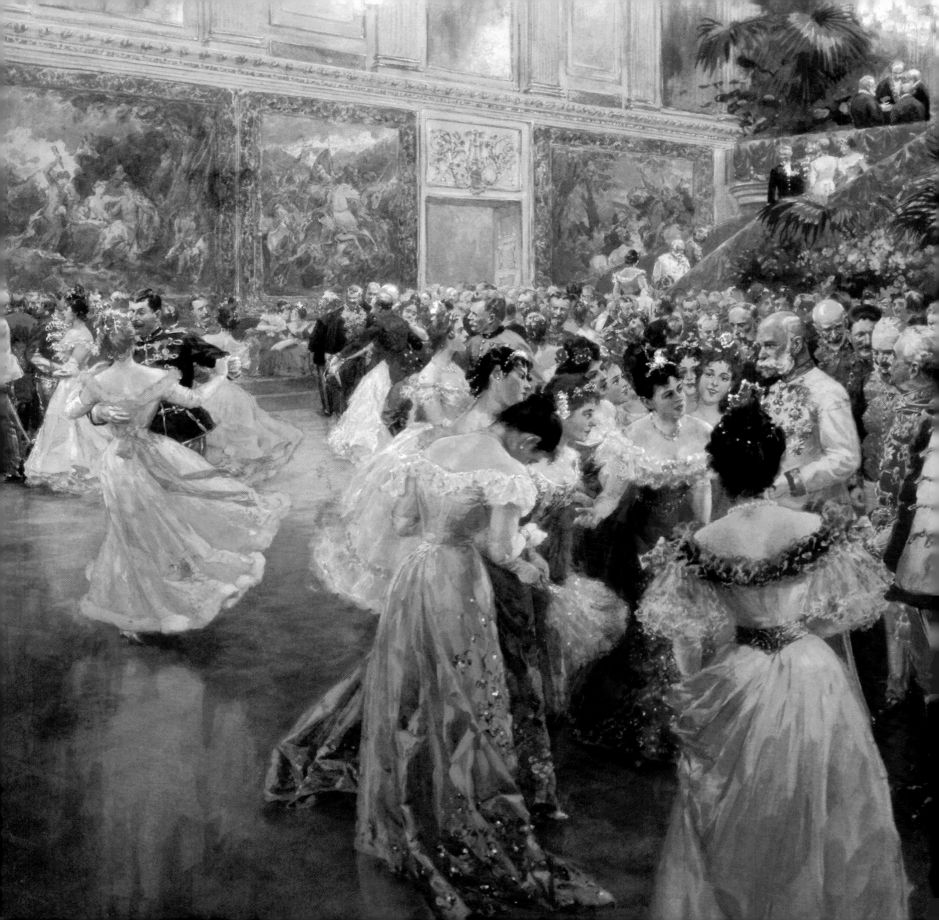

IN THE HOUSE OF HABSBURG

Aristocratic ladies pay their respects to Emperor Franz Josef at the 1900 *Hofball,* a festive annual event held in the grand ballroom of the Hofburg Palace. The Habsburg court was among the most exclusive in all of Europe; to be *hoffähig*— admissible at court— aristocrats had to prove that all their ancestors as far back as their great-great-grandparents were of noble birth.

 On the morning of December 2, 1848, in a provincial palace 100 or so miles northeast of Vienna, Emperor Ferdinand I of Austria was preparing to abdicate the throne. A weak man with little control over his own government, 55-year-old Ferdinand nevertheless had the good sense to realize that his empire needed a younger person at the helm. Without children of his own, he had chosen as his successor his nephew, 18-year-old Franz Josef. For this, his final official appearance, Ferdinand, as was his habit, wore civilian dress; his nephew—a particularly handsome man with a slender figure—donned the tight-fitting white tunic and red trousers of a general officer in the imperial army.

Only a small group had been assembled to witness the abdication: the ministers of government, several high-ranking army officers, and the members of the Habsburg royal family. Among the latter were Franz Josef's parents: Archduke Franz Karl, the emperor's brother, who, considered as ineffectual as Ferdinand, had stepped aside in favor of his oldest son; and, bursting with maternal pride and splendidly turned out in a court dress of white moiré silk with a jeweled rose in her hair, Archduchess Sophie, the guiding force behind her "Franzi's" accession to the throne.

In a nervous voice, halting between words and occasionally emphasizing the wrong syllables, Ferdinand read out a prepared statement on behalf of himself and his wife, the empress Maria Anna. "Important reasons," he began, "have led Us to the irrevocable decision to lay down Our Crown in favor of Our beloved nephew, Archduke Franz Josef." After various other official acts were read aloud by Prime Minister Felix zu Schwarzenberg, the new emperor of Austria approached his uncle and knelt before him. Ferdinand stroked the young man's hair and, lifting him to his feet, proclaimed, "God bless you! Be good and God will protect you. I have done this willingly."

Franz Josef, who was born on August 18, 1830, had seemed destined for great things from a very early age. His education had been entrusted to two powerful tutors: in the art of statecraft, to Klemens Metternich, chancellor of the empire; in matters of philosophy and religion, to the Archbishop of Vienna, Joseph von Rauscher. Between the age of six and his ascendancy to the throne, he was indoctrinated with the political philosophy of the monarch's divine right to rule. He was also taught French, Italian, Hungarian, and Czech in addition to his native German—all the languages that might be of use to a future Habsburg emperor, whose many royal titles included king of Hungary and Bohemia, king of Lombardy and Venetia, grand duke of Tuscany and Kraków, grand duke of Transylvania, and margrave of Moravia.

Franz Josef would rule for longer than any other European monarch. The 68 years of his reign would be marked by monumental changes in political, economic, social, and cultural life. His prestige would hold together the 50 million subjects—including nearly a dozen different peoples with countless conflicting tensions—who made up the polyglot and amorphous realm that was the Austrian Empire.

Urged on by his mother, Archduchess Sophie, and by his prime minister, Schwarzenberg, Franz Josef applied himself to the job of sovereign with rigor and a sense of duty, working at least 10 hours a day. Another close adviser was Count Karl Grünne, the emperor's aide-de-camp and head of the imperial armies. Grünne's political philosophy boiled down to a belief in using military discipline to eradicate society's subversive impulses, and this belief only served to encourage the young emperor's innate militaristic leanings.

The first test of those predilections came in dealing with a still-virulent uprising in Hungary that Franz Josef had inherited from his uncle. On March 3, 1848, revolutionaries in Budapest had set up a constitutional government for Hungary. By August they were pressing for autonomy for their country, if not outright independence, defying the claims of imperial authority. Franz Josef decided to go on the offensive. Just a month after he became emperor, his army drove the Hungarian rebel forces out of Budapest. As Austrian troops fought the rebels across Hungary during the summer of 1849, Franz Josef could not resist getting as close as possible to the action. But in early July, after a shell exploded just a few feet away from the emperor, Schwarzenberg persuaded him to leave the military campaign to his generals. By the second week of August, independent Hungary was on its last legs and the leader of the insurrection had fled abroad. It was time for Franz Josef to assert his authority. Under pressure from his senior advisers, he agreed to a policy of repression, deciding to make an example of those he held most responsible for the uprising: By the final days of October, 114 Hungarians had been shot or hanged, 13 of them senior officers from Hungarian regiments.

Domestic political problems also confronted the new emperor. The most pressing of these was delivering on Emperor Ferdinand's promise of a written constitution. In March 1849, after declaring his readiness to "share Our rights with the representatives of Our peoples," Franz Josef announced the completion of the much-anticipated document. The democratic and separatist

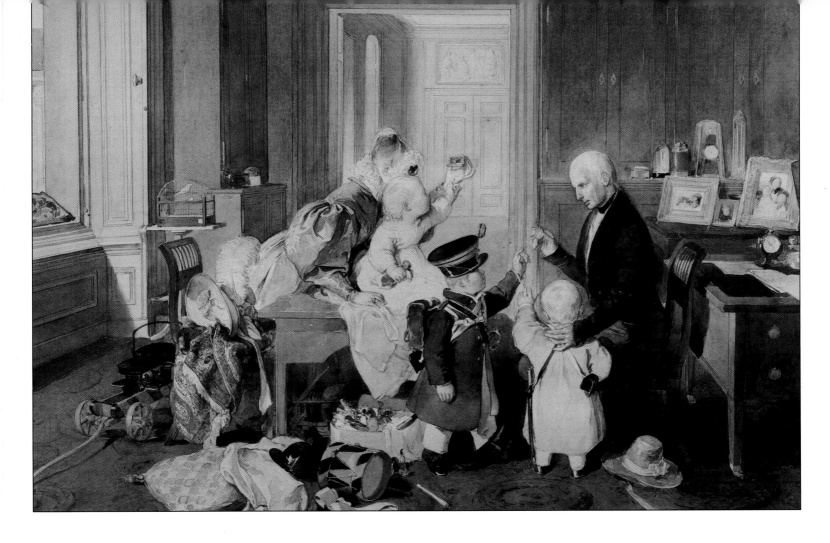

aspirations held by many of his subjects were to be dashed, however. The constitution made no reference at all to popular rule, reaffirmed the monarchy as the primary institution in the Austrian political system, and, rather than establishing a more federal system, upheld the empire as a unitary state with a centralized government in Vienna.

In the imperial capital, the trappings of majesty were evident in the regained luster of the Habsburg court. Though without any personal taste for luxury or formality, the emperor underwent a complete change of character when he assumed his official role, insisting on being addressed as "His Apostolic Majesty, our most gracious Emperor and Lord, Franz Josef I." Under Franz Josef, the court became a highly structured organization employing a cast of thousands. The most powerful of these courtiers was the grand master, under whose jurisdiction were court ceremonies, the emperor's travels, the chapel and court music, and the gardens and hunting grounds of the palaces and lands owned by the crown.

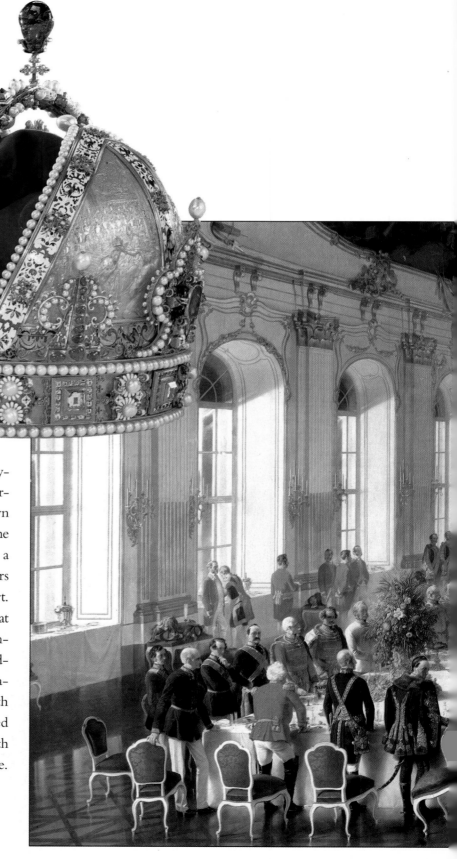

The grand master, however, did not have a monopoly on cultural affairs. The court library and the crown jewels were the domain of the grand chamberlain, who also controlled the army of footmen, valets, and chambermaids employed by the emperor. Further, it was the chamberlain's prerogative to grant the right to appear before the sovereign at court. Franz Josef's aversion to innovation was in stark evidence here, with visitors expected to back out of the room after an audience, lest they present the emperor with a view of their backs.

The last two of the four individuals who managed the court were the lord marshal and the master of the horse. The former was responsible primarily for the court's internal regulation and making decisions on everyday matters, while the latter was in charge of the stables, court carriages, and the famous Spanish Riding School in Vienna, known for its impeccably trained Lippizaner stallions. Along with the companies of guards entrusted with the emperor's security and a series of household advisers and chamberlains, these courtiers maintained the regal splendor of the young monarch's court.

The splendor of the imperial court was most in evidence at the annual *Hofball*. The high point of the Viennese social calendar, this grand court ball was held each February in the Redoutensaal, the largest room in the Hofburg Palace. For the occasion, the great room was lit by 10,000 candles and adorned with sumptuous tapestries, large potted plants, and specially created floral arrangements. The room would already be crowded with guests when, at 8:30 precisely, Franz Josef made his entrance.

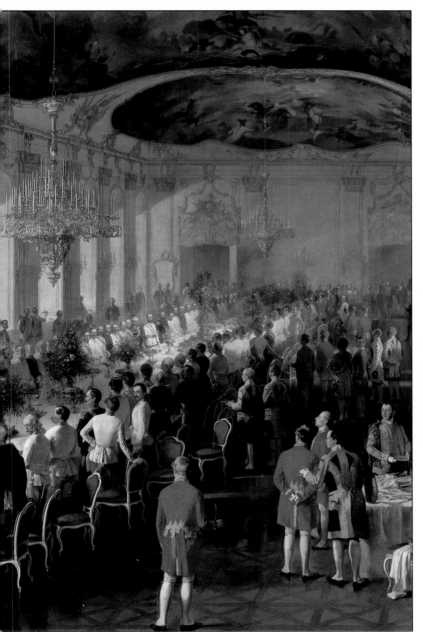

The pearl- and ruby-studded Austrian imperial crown *(left)* and the imperial summer palace at Schönbrunn both reflect the fabulous sumptuousness of Habsburg ceremonial life. In the palace's grand gallery *(below)*, Emperor Franz Josef, glass raised and standing midway up the table on the left-hand side, gives a toast at a banquet celebrating the centennial of one of the empire's military orders.

Resplendent in the dress uniform of a field marshal, the emperor strode into the Redoutensaal, followed by the archdukes and archduchesses and their retinues. Making his way through the throng, he would exchange a word with an army officer, a senior courtier, a foreign dignitary. As the orchestra struck up, dancers would begin to circle around the room. Later in the evening, the emperor and the imperial family would retire to an adjoining room for dinner while the rest of the guests flocked around an enormous buffet table in another of the palace's rooms. After dinner, the ball would continue until Franz Josef's rather early departure, marked by an announcement of the last waltz, signaled its end.

Pomp and circumstance were also part of the capital's annual religious ceremonies and feast days. This was especially true of the Corpus Christi procession, the most solemn expression of the bond between the Habsburg dynasty and the Catholic Church. Once again, the court was on display in all its magnificence. First, Franz Josef would ride in a state coach drawn by eight beautifully outfitted horses to St. Stephen's Cathedral to attend High Mass. After the service, a great crowd would assemble in the streets outside the cathedral. A group of noblemen in ceremonial dress led the procession, followed by the cathedral's clergy and choir, and then by the Archbishop of Vienna, walking beneath a canopy and holding the Holy Sacrament in his outstretched arms. The emperor came next, bareheaded and carrying a lighted candle, accompanied by the archdukes and members of the imperial guard.

The procession route took the celebrants through the narrow, crooked streets of Vienna's inner city, where elegant, modern shops, hotels, and coffeehouses nestled alongside some of the city's Roman ruins. They would stop opposite the Church of the Capuchins of Vienna, briefly resting under an open-sided tent set up especially for the emperor and his suite. Starting once again, they would turn at the top of the Michaelerplatz, site of the 13th-century Michaeler Church, move along the Kohlmarkt, which was lined with fashionable shops, and exit onto the Graben, at all other times one of Vienna's busiest thoroughfares. From the Graben rose the towering, white-marbled Trinity Column—replete with

billowing clouds and flitting cherubs—erected to celebrate the end of a devastating epidemic in 1679. Finally, they would return to the cathedral.

Another tradition linking monarch, church, and people was the medieval ceremony of the washing of the feet on Maundy, or Holy, Thursday. Every year, 12 old men were brought from the city's hospice to a room in the Hofburg Palace, where they were served a meal by their emperor. Next, a group of court officials removed the old men's right shoes and socks. Franz Josef would kneel and, with the help of two priests, carefully wash each man's foot with the corner of a napkin, moving from one old man to the next. When he was finished, he would wash his hands in a bowl of water provided by

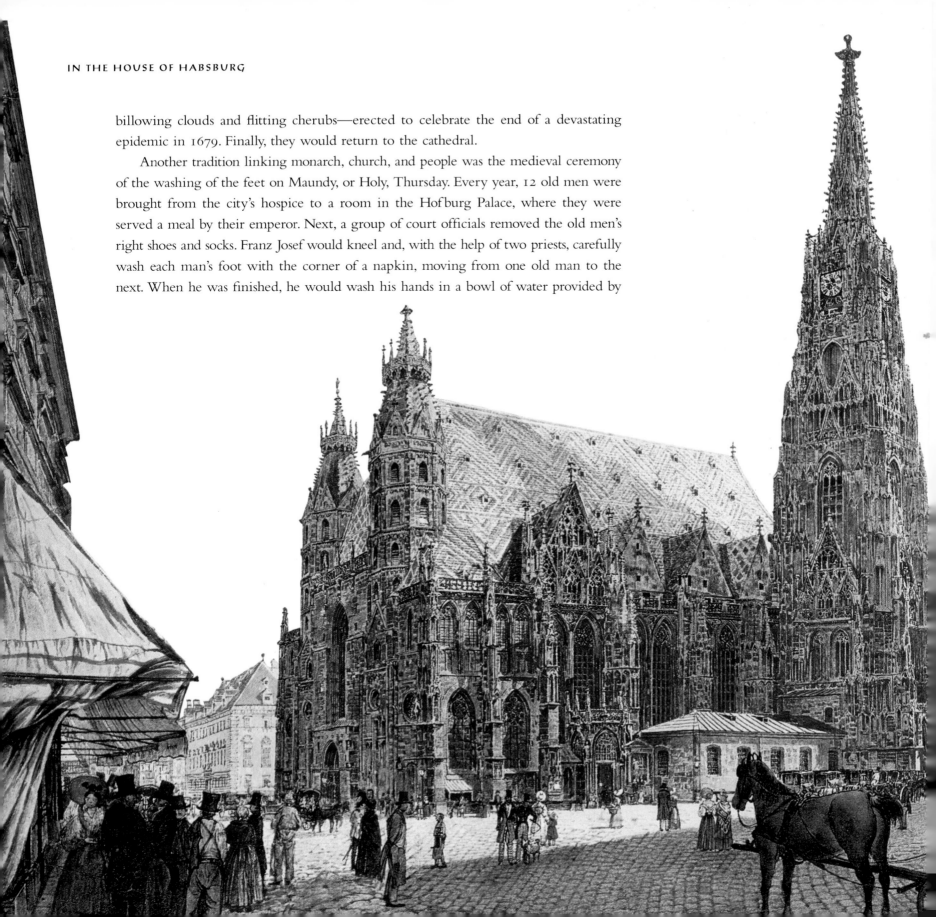

his pages. Then the grand master of the court would come forward with a towel on a silver tray for the emperor to dry his hands with. Finally, the remarkable ceremony was concluded by the emperor hanging a purse containing 30 silver coins around each old man's neck before they left the Hofburg.

Located inside Vienna's medieval walls, the Hofburg Palace was where Franz Josef spent most of his time. A complex of 17 buildings from 17 different eras and architectural styles, the palace had been repeatedly altered, expanded, and reconstructed over a 600-year period. It housed the Imperial Library, which was described by one visitor as "a temple worthy of the intellectual treasures it enshrined." These treasures consisted of some 300,000 volumes; thousands of rare manuscripts from the 14th and 15th centuries were lodged in a separate large room. In the Baroque great hall, rows of multicolored books with morocco bindings filled richly ornamented bookcases, surrounded by portraits and statues of various benefactors and by magnificently colored globes. The Natural History Museum adjoining the library boasted a large collection of stuffed and mounted animals, birds, and fish.

When at the Hofburg, Franz Josef would often exercise by walking along the ramparts of the city's walls, dressed in his usual army uniform. On at least one occasion, however, such a walk proved life threatening. On February 18, 1853, while strolling along the ramparts with one of his aides, Franz Josef was attacked by a man armed with a knife. Only a piece of good fortune saved him. A woman, seeing the armed man advancing on the emperor from behind, cried out, causing Franz Josef to turn. As he did so, the blow, intended for the emperor's back, glanced off the gold embroidery of his stiff military collar. The attacker, who was quickly overcome, turned out to be a young Hungarian revolutionary determined to kill the man he held responsible for his country's misfortunes and the suppression of the 1848 revolution.

Shocked that her son had come so close to death, the archduchess Sophie strengthened her resolve to find Franz Josef a wife. As it turned out, the realization of that wish—in the unexpected form of the archduchess's 15-year-old niece, Elisabeth—was only a few months away.

To mark the occasion of Franz Josef's birthday on August 18, 1853, the archduchess Sophie and her sister Ludovika, the duchess of Bavaria, had devised an ideal scheme: They would have a fam-

ily reunion at the imperial summer resort of Ischl, amid the mountains and lakes of Upper Austria, and Ludovika would bring along her 19-year-old daughter, Helene, whom Sophie had chosen as her future daughter-in-law. The relaxed, familial atmosphere of Ischl, the two sisters hoped, would ease their undertaking. But one small matter was to upset the sisters' well-laid plan: To provide a traveling companion for Helene, Ludovika decided to also bring along her younger daughter Elisabeth, known to all as "Sisi."

On August 16 Ludovika and her two daughters arrived in Ischl. They got to their hotel later than expected, however, and their baggage had not yet been delivered. There would be no time to change clothes before their crucial meeting with Franz Josef at the Habsburg summer residence. So, after only enough time to fix their hair, the two young sisters were whisked away with their mother to have tea with Archduchess Sophie and her son. Both girls still wore the dusty black dresses in which they had traveled to Ischl.

Franz Josef had last met his two cousins when he was 18, and the girls seemed to have made no impression whatever on him. This time it would be quite different. But it was not the designated bride who attracted his attention; it was her younger sister, Elisabeth. Franz Josef was immediately smitten. "At the moment when the emperor caught sight of Sisi," one observer remarked, "an expression of such great pleasure appeared on his face that there was no longer any doubt whom he would choose." Young Sisi felt embarrassed that her cousin the emperor concerned himself more with her than with her sister; she also felt more than a little scared.

The next day, at a ball to mark the eve of Franz Josef's birthday, Helene appeared in a splendid white silk gown, her forehead wreathed by ivy tendrils that lent a romantic touch to her tall, rather austere appearance. But it was already too late. Sophie's attempts to divert her son's

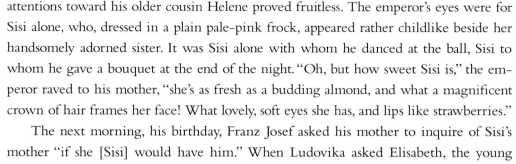

attentions toward his older cousin Helene proved fruitless. The emperor's eyes were for Sisi alone, who, dressed in a plain pale-pink frock, appeared rather childlike beside her handsomely adorned sister. It was Sisi alone with whom he danced at the ball, Sisi to whom he gave a bouquet at the end of the night. "Oh, but how sweet Sisi is," the emperor raved to his mother, "she's as fresh as a budding almond, and what a magnificent crown of hair frames her face! What lovely, soft eyes she has, and lips like strawberries."

The next morning, his birthday, Franz Josef asked his mother to inquire of Sisi's mother "if she [Sisi] would have him." When Ludovika asked Elisabeth, the young woman's response was emphatic: "How could anyone not love *that* man?" she replied. Then, as if realizing the enormity of what was happening, she blurted out, "If only he were not the Emperor!"

On August 19 the engagement was made official. By eleven o'clock that morning an enormous crowd had gathered in the small square outside the parish church in Ischl to catch a glimpse of the girl who had captured the emperor's heart. The onlookers watched as the royal carriage drew up outside the church. Archduchess Sophie stepped down from the carriage, followed by Franz Josef and, on his arm, his bride-to-be, dressed in a simple muslin dress and wearing a wide-brimmed straw hat. Bashful and self-conscious, the 15-year-old future empress entered the church to the sounds of the Austrian national anthem. After the benediction, Franz Josef took Sisi gently by the hand, led her to the priest, and said, "I beseech you, Reverend, bless us, this is my bride."

By the time the couple exited the church, all of Ischl was in celebration. Locals wearing ribbons in the blue and white of Bavaria thronged streets adorned with yellow-and-black Habsburg banners. As the royal carriage passed by, people tossed bunches of wildflowers in Elisabeth's direction and called out her name. The high-strung young woman was terrified of the crowds, however, and rode back through the town on the verge of tears.

The "divine sojourn in Ischl," as Franz Josef called it, lasted until August 31, when the two families said their farewells. The date for the royal wedding had been fixed for April 24, 1854. Elisabeth, it was decided, would travel from her native Munich to the Austrian capital aboard a Danube steamer; that way, she would be able to see some of the scenery of her new country and—more important—be seen by her new subjects. And so, on April 20, a huge crowd gathered in Munich to watch her departure. Rising to her feet in her carriage, crying openly, Elisabeth waved her handkerchief as she left the city to catch the waiting steamer.

The journey down the river to Vienna took three days. On April 21 at 2:00 p.m., the steamer docked at the Austro-Bavarian border in Passau, where a triumphal arch had been erected and an imperial deputation waited to greet her. The steamer set off again, arriving in Linz at six o'clock in the evening. To Elisabeth's great surprise, the emperor himself was there to welcome her, having traveled to the town from Vienna early that morning.

After a gala performance of *The Roses of Elisabeth* at the Linz theater and a torchlight parade through the town, Franz Josef departed at 4:30 a.m. so that he could welcome his bride again, this time at the official reception in Vienna. Elisabeth arrived in the capital around 12 hours later. Tens of thousands waited to catch a first glimpse of the future empress. As the steamer docked, Franz Josef, elegant in his marshal's uniform, raced on board to embrace her. Amid great shouts of jubilation, gun salutes, and waving flags, the bride then disembarked on her groom's arm and they set off for Schönbrunn Palace, the emperor's majestic summer residence located just outside the city.

Arriving at the palace around dusk, Franz Josef leaped to the ground to open Elisabeth's carriage door and lead her into Schönbrunn's great salon. There, Sophie formally presented to Sisi the archduchesses of the House of Habsburg and the emperor did the same for the archdukes. Then, with great ceremony, Franz Josef bestowed on his bride his wedding gifts, among them a diamond tiara inset with precious emeralds and a matching diamond waist ornament. That evening Elisabeth appeared with the imperial family on the large balcony of the palace, much to the delight of a cheering crowd gathered below, and then attended a large court banquet held in her honor.

It all proved very stressful for Elisabeth. From her afternoon arrival in Vienna until late into the night, the exhausted 16-year-old was constantly under the eyes of strangers. This, however, was to be just the beginning of her exertions. The next day, April

23, the traditional entrance of the emperor's bride into the capital was celebrated. Wearing her new diamond tiara and a pink gown threaded through with silver, Elisabeth left the palace in a state carriage pulled by eight white Lippizaners. As she neared the medieval walls of Vienna, all the city's bells began to peal in welcome. Outside the Hofburg, her carriage came to a halt, and the fatigued young empress-to-be started to get out. As she did so, her tiara caught in the doorframe of the carriage, and—

in full sight of the imperial family—she stumbled and fell. This was Elisabeth's only misstep, however. The archduchess Sophie found her future daughter-in-law "enchanting," and the day ended on a promising note.

At four o'clock the next afternoon, Joseph von Rauscher, Archbishop of Vienna, performed the wedding ceremony in the magnificent Augustiner Church. For the occasion, this 14th-century court church near the Hofburg was draped in red velvet and bathed in the light of 15,000 candles. More than 50 bishops had assembled to witness the vows. Just as the wedding rings were exchanged, an artillery battalion on the roof of the church fired off a salvo and church bells throughout the city began to peal. Duchess Elisabeth of Bavaria had officially been transformed into Empress Elisabeth of Austria.

After a 50-yard procession back to the Hofburg and a gala banquet, one more bit of tradition remained. The archduchess Sophie escorted the bride to her new rooms in the palace and waited until her daughter-in-law got into bed. "Then I fetched my son and led him to his young wife," Sophie noted in her diary. "She hid her pretty face, surrounded by the masses of her beautiful hair, in her pillow, as a frightened bird hides in its nest."

If Elisabeth was disconcerted to have her mother-in-law in her bedroom, she must also have been dismayed at seeing her early the next morning. While Elisabeth and Franz Josef were enjoying a quiet breakfast, Sophie appeared and joined them. To the archduchess, her son looked "radiant and full of himself, a picture of happiness." Deprived of this precious time alone with her husband, Elisabeth was less happy.

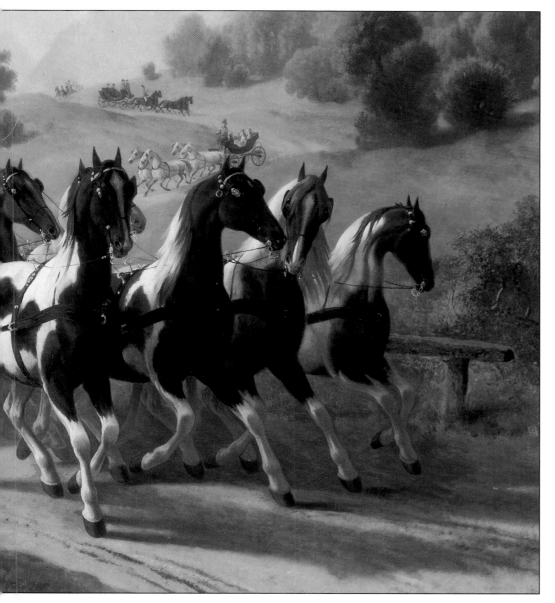

Franz Josef and Elisabeth take a romantic excursion through the countryside near the resort of Ischl shortly after their engagement in August 1853. While at Ischl, Elisabeth's future husband showered her with expensive jewelry and even erected a swing on the grounds of the Habsburg summer retreat for the amusement of his young fiancée.

The new empress was getting an early taste of the intrusiveness of life at court. Up to this point, she had seen the Habsburgs only on holiday at Ischl and, raised in the more relaxed environment of Bavaria, Sisi had little idea of the formalities of the Viennese court. The strain was beginning to tell on her, and it would only get worse.

Six days after the wedding, Franz Josef and Elisabeth finally left Vienna. They would spend their honeymoon at Laxenburg Castle, 15 miles from the city. But even now the new bride would not have her husband all to herself. Each morning the emperor would rise long before she was awake and travel back to the Hofburg to immerse himself in affairs of state, only returning to her in time for six o'clock dinner. Still, at Laxenburg the young empress could resume one of her favorite activities, riding, which provided exercise and fresh air and seemed to restore her vitality.

Once the newlyweds were back within the gloomy confines of the Hofburg, however, Elisabeth was again subject to the constraints of court life. Archduchess Sophie had definite expectations of her 16-year-old daughter-in-law. Having succeeded in making her son emperor, Sophie now set about turning Elisabeth into her idea of an empress. Everything came under the scrutiny of the archduchess. She forbade the couple the innocent pleasure of wandering alone through the Hofburg's twisting corridors to the old Burgtheater, which was connected to the palace, insisting instead that they be escorted there by carefully specified court officials. She even removed several pet parrots Elisabeth had brought from Bavaria, deeming them unsuitable for an empress of Austria. Franz Josef made no effort to resist his mother's demands, and Elisabeth felt trapped. "I was," she complained to one of her ladies-in-waiting, "completely at the mercy of this completely malicious woman."

Later that summer, amidst signs that she was pregnant, Elisabeth had to give up riding. Months before the baby's birth on March 5, 1855, the archduchess decided that the new nursery was

DANGEROUS INHERITANCE

When Emperor Franz Josef announced his intention to marry Elisabeth of Bavaria, members of the imperial court in Vienna were most concerned about whether the woman's blood was a sufficiently pure shade of blue. No one seems to have minded that Franz Josef and Elisabeth were first cousins or that Elisabeth's own parents were second cousins, both of them Wittelsbachs—a family with a long history of madness and hereditary disease.

The Wittelsbachs had ruled over the kingdom of Bavaria for seven centuries. During that time they had mostly wed members of the other royal households of Germany. But Wittelsbachs had also married Wittelsbachs and thus bequeathed to their offspring a most dangerous inheritance. Wittelsbach eccentricity had had a firm hold on Elisabeth's paternal grandfather, Duke Pius, who ended his years a crippled, feebleminded hermit. Pius's strange ways were shared by his son and heir, Duke Maximilian—Elisabeth's father. Possenhofen, Max's country home on the shores of Lake Starnberg, was a run-down castle where dogs romped in the living room and cows grazed in the rose gardens. In Munich he built a circus menagerie adjoining his palace, and there he performed riding tricks for his children and his friends.

Elisabeth was a second cousin to Ludwig II, the melancholic and highly theatrical king of Bavaria

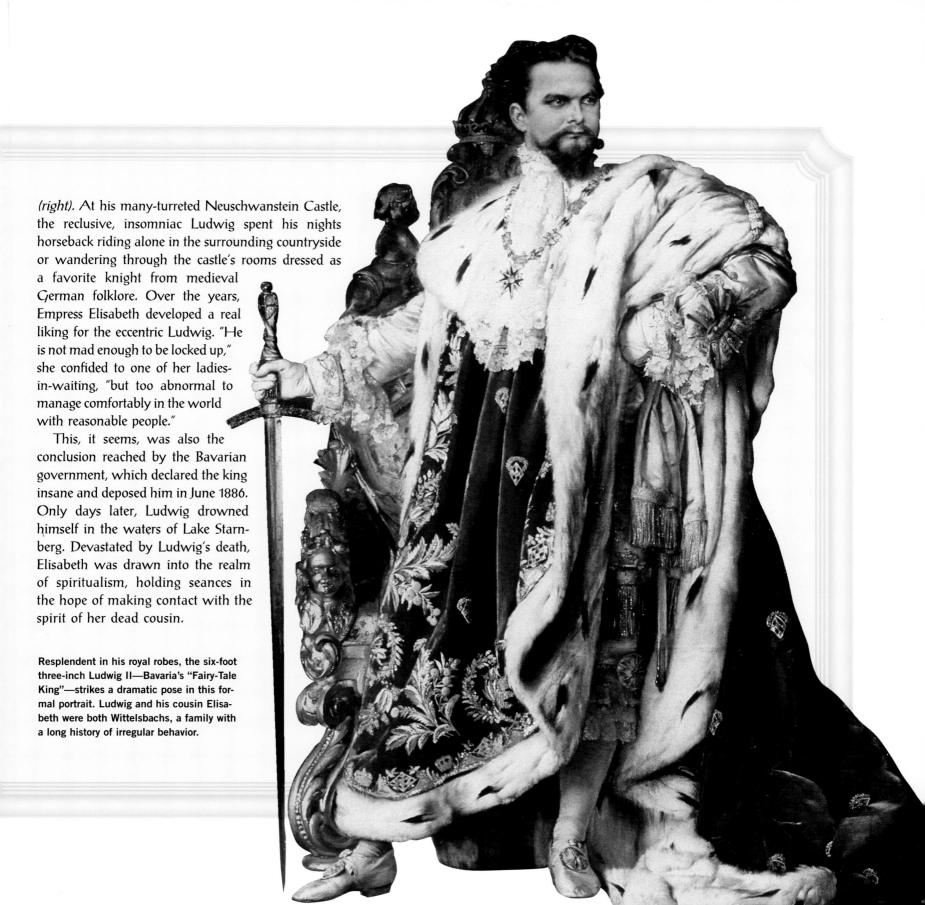

(right). At his many-turreted Neuschwanstein Castle, the reclusive, insomniac Ludwig spent his nights horseback riding alone in the surrounding countryside or wandering through the castle's rooms dressed as a favorite knight from medieval German folklore. Over the years, Empress Elisabeth developed a real liking for the eccentric Ludwig. "He is not mad enough to be locked up," she confided to one of her ladies-in-waiting, "but too abnormal to manage comfortably in the world with reasonable people."

This, it seems, was also the conclusion reached by the Bavarian government, which declared the king insane and deposed him in June 1886. Only days later, Ludwig drowned himself in the waters of Lake Starnberg. Devastated by Ludwig's death, Elisabeth was drawn into the realm of spiritualism, holding seances in the hope of making contact with the spirit of her dead cousin.

Resplendent in his royal robes, the six-foot three-inch Ludwig II—Bavaria's "Fairy-Tale King"—strikes a dramatic pose in this formal portrait. Ludwig and his cousin Elisabeth were both Wittelsbachs, a family with a long history of irregular behavior.

to be installed not near the imperial couple but beside her own apartments. After the baby was born, it was impossible for the young mother to visit her own child without her mother-in-law also being present. And when the baby was christened, she was named Sophie, in honor of her grandmother. No one had consulted the mother.

Little over a year later, Elisabeth gave birth to a second daughter, Gisela, about whom Archduchess Sophie was equally possessive. When the child was 10 months old, Elisabeth did persuade her husband to take their children with them on a visit to the Hungarian provinces. Just as the royal family was about to leave, however, Gisela came down with a fever and diarrhea. The trip was postponed. Once Gisela recovered, young Sophie fell ill. En-

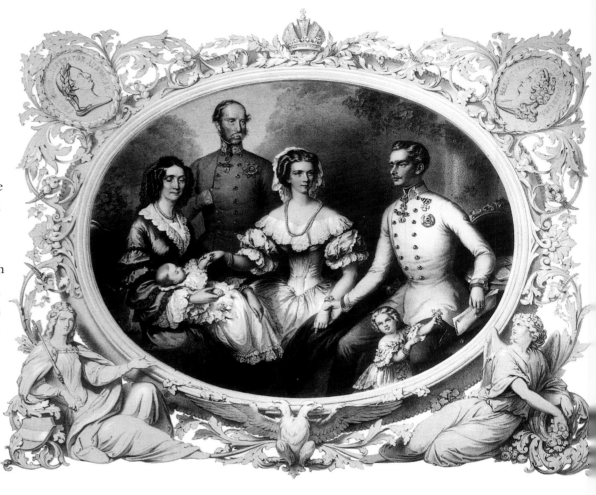

couraged by their personal physician, Franz Josef and Elisabeth decided to go ahead with the trip. After five days, their journey was broken off in the city of Debrecen, about 120 miles east of Budapest. Little Sophie had grown worse. As her 19-year-old mother looked on in despair, the two-year-old girl died. Franz Josef sent a telegram to his mother from Budapest on May 31, 1857. "Our little one is an angel in heaven," he informed her. "We are devastated."

Elisabeth was inconsolable. Confronted by her mother-in-law's domineering presence and the demands of office that left her husband with little time to devote to her, she had already begun to turn inward. Now, with the death of Sophie, she withdrew even more into her own private world. Determined to

maintain her youthful figure, she developed a virtual cult of beauty, following strict diets that strained her nerves and devoting herself to physical exercise to the point of exhaustion. She even went so far as to have a gymnasium installed in the Hofburg for her own personal use, a previously unthinkable thing for a Habsburg empress.

By December 1857, there were signs of the new pregnancy everyone had hoped for, and on August 21, 1858, hardly a year after his little sister's death, Crown Prince Rudolf was born. The birth of the emperor's male heir had been a difficult one, and Sisi fell ill with fevers and weakness. She went back on her starvation diets and fled from family events. Although he could see that his wife was undergoing some kind of personal crisis, Franz

Josef was bewildered by it all. "I beg you," he pleaded with her, "for the love you bear me, pull yourself together."

But Elisabeth seemed incapable of doing so. Instead, she grew desperate to get away from Vienna, where she would always feel herself a stranger. In the city she was constantly seized by violent bouts of coughing, and her health grew worse. Citing the healing powers of gentler climes, she became a perpetual wanderer for the next three years, traveling first to the distant Portuguese island of Madeira, then to Corfu, Venice, and the spa of Bad Kissingen in Bavaria.

The legend of Elisabeth's striking and unusual beauty only grew during the 1860s. Despite three pregnancies within the first four years of her marriage, her manic exercise and activity level—horseback riding, long walks, and sessions in the gymnasium—had kept her five-foot six-and-a-half-inch figure slender. When the empress attended a wedding in Dresden in 1864, one male guest reported that she was so "stunningly beautiful" that "the people here acted insane. I have never seen anyone having such an effect before." The American ambassador to the Habsburg court was equally enchanted with her. "The Empress," he wrote to his mother back home, "is a wonder of beauty—tall, beautifully formed, with a profusion of bright brown hair, a low Greek forehead, gentle eyes, very red lips, a sweet smile, a low musical voice, and a manner partly timid, partly gracious."

Fully aware of the power of her beauty, especially over her devoted husband, the shy, insecure girl from Bavaria began to develop a greater self-assurance. Finally she reached a point where she felt able to challenge her husband and his mother, the archduchess Sophie, who so influenced him. At Ischl on August 27, 1865, the empress issued a virtual declaration of independence: She threatened to leave Franz Josef unless, as she put it, "full powers will

In a revealing family portrait from 1856, the archduchess Sophie *(far left),* rather than Empress Elisabeth, holds Gisela, the imperial couple's second child, while their first child, Sophie, plays at Franz Josef's knee. The emperor's father, Franz Karl, who allowed the crown to bypass him in favor of his son, stands in back. Upon the birth of Elisabeth and Franz Josef's third child, Crown Prince Rudolf, the citizens of Vienna presented the family with the silk-lined, Rococo-style cradle shown below.

be given me in all matters concerning the children" as well as "the right to make all decisions concerning my personal affairs."

Feeling that he had no choice but to comply, the emperor bowed to his wife's demands, at her request replacing young Rudolf's tradition-minded military tutor with a less-autocratic teacher named Joseph Latour. Now almost 28 years old, the empress had finally succeeded in asserting herself in her marriage and, perhaps more important, in diminishing the influence of her longtime nemesis, her mother-in-law. Empress Elisabeth was now ripe for yet another influence to enter her life.

In January 1866, a delegation from the Hungarian parliament strode through the anterooms of the Hofburg Palace and toward the empress's apartments. They were led

From her first glimpse of Andrássy, Elisabeth was fascinated by the nobleman's charm, which she felt embodied the Magyar spirit of independence, and by the rather wild, gypsylike aura that seemed to surround the man. She, in fact, had already learned a great deal about Andrássy from her closest confidant, a young Hungarian woman named Ida Ferenczy who had been at the empress's side since 1864. A descendant of one of Hungary's oldest noble families, Andrássy had joined the struggle for constitutional freedom in Hungary and had fought in the failed revolution of 1848 against the Austrian army. After fleeing abroad—first to London, then to Paris—he was condemned to death in absentia by the government in Vienna for his part in the revolution and was hanged in effigy on September 21, 1851.

"We have nothing more to lose, so it is better to perish with honor."

by the dashing 42-year-old Gyula Andrássy, who wore the ceremonial dress of the Magyar aristocracy—a gold-embroidered coat studded with precious gems and a tiger skin draped over his shoulders. In the last anteroom, Andrássy and the other deputies were greeted by the empress's chamberlain, who ushered the party into the audience chamber.

Andrássy and his colleagues had come to visit the empress in the hope that she might continue to further one of her pet causes: Hungarian sovereignty within the Austrian Empire. Elisabeth had long ago developed an interest in all things Magyar, to the great irritation of many at the Viennese court, including her mother-in-law. To meet the delegation, the empress wore Hungarian national costume—a white silk dress, black bodice, and Hungarian bonnet. She greeted the visitors in flawless Hungarian.

As his exile continued, however, Andrássy had become convinced that Hungary's best interests lay in a closer connection with Franz Josef's Austria rather than in outright independence. Andrássy was eventually granted amnesty in 1857, and he returned to Hungary in 1858. Seven years later the policy of Austro-Hungarian conciliation had gone so far that Franz Josef traveled down to Budapest to open the new parliament.

By the time he arrived in Vienna to meet with the empress, Andrássy was working toward a compromise with Austria that would allow Franz Josef to rule Hungary not as part of his empire but as the Hungarian king. Franz Josef, though opposed to any scheme that would threaten the unity of his empire, favored an agreement with Hungary. Elisabeth became a powerful proponent of the Magyar cause.

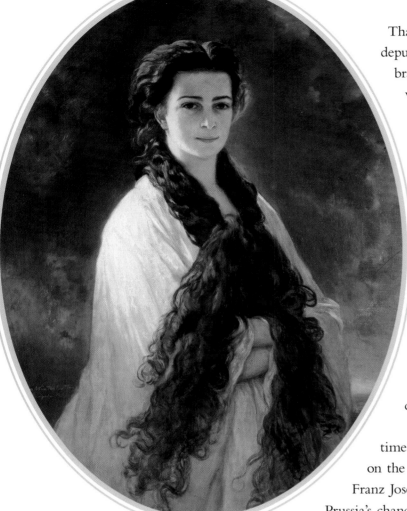

This intimate portrait showcases one of Empress Elisabeth's favorite features: her knee-length chestnut brown hair. Washed every three weeks in a concoction that included cognac and egg, the imperial tresses took nearly three hours to arrange in the elaborately braided coiffure that the empress favored. On days when the weight of this great mass gave her headaches, she would stay in her private apartment with her hair tied up with ribbons. Knowing about the empress's obsessive concern about her hair, Elisabeth's hairdresser kept a piece of adhesive tape under her apron so that she could hide any strands that might fall out during combing.

That evening in January 1866, at the court dinner for the Hungarian deputation, Sisi appeared in a beautiful white dress with a train, pearls braided into her long hair. At the after-dinner reception, the first conversation between the beautiful empress and the charismatic count—in Hungarian, of course—took place. "You see," Elisabeth told Andrássy, "when the Emperor's affairs in Italy go badly, it pains me; but when the same thing happens with Hungary, that is death to me."

Three weeks after the visit of the Hungarian delegation, Franz Josef and Elisabeth traveled to Budapest. During Elisabeth's stay in the capital, Andrássy was constantly at her side, and rumors that the empress had her eye on Andrássy spread through the country like wildfire. The undisputed high point of the triumphant six-week visit was the empress's address to the Hungarian parliament. "May the Almighty attend your activities with His richest blessing," she declared in fluent Hungarian, her eyes filling with emotion. Her audience was equally moved. According to one deputy, "Tears streamed down the cheeks of the old and young."

Less than six months later Elisabeth was in Budapest again, this time in flight with her two children from Prussian troops advancing on the gates of Vienna. The trouble that had long been brewing within Franz Josef's contentious empire had finally come to a head: In April 1866, Prussia's chancellor Otto von Bismarck had concluded a secret treaty with Italy against Austria. Bismarck's objective was to make Prussia the dominant power in Germany, which was at that time subdivided into dozens of principalities, many of them under Austrian influence; if Bismarck got his way, the Habsburgs would be excluded from the new, Prussian-dominated Germany. After securing Italian support, Bismarck fomented conflict with Vienna over the tiny German province of Schleswig-Holstein, and in June, Prussia and Italy declared war on Austria and its southern German allies.

On the battlefield, Franz Josef's army proved no match for the Prussian troops. In the decisive Battle of Königgrätz on July 3, 1866—the largest military encounter the world had ever seen—the Prussians dealt the Austrian army a disastrous defeat. Prussia's leadership in Germany was assured, and Austria was consigned to the rank of a

second-rate power. Habsburg forces could do little to stop the advancing Prussians. "We have nothing more to lose," Elisabeth wrote to Rudolf's tutor, Latour, "so it is better to perish with honor." During the event, however, she chose not to perish but to take refuge in her beloved Hungary.

Once in Budapest, Sisi again fell under Andrássy's spell, putting renewed pressure on her already beleaguered husband to accede to Hungary's demands. "I beg you in the name of Rudolf," she wrote to Franz Josef on July 15, "do not let the last opportunity slip by." The situation was indeed desperate for the emperor. With his capital threatened by the Prussians, about to lose northeast Italy to the Italians, and with his wife pleading the Magyar cause, Franz Josef finally capitulated.

The compromise agreed upon replaced the empire of Austria with the Dual Monarchy of Austria-Hungary, creating a union of two sovereign states with their own prime ministers and government cabinets; only the ministers of war, finance, and foreign affairs would serve both states. The unitary empire was no more: Franz Josef would reign in Hungary not as emperor but as king. The only curbs on Hungarian self-rule would be Franz Josef's rights to appoint and dismiss his own Hungarian prime minister and to convene, suspend, or dissolve the country's parliament.

On February 17, 1867, an imperial rescript was read aloud in the Hungarian parliament and a new constitution adopted. Franz Josef named Gyula Andrássy as Hungary's first constitutional prime minister. But the most momentous ceremonial event was still to come: Franz Josef and Elisabeth's elaborate 1867 coronation as king and queen of Hungary. Here, too, Andrássy would play a highly visible—and symbolic—role.

The festivities officially began at four o'clock in the morning on June 8, with a 21-gun salute from the Citadel of St. Gerhardsberg. By this time, people were already streaming into the city from outlying areas and filling the streets. At 7:00 a.m. the royal procession left Buda Castle for nearby St. Matthias Church led by Count Andrássy, who was wearing the large cross of the Order

The dashing count Gyula Andrássy is shown posing in the traditional costume of a Hungarian aristocrat: boots, close-fitting pants, a silk brocade jacket, an outercoat slung over the shoulders, and a plumed fur cap.

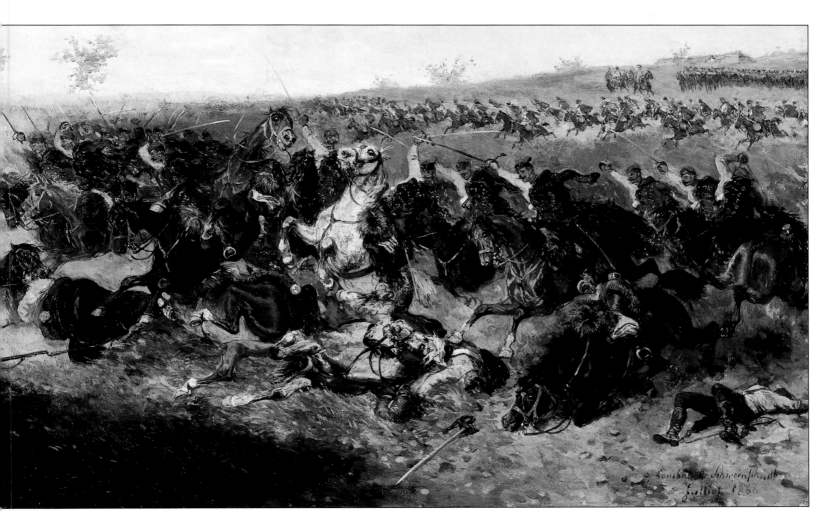

of Saint Stephen on his chest and carrying on a cushion the holy crown of Hungary. Following him were the emperor, clothed in an 800-year-old royal mantle, and Elisabeth, dressed in a new gown from Paris.

After the emperor had been anointed by the Hungarian primate, the ceremony's high point came when Andrássy placed the crown on Franz Josef's head. Then, in keeping with an old Hungarian custom, Andrássy held the crown over the empress's right shoulder, anointing Elisabeth as well. Walking out into the middle of the church, he shouted three times, *"Eljen a kiraly!"*—long live the king!

After the coronation, Andrássy rode with the new king and queen through the narrow streets of Buda and over the suspension bridge across the Danube to swear the constitutional oath outside Pest's old parish church. There, standing on the traditional mound composed of clods of dirt from all over Hungary, the new king of Hungary

brandished his sword toward the four points of the compass, thereby renewing the ancient pact between the Hungarian nation and the Habsburg dynasty.

Once ensconced in his position as prime minister, the practical-minded Andrássy wasted no time in making an impact on the Hungarian portion of the Dual Monarchy's affairs. Despite stubborn opposition from anti-Magyar conservatives within the court in Vienna, he secured and organized a Hungarian national militia, and he preserved the country's territorial integrity through the Croatian-Hungarian Compromise, which confirmed Transylvania as an integral part of the Magyar state. Andrássy also succeeded in modernizing the political administration and securing the enactment of a number of liberal laws, among them the Nationality Law of 1868. Under his administration, arbitrary press censorship was relaxed and full civil equality was granted to Hungary's Jews.

In foreign affairs, Andrássy's achievements were equally noteworthy. It was largely at his insistence, for example, that the Dual Monarchy remained neutral during the Franco-Prussian War of 1870-1871. When he was appointed foreign minister of Austria-Hungary on November 14, 1871, Andrássy immediately sought to establish good relations with the new nation of Germany, which Prussia created out of the aftermath of the war with France. "Our policy," he announced, "is a policy of peace—clear, frank, and unswerving." With his new ally Bismarck, he worked tirelessly to conclude the partnership that would be realized in the alliance signed in 1879 between the German Empire and the Austro-Hungarian Empire.

A crowning jewel of Andrássy's achievements was the opening of the World Exhibition in Vienna on May 1, 1873. The exhibition was designed as a showcase for the new Austria, evidence that—despite the national humiliation at the hands of the Prussians in 1866—the country was still a great European power. Among the seven million visitors who traveled to Vienna to see

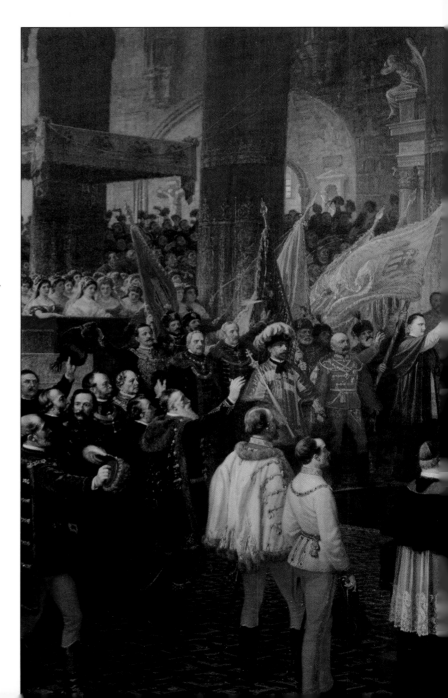

Arrayed in their traditional finery, members of the Hungarian aristocracy join Andrássy *(right, with arm raised)* in cheering Franz Josef and Elisabeth after their coronation as king and queen of Hungary in Budapest's St. Matthias Church. The brilliance of the occasion was further enhanced by a special coronation Mass with music by the great Hungarian composer Franz Liszt, who traveled from Rome to Budapest for the event.

the exhibition were numerous foreign dignitaries and heads of state. Arriving in an exhausting, but mostly well-regulated, sequence that lasted more than five months, they included Crown Prince Wilhelm of Prussia, King Leopold II of Belgium, the prince and princess of Montenegro, Tsar Alexander II of Russia, Isabella II of Spain, and Edward, Prince of Wales.

Many of the visitors wanted to catch a sight of one of the exhibition's main attractions—Empress Elisabeth herself. But the empress caused great confusion by departing Vienna in late July for the Austrian summer resort town of Payerbach, saying she was unwell and in need of mountain air. But one sovereign—the shah of Persia, Naser od-Din—could not be so easily put off. A renowned flirt, the shah had arrived in Vienna with a multitude of court dignitaries and what were described as two "ladies of pleasure"; he also brought with him an array of animals, including 40 sheep destined for the dinner table and a number of horses, five dogs, and four gazelles intended as gifts for Elisabeth. When he found that the famously beautiful empress was not in town, he threatened, quite simply, not to leave until he had an audience with her. Elisabeth eventually agreed to appear at a dinner held in his honor at Schönbrunn, and the shah, declaring it the best evening of his European trip, agreed to return to Persia the following morning.

In addition to the trouble with the shah, the exhibition was dogged by more serious misfortunes, including an opportunistic cabdrivers' strike and then a cholera scare that turned into a deadly epidemic, claiming more than 2,500 victims. The worst setback of all, however, was "the Crash," the sudden collapse of the Vienna stock exchange due to hopelessly overstretched credit resources just a week after the exhibition opened. Finally,

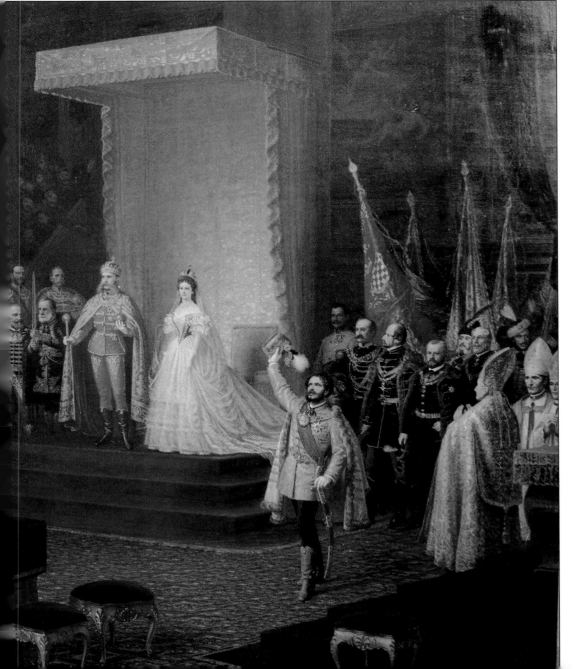

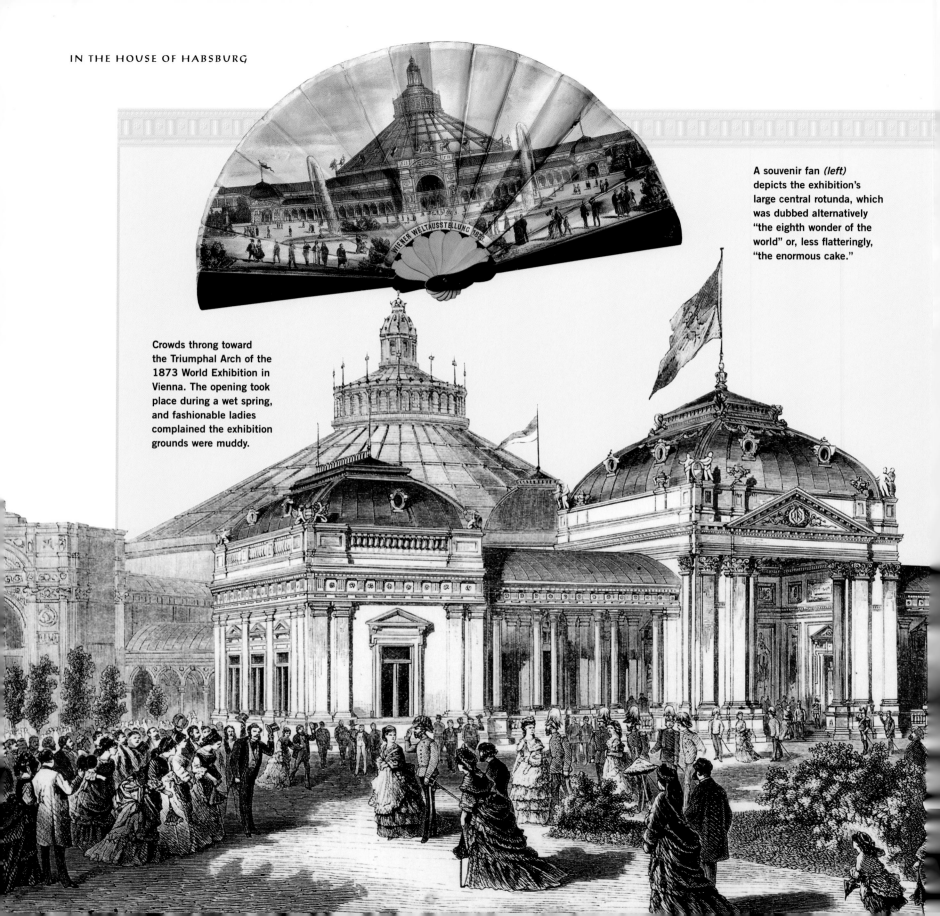

A souvenir fan *(left)* depicts the exhibition's large central rotunda, which was dubbed alternatively "the eighth wonder of the world" or, less flatteringly, "the enormous cake."

Crowds throng toward the Triumphal Arch of the 1873 World Exhibition in Vienna. The opening took place during a wet spring, and fashionable ladies complained the exhibition grounds were muddy.

THE WORLD COMES TO VIENNA

The beauty of Empress Elisabeth seems to have been enough to draw the shah of Persia to Vienna in the summer of 1873. But for most of the other visitors to the city that year, it was the World Exhibition, which opened its doors to the public on May 1, that beckoned.

The fifth of its kind to be held, the Vienna Exhibition of Industry and Art was five times bigger than the famous Paris Exposition of 1867 and drew exhibits from 40 different countries. During an afternoon's stroll through the exhibition's halls and gardens, visitors could make a virtual tour of the world: They could inspect Bohemian glassware or Italian bronzes, artificial teeth from the United States or carpets from Persia, gigantic cannons from Germany or prize strawberries from England. There were statues of Shinto gods, samples of Sèvres porcelain, displays of gold and silver jewelry from India, even a replica of Istanbul's Fountain of Ahmed III, where colorfully clad attendants served water and sherbet to thirsty visitors.

The exhibition proved a dismal business failure, however. It attracted only about a third of the 20 million visitors the promoters had predicted—and few visitors were there to buy. The exhibition was closed with little fanfare on November 2, more than $30 million in debt. Only the indomitable shah of Persia, it seems, went home pleased.

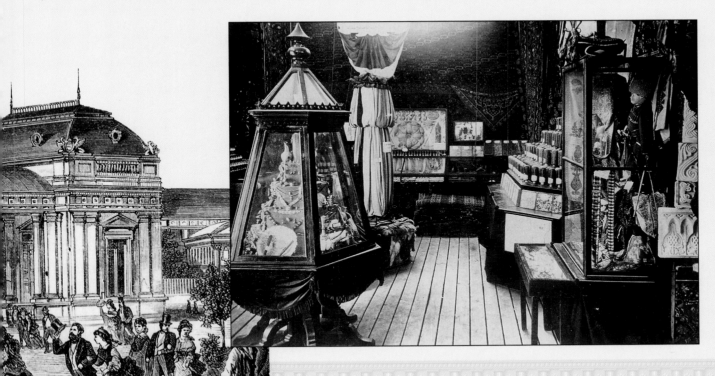

The Russian exhibit in Vienna featured furs and leather goods, products the country wanted to promote as exports. The exhibition boasted some 60,000 articles from countries all over the world, a third of the items from Austria itself.

the disastrous summer gave way to an even worse autumn: Rain ruined the grain harvests in Hungary, and valuable timbers from the empire's great forests were lost through an infestation of a species of bark-boring beetle.

Franz Josef's troubles were compounded when, in the second week of September, Elisabeth suffered a collapse and had to spend 10 days in bed. The emperor might be used to dealing with such difficulties, but Gyula Andrássy was not. After the empress recovered from her illness and left Vienna for Budapest, the foreign minister was no longer such a frequent guest. To Elisabeth's surprise, she was beginning to find that Andrássy would

put her husband's interests before her own. By now, the intimacy of their earlier relationship was fading, as Andrássy devoted himself more and more to the service of his sovereign.

But in his service to the new Dual Monarchy, Andrássy was soon to come upon hard times. In order to prevent Russian influence from spreading westward into the Balkans, Andrássy agreed to Austro-Hungarian occupation of the former Turkish province of Bosnia-Herzegovina at the Congress of Berlin in 1878, an occupation highly unpopular in both halves of the monarchy. The strain of 12 consecutive years at the center of the empire's affairs was also beginning to tell on Andrássy. He was

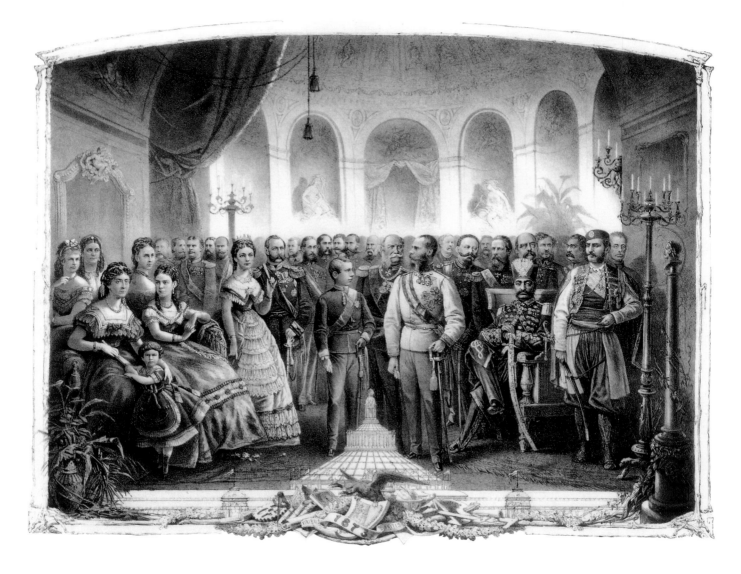

A painting of the imperial family members and foreign dignitaries who attended the 1873 exhibition shows Andrássy and German chancellor Otto von Bismarck peering out from behind the seated shah of Persia and the prince of Montenegro *(second from right)*. Andrássy is also featured in the Italian political cartoon above, which lampoons Austria's 1878 occupation of Turkish Bosnia and Herzegovina, represented by the two flowerpots in the foreign minister's hands.

tired, his estates in Hungary required his attention, and he was keen to leave office. Franz Josef still needed the services of the one-time rebel, however, and persuaded him to stay on for six more months. It was during that time that Andrássy pulled off what he considered the greatest achievement of his career: the defensive alliance with Chancellor Bismarck's Germany against possible attack by Russia. A day after signing the treaty, Andrássy tendered his resignation and retired into private life. He had served his native Hungary well, as he had served his king and emperor. When he died in February 1890, his passing was universally mourned.

Despite Gyula Andrássy's departure from government, the 1880s proved to be the golden years of Franz Josef's reign. Possessed of the strength of an oak, the emperor—now in his mid 50s—could stay in the saddle during maneuvers for 10 hours at a stretch without a trace of fatigue, and the force and spring of his walking stride became proverbial. As a result of the alliance with Germany engineered by Andrássy, the empire was protected from possible Russian aggression, and the economy was flourishing.

During these years, the main characteristic of Franz Josef's lifestyle—whether at the Hofburg during the winter months or at Schönbrunn during the summer—was continuity. The emperor maintained an ironclad routine. He would begin each day by rising between 3:30 and 4:00 a.m., bathing with cold water, and then donning his modest infantry lieutenant's uniform. Settling down in his study, he would make a start on the pile of papers on his desk that required his immediate attention. While thus at work, the emperor would be served a frugal breakfast—a cup of coffee, a buttered roll, and perhaps a slice of ham.

At around 7:30, he would put his paperwork aside and ring for his duty officer. Franz Josef would then meet with various military and cabinet officials, including his prime minister and foreign minister. Twice a week, between 10 o'clock and lunchtime, he would hold general audiences, meeting with as many as 100 of his subjects to hear their problems and concerns. On occasion he would join his family for lunch. More frequently, he would partake of a simple meal in his study—a bowl of soup, roast meat and vegetables, a glass of beer—after which he would immediately set to work again, receiving a report from the Vienna chief of police and a press summary from the foreign and domestic newspapers. Between 5:00 and 6:00 p.m., he would straighten his desk and leave for dinner.

When other family members were in Vienna, Franz Josef usually joined them for the evening meal, a rather dreary affair since etiquette demanded that no one speak to the emperor unless he first addressed them. Dinner was mercifully brief, however, ending when the emperor—who ate very little and very rapidly—finished his meal. Afterward, following a brief moment's relaxation with a solitary Virginia cheroot, Franz Josef would sometimes attend the theater or the opera. But usually, by around 8:30 he was in bed and—as was his habit—quickly asleep.

For Elisabeth, meanwhile, the older she grew, the more strenuous and demanding was her struggle to maintain her looks. Only through hours of daily exercise and skin care—the latter including warm olive-oil baths and nightly face masks with raw veal—could she maintain her slender figure and supple complexion. In Vienna, her day began with a cold bath and a massage at around 5:00 a.m. in summer, an hour or so later in winter, followed by a period of exercise and a frugal breakfast. Sometimes she was joined at her morning meal by her youngest daughter, Marie Valerie, who had been born in Budapest in 1868 and was the empress's favorite child. While Elisabeth's hair was being dressed, she read, wrote poetry, or

ELISABETH'S HUNGARIAN COURT

After their 1867 coronation in Budapest, Franz Josef and Elisabeth began to spend more time in the Hungarian half of the Dual Monarchy, often staying part of the year at Gödöllö Castle *(right)*, a gift to the royal couple from the Hungarian people. To the dismay of Vienna's German-speaking elite, Elisabeth surrounded herself with Hungarians in her household. In the picture below, Franz Josef confers with Count Andrássy while Elisabeth, young Rudolf, and Gisela *(standing, third from right)* are joined by some of the empress's Hungarian courtiers; on Elisabeth's lap, attended to by a Hungarian nurse, sits the infant Marie Valerie, rumored at the time to be Elisabeth's child by Andrássy.

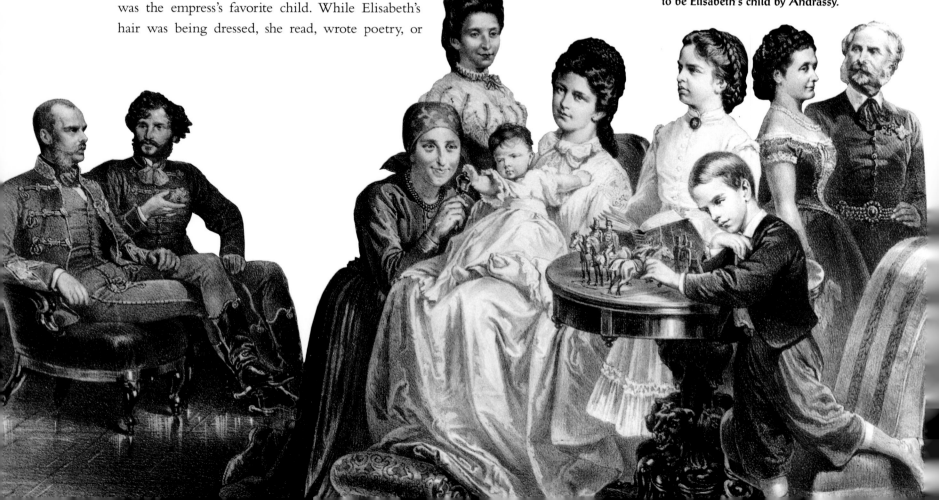

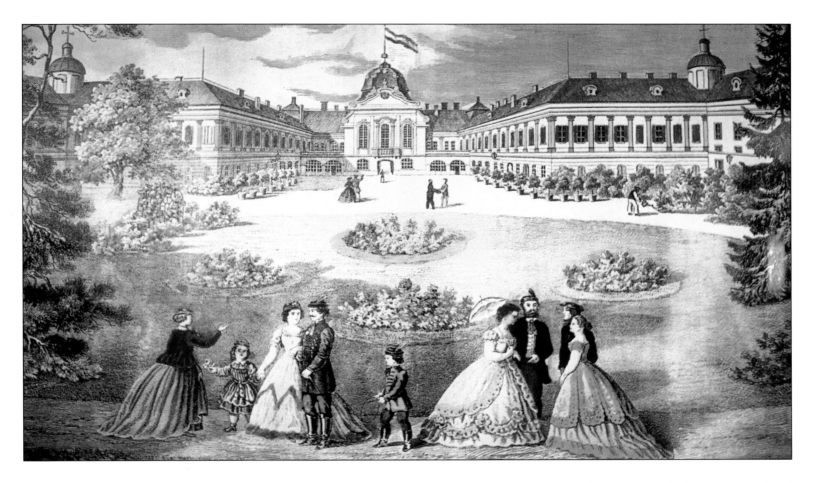

studied Hungarian. Then, depending on which activity she had planned for that morning, she was dressed in either her fencing costume or her riding habit.

After a quick lunch—often consisting of little more than a thin broth—the empress went for a long walk, often lasting several hours. The demands of these walks could get rather extreme: While staying at Ischl one year, for example, the empress set a goal of walking almost eight hours daily, ordering wagons to follow her with chairs for her ladies-in-waiting.

At around 5:00 p.m., Marie Valerie came to play. If a family dinner proved unavoidable, Elisabeth would join Franz Josef for the evening meal, perhaps the only time she saw her husband all day. Soon afterward she would retire for her daily chat with her friend and confidant Ida Ferenczy, who prepared her for bed.

During the mid-1880s, the increasingly lonely and isolated Franz Josef found a most welcome addition to his daily routine in the actress Katharina Schratt, with whom he began to share breakfasts and early morning strolls. A lively, strong-willed woman with expressive eyes and wavy blondish brown hair, Schratt had come to the emperor's attention when she debuted in a play at the Burgtheater in November 1883. Located next to the Hofburg, the theater was a particular favorite of the emperor's, and he would sometimes attend performances there several times a week. Because the Burgtheater was subsidized by imperial funds, Schratt, as a new actress at the Burgtheater, was required after the performance to thank the emperor personally for her engagement. The conversation on this occasion could only have been of the most formal kind. But the 30-year-old

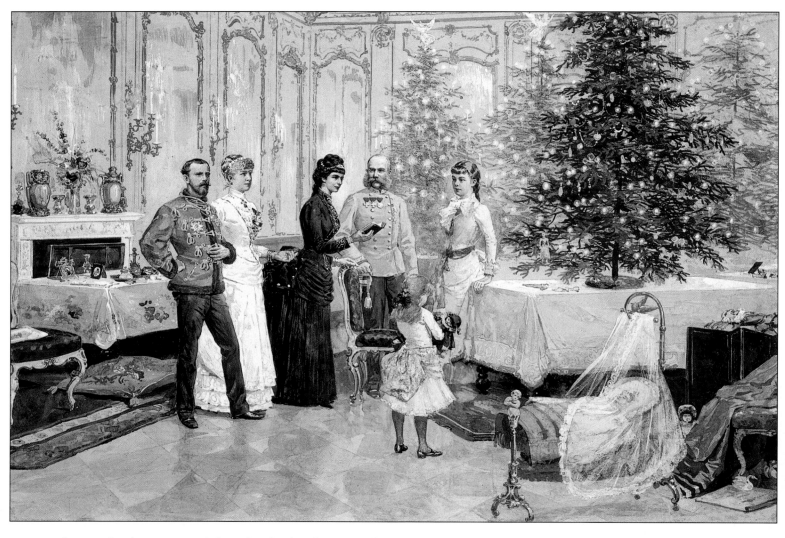

actress, who was by then separated from her husband, apparently made a real impression on the 53-year-old emperor. At a later meeting, during a ball held in honor of Vienna's leading industrialists, the actress and the emperor enjoyed an unusually long conversation. The duration of the chat was quickly noticed, and tongues at court started to wag.

Elisabeth, far from being jealous, made a rather straightforward gesture to promote the relationship between her husband and Katharina Schratt. In May 1886 the empress commissioned a portrait of the actress for Franz Josef and contrived to have the couple meet at the studio of the portrait painter, Heinrich von Angeli. Thinking he was going to see Angeli's progress—and with no idea that Schratt would be there herself—Franz Josef accompanied Elisabeth to the painter's studio. There, Franz Josef encountered an equally surprised Schratt. Elisabeth herself had brought them together and, by her very presence, conferred her approval. Two days later Franz Josef sent Schratt a letter and an emerald ring, a thank-you gift "for having gone to the trouble" of posing for the painting. The letter was the first of the more than 500 missives that would pass between them over the next 30 years. It was signed by Franz Josef with the words, "Your devoted admirer."

That summer Schratt rented a holiday villa not far from Ischl, and while the emperor was at the imperial resort he took advantage of every opportunity to visit her. Removed from the protocol and etiquette of court life, Franz Josef began to relax, indulging himself in simple pleasures. Ensconced in a comfortable stuffed armchair, he would enjoy the rich pastries and coffee Schratt served him, smoke more than usual, and generally give himself up to the actress's infectious gaiety. For the lonely emperor, it was a taste of domestic bliss.

Back in Vienna, the relationship continued—and intensified. "You no doubt already know that I adore you," he wrote her on February 14, 1888. "This affection has done nothing but grow since the day on which I was fortunate enough to meet you." "Were I not so old and had no cough," he wrote on another occasion, "I could shout with joy at the idea of meeting you again tomorrow."

But the emperor was a man of duty. He knew that as head of the Habsburg dynasty he could not meet with Schratt whenever he wanted. In fact, he took great pains to keep

At left, Franz Josef and Elisabeth celebrate Christmas at the Hofburg with daughter Marie Valerie; son Crown Prince Rudolf and his wife, Stephanie; and, clutching one of her baby dolls, granddaughter Elisabeth. Although the palace cooks, shown below in the Hofburg's main kitchen, served the usual grand repast, such gatherings had become purely perfunctory. "I often think how elsewhere the Christmas holiday brings families together in love and understanding—how happy such a group must be!" wrote Marie Valerie in her diary entry for Christmas Eve 1886. "At 5:30 dinner for the five of us and then we would go our separate ways."

his relationship with the actress beyond reproach. Far less restrained was the emperor's son, Crown Prince Rudolf. Rudolf differed from his father in other ways, too. Filled with liberal ideas by teachers chosen by his chief tutor, Joseph Latour, Rudolf became a virulent critic of many of his father's policies, including the empire's ties with what the crown prince saw as an increasingly reactionary Germany. As a result, Rudolf was carefully kept out of all affairs of state and was distrusted at court, a situation he deeply resented. "The most minor court adviser has more to do with government than I do," he complained. "I am condemned to inactivity." He began to mix freely with well-known Viennese liberals and, in 1879, wrote the first of several articles critical of his father's ministers for the progressive *Neues Wiener Tagblatt.*

Rudolf's marriage to a young Belgian princess, Stephanie, did little to content the heir apparent. He drank heavily, was addicted to opium, and engaged in short-lived affairs with society women; in the process he contracted—among other things—bad debts and, apparently, venereal disease, with which he may have infected his wife. The unloved Stephanie was to suffer further ill-treatment from her husband when he appealed to the pope to annul his marriage vows. Such a thing would have been unthinkable to Franz Josef. Indeed, the dissolution of Rudolf's marriage may have been the subject of a heated argument between the otherwise noncommunicative father and son. The argument took place on January 26, 1889, just four days before the tragic events at Mayerling.

The morning of January 30, 1889, seemed like any other at the Hofburg. By 10:30 the empress was having a modern-Greek lesson, Archduchess Marie Valerie was with her singing teacher, and the emperor was working in his study, looking forward to a morning visit from Katharina Schratt. Suddenly, a carriage pulled up to the palace's inner courtyard and out jumped Count Josef Hoyos. He brought the chilling news that Crown Prince Rudolf and his 17-year-old mistress, Marie Vetsera, had been found dead in a locked room in the royal hunting lodge at Mayerling—victims, it would turn out, of a double suicide.

The empress was the first member of the imperial family to hear of her son's death. It fell to her to break the horrific news to her husband. Drawing on all her strength, she went to the emperor's study: Their son lay dead at Mayerling, she told him, poisoned by Marie Vetsera, as she then believed. The emperor could barely take in the news. Minutes after he was informed of the tragedy, Katharina Schratt arrived at the palace. "You must go to him," a near-desperate Elisabeth told Schratt. "You must try and help him. I can do nothing more."

FRANZ JOSEF'S FRIEND

The relationship between Franz Josef and the actress Katharina Schratt was an enduring and complex one. When possible, Schratt would visit him at the Hofburg, slipping into the palace through a private entrance, or in the relative seclusion of the gardens of Schönbrunn. He would sometimes join her at one of her numerous villas.

The two often exchanged presents—useful items such as a desk calendar, a dressing gown, or a bedside rug for the emperor, generous gifts of money or stunning pieces of jewelry for Schratt. Sensitive to appearances, Franz Josef did not shop for Schratt himself. Instead, the actress would visit Köchert's, a prominent Viennese jewelry firm, to make her selection; Herr Köchert would then present the emperor with an assortment of jewels arranged on a green velvet tray, with Schratt's pick always in the bottom right-hand corner.

Despite such intimacies, their relationship was probably platonic. Schratt, seen at right in the emperor's favorite role as Frau Wahrheit, the lead character in a popular medieval comedy, likely remained what the emperor and the empress had always called her, *die Freundin*—the friend.

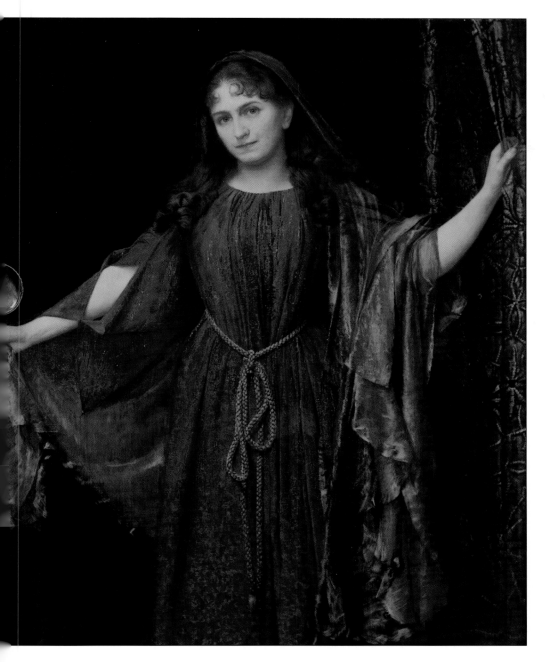

Ushered into Franz Josef's study by the empress herself, Schratt provided for the distraught father the soothing words and tenderness that Elisabeth could not. Schratt could see that Franz Josef's legendary self-control had broken down. His eyes were red with weeping, and he seemed a fragile version of his former self. Now, when he needed her most, Schratt helped ease the emperor through these most difficult hours of his life. He was to be forever grateful. "Your true friendship and your tranquil sympathy," Franz Josef would later write to Schratt, "have been a great consolation to us both in these awful days."

The emperor and empress were never the same after Mayerling. Although he summoned all his dignity, Franz Josef felt the strain of grieving for a son who had, he knew, brought everlasting shame on the monarchy. He began to age rapidly. Despite his famously elastic step, he was becoming *der alte Herr,* the old gentleman, a beloved, if distant, ruler whose portrait hung in virtually every public place and many a private home. No likely successor would command such public devotion. Franz Josef's new heir, his younger brother Karl Ludwig, was widely distrusted. And when Karl Ludwig died in 1896, his son Franz Ferdinand—the emperor's nephew—became official heir to the throne. But he too had problems. Considered self-important and something of a prig, Franz Ferdinand was not a favorite of the emperor's, and the general public cared for him even less. Moreover, he had recently been diagnosed with tuberculosis. In Vienna the feeling was gaining ground that Franz Josef's death would spell the end of the monarchy in Austria.

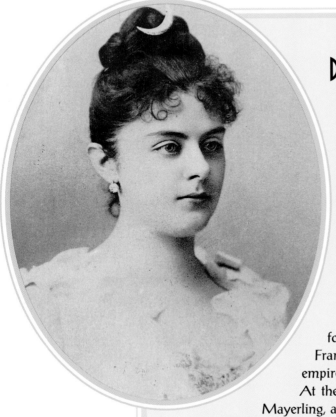

DEATH OF A CROWN PRINCE

Crown Prince Rudolf had long been a disappointment to his father. The tradition-bound emperor was at a loss to understand Rudolf's liberalism, his opposition to the church, his contempt for the aristocracy, his questioning of the legitimacy of the Habsburg state. His son's profligate lifestyle also angered and dismayed him. But nothing the crown prince had ever done in all his 30 years prepared the emperor for Rudolf's final act, which would shock Franz Josef like nothing else and rock the empire to its very foundations.

At the end of January 1889, Rudolf went off to Mayerling, a royal hunting lodge about 15 miles southwest of Vienna. His guest at the lodge was 17-year-old Baroness Marie Vetsera, one of his numerous lovers. Vetsera was a lighthearted flirt who had become something of an embarrassment to Rudolf. But her presence at Mayerling apparently gave him the courage to do what he might not have been able to do alone. Unhappy and dissatisfied with every part of his life, the heir to the Habsburg throne had decided there was only one honorable thing left for him to do.

On the evening of January 29, Rudolf retired early. He was not to be disturbed, he told his valet, "even if it were the Emperor himself." The next morning, around 7:30, the valet, as instructed, knocked gently on Rudolf's bedroom door. There was no answer, and the door was locked. By eight o'clock Rudolf's friend Count Hoyos—who

Crown Prince Rudolf's partner in death was his mistress, the "little baroness," Marie Vetsera *(left)*. The teenage Vetsera was introduced to Rudolf by Countess Marie Larisch, a favorite niece of Empress Elisabeth's. After the tragedy that took place at Mayerling, Larisch—who is shown in a playful pose below—was banned forever from the royal court.

was staying at a house nearby—had joined the valet outside the door. When repeated knocking brought no answer, Hoyos ordered the valet to force open the door. The valet smashed one of the door panels and peered into the room, which was still lit by candles from the previous night. Next to the bed sat Rudolf, slumped on the floor in a pool of blood. The top of his skull had been blown off, and his army revolver lay next to him on the floor. On the bed lay the half-naked body of Marie Vetsera, clasping a rose between folded hands. Except for the bullet wound piercing her left temple, she could have been asleep.

When Franz Josef learned what had happened—that his son and heir not only had killed himself but also had murdered Vetsera—he moved quickly to head off scandal. On his orders, Marie's body was spirited away from Mayerling and secretly interred at a nearby cemetery; not even her mother was allowed to attend the burial. On January 31 an official bulletin announced the crown prince's "suicide by revolver." His death, the bulletin claimed, had occurred while Rudolf was "in a state of temporary derangement," thereby clearing the way for a church funeral. Eventually, the hunting lodge at Mayerling was demolished and a cloister for Carmelite nuns built in its place. A chapel was erected on the precise site of Rudolf's death, adorned with a fresco of the boy-martyr Saint Rudolf.

Liebe Stephanie!
Du bist von meiner Gegenwart und Plage befreit; werde glücklich auf Deine Art.
Sei gut für die arme Kleine, die das einzige ist, was von mir übrig bleibt.
Allen Bekannten, besonders Bombelles, Spindler, Latour, Wowo, ...

Grüsse Leopold, etc. etc... sage meinen letzten Grüsse.
Ich gehe ruhig in den Tod, der allein meinen guten Namen retten kann.
Dich herzlichst umarmend, Dein Dich liebender
Rudolf

His head bandaged to hide the bullet wound in his skull, the crown prince lies in state at the Hofburg. Rudolf left several farewell notes for family and friends but not a single word for his father. "I am going calmly to my death which alone can save my good name," he wrote his wife, Stephanie, in the letter above.

At the same time, the emperor was growing increasingly uneasy about his wife's well-being. Tortured by feelings of guilt after Rudolf's death, Elisabeth sank into a state of despair, accompanied by frequent thoughts of death. Matters worsened when, a year after Mayerling, Gyula Andrássy died. According to her daughter Marie Valerie, "for the first time [Elisabeth] felt completely abandoned, without adviser or friend."

Following Marie Valerie's marriage on July 30, 1890, Elisabeth was, in a sense, again free to fly. Her only son was dead. Her only confidant in the outside world, Andrássy, was dead. Her husband was contented in his friendship with Katharina Schratt, and her daughter was happy in her new marriage. Elisabeth—lonely and self-absorbed, in almost continuous pain from sciatica and neuritis—resumed her itinerant ways. A forlorn figure dressed habitually in black, she crisscrossed Europe, never remaining for long in any one place. "[If] I knew that I would never have to leave it again," she explained, "even a paradise would become hell for me." Yet even in all her grief and decline, and even after 40 years of marriage, the emperor, sadly and poignantly, still faithfully sent her letters wherever she was. "I think of you continually," he wrote her one Christmas Day—"with boundless longing."

Only once in the final years of her life did the empress appear officially in public; it was, characteristically enough, during Hungary's millennial celebration of 1896. The newspaper *Magyar Hirlap* described her then as "a black, female head, a new, an infinitely sorrowing face, with a smile that seemed no more than a shallow reflex." By the winter of 1897-1898, which she spent on the French Riviera, her once-floating steps had grown ponderous, and she could no longer embark on the long walks that had been her trademark. Attempting a cure at a German spa in late July, she wrote to Marie Valerie: "I am in bad humor and sad, and the family can be glad that they are away from me. I have a sense that I will not rally again."

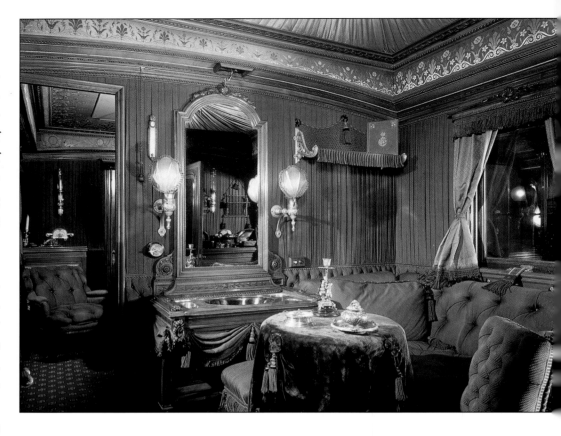

The luxuriously appointed parlor car shown above allowed the restless empress to travel by rail in comfort and style throughout Europe. At right, in an 1891 photograph of Elisabeth and her confidant Ida Ferenczy, the empress wears her hair in a bun instead of her usual intricate crown of braids. Elisabeth refused to pose for portraits or official photographs after she entered middle age. In public, she normally shielded her face with a fan or an umbrella, both to protect her privacy and to preserve the legend of her beauty.

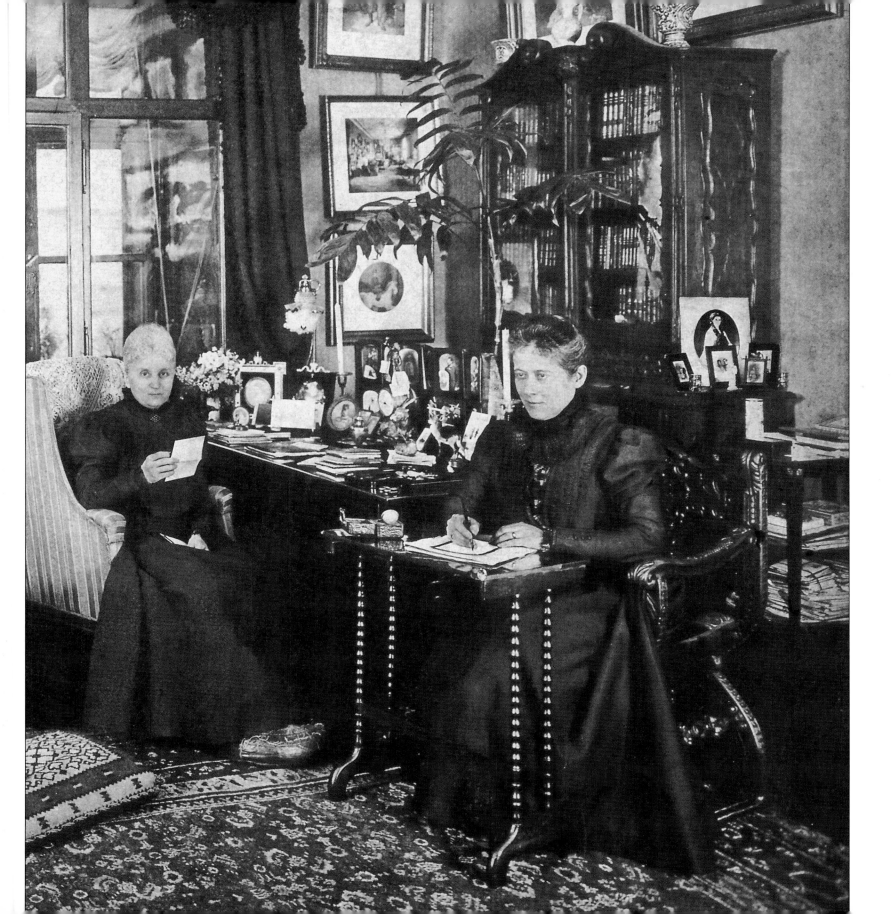

The option of rallying, as it turned out, was not to be hers. On the afternoon of September 10, 1898, Franz Josef sat in his study at Schönbrunn, writing a last letter to Elisabeth before leaving for military maneuvers. Lying on his desk was a present given to him on the occasion of the millennial celebrations in Budapest: a gold model of Elisabeth's hand wearing a bracelet containing a ruby, a diamond, and an emerald—the red, white, and green of Hungary's national colors. Before him, on an easel, leaned a portrait of the empress, wearing a simple white gown, from a happier time. The emperor completed his letter to his wife, adding a final line in Hungarian, "I commend you to God, my beloved Angel."

Not long afterward there came a knock on his study door, and his adjutant Count Eduard Paar urgently requested an audience. "What is the matter?" the emperor demanded of Paar.

"It is bad news," Paar replied. "There is a telegram from Geneva saying that the Empress has been seriously injured." At that moment, an aide-de-camp arrived, bearing yet another telegram from Geneva. Franz Josef immediately seized the second telegram, reading through tears, "Her Majesty the Empress has just passed away."

When she was on her way to catch a steamer at a lakeside quay in Geneva, the empress had been attacked and stabbed in the chest by a 26-year-old Italian anarchist by the name of Luigi Luccheni. She had been taken back to her hotel, but it was too late: The blade had penetrated three and a half inches deep and passed through her left ventricle. Within minutes, Elisabeth, empress of Austria, was dead.

"Is nothing to be spared me on this earth?" Franz Josef uttered out loud, sinking back into his chair. Then, a few moments later, he was heard murmuring to himself, "No one will ever know how much I loved her."

A portrait of his wife hanging nearby, Franz Josef reads in his study at Schönbrunn, where he had learned of Elisabeth's assassination. The "old gentleman" continued to put in grueling, solitary hours at his desk in the years after her death. "My state of mind is boundlessly sorrowful in my comfortless loneliness," he wrote Schratt in 1901, "my age makes itself ever more felt, especially of late, and I am very tired."

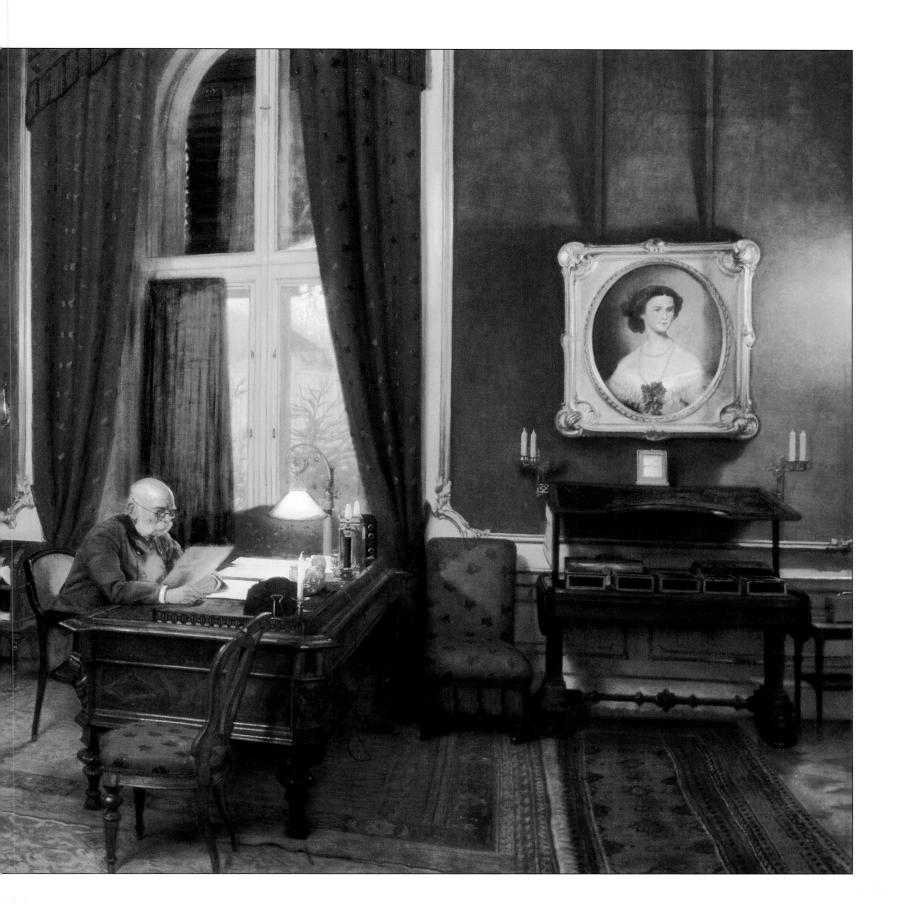

CRADLE OF THE EMPIRE

At the heart of Franz Josef's empire were the "hereditary lands," the ancient domain of the Habsburgs, a collection of principalities stretching from the northern spur of the Alps south to the Adriatic Sea. The dynasty acquired the first of these territories—the duchies of Austria and Styria—in the 1200s, during the reign of the first Habsburg king of Germany, Rudolf I. By the early 1500s, Carinthia, Carniola, Tyrol, Vorarlberg, Gorizia, Gradisca, part of Istria, and Trieste had joined the Habsburgs' Alpine dominions.

The empire grew to embrace an array of peoples, richly diverse in ethnicity, culture, and religion. While most were Catholic, there were Lutheran, Calvinist, and Eastern Orthodox minorities, as well as Muslims and Jews. This diversity is evident in the colored engravings reproduced here and on the following pages, which date from the time of Austrian emperor Franz I, and in the accompanying watercolor scenes, most of which were commissioned by Franz Josef's uncle, Ferdinand. The black-and-white illustrations were created at the request of Crown Prince Rudolf in 1884 as a way to "present a comprehensive picture of our Fatherland and its race of peoples."

This mountaineer from Tyrol, a land of ardent hunters, wears a large hat to block the sun and carries a musket and a haversack. A mountainous, independent-minded province inhabited by Germans and Italians, Tyrol is now divided between Austria and Italy.

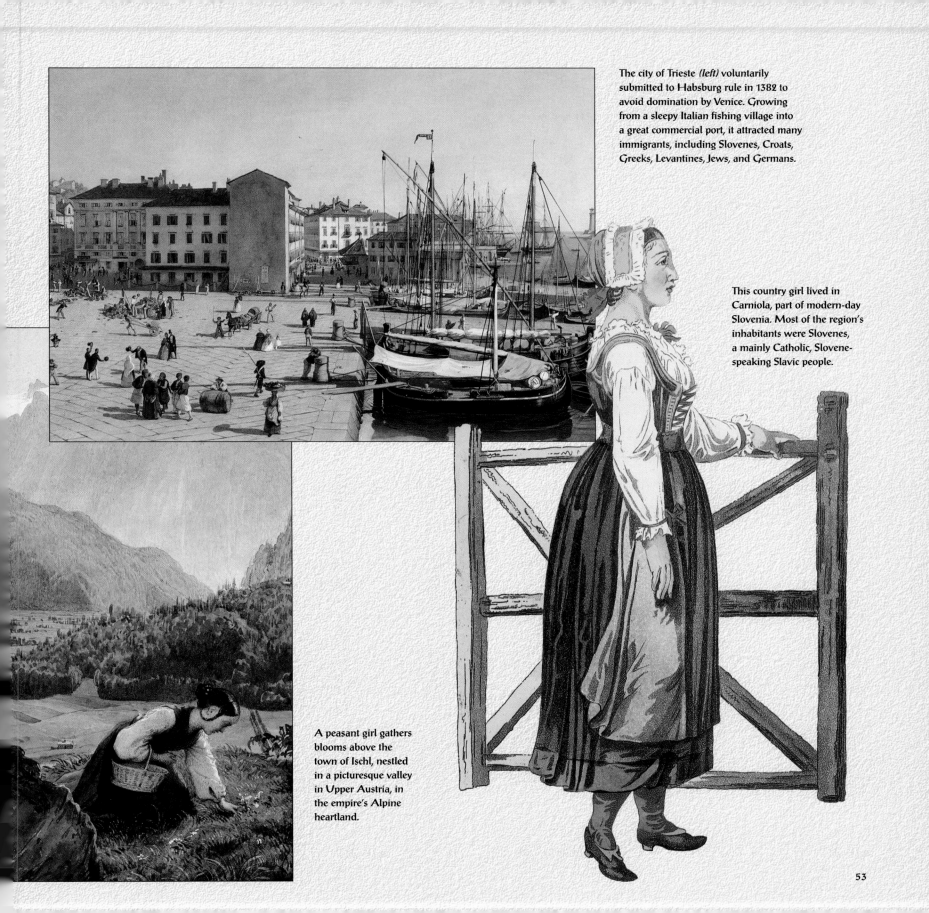

The city of Trieste *(left)* voluntarily submitted to Habsburg rule in 1382 to avoid domination by Venice. Growing from a sleepy Italian fishing village into a great commercial port, it attracted many immigrants, including Slovenes, Croats, Greeks, Levantines, Jews, and Germans.

This country girl lived in Carniola, part of modern-day Slovenia. Most of the region's inhabitants were Slovenes, a mainly Catholic, Slovene-speaking Slavic people.

A peasant girl gathers blooms above the town of Ischl, nestled in a picturesque valley in Upper Austria, in the empire's Alpine heartland.

The Gothic spires of the Tyn Church soar above Old Town Square in Bohemia's capital of Prague *(below).* At right, an early steam train leaves Brno, capital of Moravia. Bohemia, Moravia, and Austrian Silesia formed the manufacturing center of the Habsburg empire.

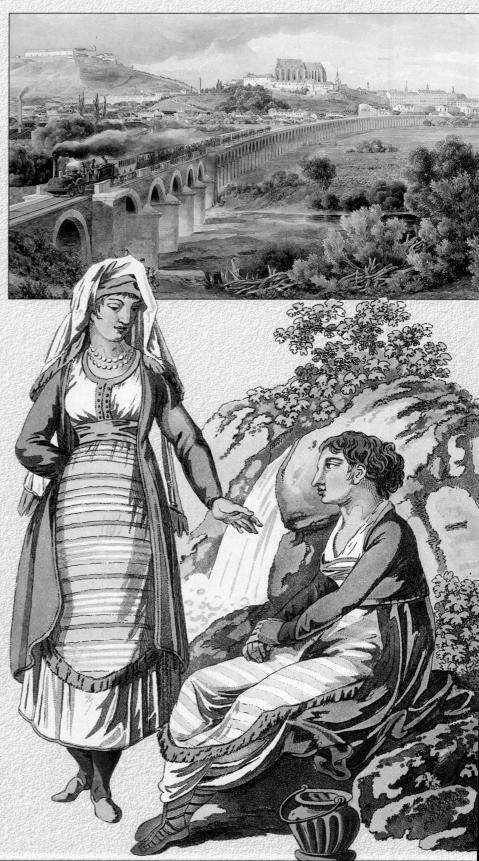

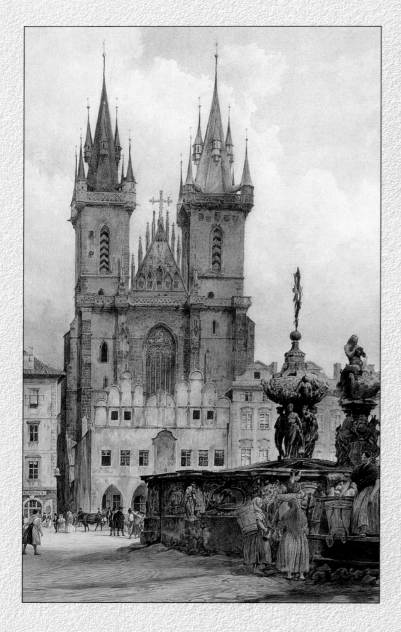

The women at right are Croats, a Catholic, Slavic people who were among the Habsburgs' most loyal subjects. Croatian troops helped defend the empire against the Turks and fought against Viennese, Italian, and Hungarian revolutionaries in 1848.

THE EASTERN CROWNS

The Habsburgs owed their long dominion over the lands that belonged to the eastern crowns—Bohemia, Hungary, and Croatia-Slavonia—to several factors, including the persistent forays of the Ottoman armies into Hungary and two fortuitous marriages arranged by Maximilian I, Franz Josef's illustrious forebear. In 1515 Maximilian promised his granddaughter to Louis II, king of Bohemia and Hungary-Croatia, and his grandson, Ferdinand, to Louis's sister. Following his army's catastrophic defeat by Ottoman sultan Süleyman the Magnificent in 1526, Louis died and Ferdinand laid claim to his thrones.

As kings of Bohemia, Ferdinand and his descendants ruled not only Bohemia, but also Moravia and, for a time, Silesia and Lusatia. Czechs and Germans constituted the majority in the Bohemian lands, although many Poles lived in Silesia. The historic kingdom of Hungary extended far beyond Hungary's current modern boundaries to include the kingdom of Croatia-Slavonia, Transylvania (in modern Romania), the region now known as Slovakia, and parts of modern Austria, Serbia, and Ukraine. For most of the 16th and 17th centuries, however, the Habsburgs actually ruled only a fraction of the large kingdom and its population of Magyars, Croats, Germans, Slovaks, Serbs, Romanians, and Ruthenians: The Ottoman Turks held sway over the rest.

This festively garbed peasant *(above)* hails from Slovakia, home of the Slovaks and until 1918 part of Hungary. During the reign of Franz Josef, Hungary's Magyar authorities restricted the use of the Slovak language—every town and village was given a Magyar name, for example—and limited Slovak participation in government.

Hungary's peasants, like the one depicted below, helped supply the empire with grain, meat, wine, and tobacco. Peasants in Hungary were members of many different ethnic groups, including Magyars, Germans, and Ruthenians, a Ukrainian people.

OVERCOMING THE OTTOMANS

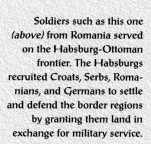

In 1683, as a Turkish army besieged Vienna, the fate of the Habsburg empire hung in the balance. Yet in just a few years Austria reversed the tide of Ottoman expansion, pushing the Turks almost completely out of Hungary-Croatia. Instead of welcoming the Habsburgs as their liberators, however, many Magyars regarded them as heavy-handed foreign overlords. Indeed, the Habsburgs acted as such: Transylvania, historically part of the Hungarian kingdom, had enjoyed autonomy for most of the Ottoman era, but the Habsburgs not only blocked its independence, they also sought to impose Catholicism on the kingdom's many Protestant Magyars and Germans.

Because occupation and warfare had depopulated Hungary-Croatia, the Habsburg rulers encouraged immigration. Settlers came from other Habsburg domains and from Germany, the Balkans, and elsewhere in Europe. The resulting ethnic hodge-podge was especially notable in southern Hungary, with its population of Serb, Magyar, Romanian, German, Slovak, Bulgarian, and Italian stock. Hungary's resettlement caused the Magyars to lose their majority, and in the 1800s Hungarian authorities tried to "Magyarize" other nationalities by pressuring them to adopt the Magyar language.

Soldiers such as this one *(above)* from Romania served on the Habsburg-Ottoman frontier. The Habsburgs recruited Croats, Serbs, Romanians, and Germans to settle and defend the border regions by granting them land in exchange for military service.

As their empire expanded into Turkish territory, the Catholic Habsburgs acquired increasing numbers of Eastern Orthodox subjects, such as this priest *(left),* from among the Serbs, Romanians, and Ruthenians.

Transylvania, where the Gothic castle at left is located, was home to four major groups: Magyars, Germans, Szeklers (akin to the Magyars), and Romanians. Though Transylvanian Romanians constituted the majority of the population, they suffered discrimination from the time of the Middle Ages until the end of the Habsburg period.

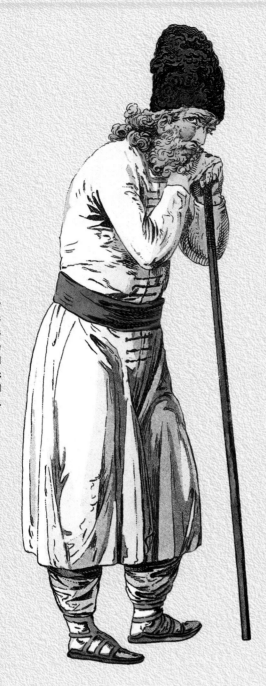

Bukovina, an underdeveloped Turkish province inhabited by peasants such as this herder *(right)*, was annexed by Austria in 1774. It was populated mainly by Orthodox Romanians and Ruthenians.

At left, Serb villagers in southern Hungary engage in a folk ritual meant to bring rain. Following its recovery from the Ottomans, Slavic Serbs moved into the region in large numbers. With the encouragement of the Habsburgs, Serb refugees also settled on Croatian lands reclaimed from the Turks.

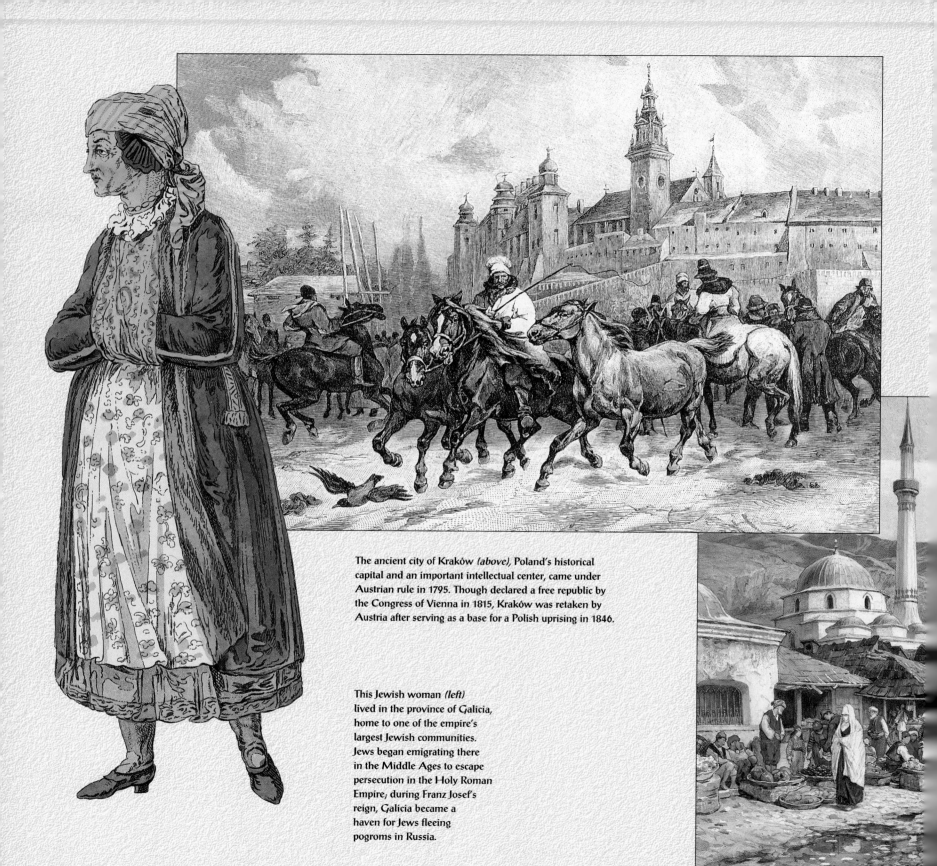

The ancient city of Kraków *(above)*, Poland's historical capital and an important intellectual center, came under Austrian rule in 1795. Though declared a free republic by the Congress of Vienna in 1815, Kraków was retaken by Austria after serving as a base for a Polish uprising in 1846.

This Jewish woman *(left)* lived in the province of Galicia, home to one of the empire's largest Jewish communities. Jews began emigrating there in the Middle Ages to escape persecution in the Holy Roman Empire; during Franz Josef's reign, Galicia became a haven for Jews fleeing pogroms in Russia.

GREAT POWER POLITICS

No sooner had the Habsburgs overcome the Ottomans than they had to face the expansion-ist ambitions of Russia, Prussia, and France. Austria lost most of Silesia in a war with Prussia in 1742. Then, in the late 1700s, Prussia and Russia began to carve up Poland, a valuable buffer state for Austria, and the worried Habsburgs insisted on sharing in the spoils. Austria's acquisition of the province of Galicia and the city of Kraków made the Poles one of the empire's largest minorities.

Austria's borders expanded and contracted during its wars with Napoleonic France. After Napo-leon's defeat, however, the Con-gress of Vienna redrew the map of Europe, and Dalmatia, Lom-bardy, and Venetia were ceded to the Habsburgs. After Franz Josef lost Lombardy and Venetia to Italy in the mid-1800s, Aus-tria wanted to acquire territory in the Balkans, curbing Russian expansion. In 1878 Europe's great powers condoned Austria's occupation of Turkish Bosnia-Herzegovina, a move the Habsburgs hoped would increase their security but that ulti-mately—by antagonizing Serb na-tionalists—led to their downfall.

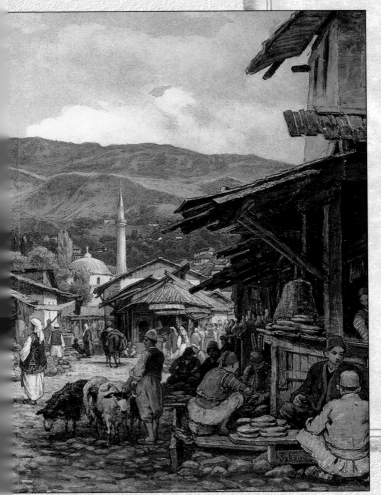

Bazaar stalls, minarets, and veiled women add Middle Eastern flavor to Sarajevo *(below)*, the capital of Bosnia-Herzegovina. Many Austrian-Germans and Magyars opposed Austria-Hungary's 1878 occupation of Bosnia-Herzegovina because they did not want the empire's Slavic population increased.

This swashbuckling noble lived near Cattaro (now Kotor), a Dal-matian port and imperial naval base. Dalmatia was mostly Croa-tian and Serb, although many coastal residents were Italian. Today Kotor and its hinterland form part of Montenegro.

"THE DESIRES OF THE PEOPLE"

The dome of the Church of St. Charles looms over Vienna's Naschmarkt, where street vendors offer overflowing baskets of fresh fruits and vegetables to city dwellers. The grand architecture of the church and the liveliness of the market were part of the colorful street life of cosmopolitan Vienna, home to all classes of society.

Standing alone at one end of the ballroom, 18-year-old Bertha Kinsky plucked nervously at one of the hundreds of rosebuds stitched to her gown. The young countess's cheeks flushed as pink as the tiny silk flowers as she watched several dozen handsome military men lead their new partners into a waltz. Her very first ball was almost half over, and still no one had asked her to dance.

Along the sidelines, rows of aristocratic mamas perched on little gilt chairs, beaming at their daughters and whispering among themselves. Bertha felt sure that she was the only topic under discussion. She could almost hear them saying, "Look at the poor Kinsky girl. What a gauche little creature! Of course, she's only noble on the father's side. The old count married a commoner. And breeding tells . . . "

Bertha caught sight of her own mother, who, knowing her place, sat a little apart from these superior beings. Sophie, the widowed Countess Kinsky, had tried hard to catch her daughter's eye. Now that she had succeeded, Sophie swiftly drew her forefinger across her lips. Bertha understood the signal and forced herself to smile.

The supper interval brought no relief. Bertha, clutching a plate

with a single sliver of chicken on it for the sake of appearances, seated herself among a little bevy of her fellow countesses and tried to find a way into their conversation. But they spoke only of people she had never met and dances she had not attended.

Being only half noble, Bertha had no right of entry to the imperial court. It would never have occurred to members of the 80 intensely intermarried families who were the cream of the Habsburg ruling class to invite a young woman of such dubious pedigree to their private celebrations.

Instead, she was making her debut at one of the less exclusive events on the social calendar—a "pick-nick ball." These gatherings took their name from the outdoor meals that, according to fashionable Viennese hostesses, were all the rage among the English landed gentry. They were seen as relatively informal occasions, open even to guests whose blood was not quite so blue. Bertha reminded herself that the evening was not over yet. She tried to keep her hopes up for the climax of the ball, the cotillion, when gentlemen customarily presented flowers to their favorite young ladies. After this ritual, the most popular maidens generally went home so laden with bouquets that they could hardly cram these fragrant trophies into their chaperons' carriages.

As the cotillion began, Bertha held her breath. Someone came toward her, proffering a bouquet and requesting the pleasure of a dance. But her heart sank once more into her slippers: Her admirer was not a dashing member of the Imperial Guard but, rather, was an officer in the far less glamorous infantry. And even she, a mere outsider, knew that this particular gentleman had already offered himself in marriage to several young ladies. They had all refused him. And, worst of all, he was perhaps the homeliest man in the whole room. Still, she did not want to sit out the most eagerly anticipated dance of the night. So she swallowed her pride, extended her hand, and allowed herself to be led onto the floor.

The gulf between Bertha and the other young ladies at the ball was rendered even

With her hat in one hand and an umbrella in the other, an adolescent Bertha Kinsky stands in front of a flower-laden fence in Vienna around 1860. Although Bertha was hampered in her early years by poverty and lack of social status, she achieved success and international fame in later life as a writer and a leader of the Austrian pacifist movement, and she was the first woman to win the Nobel Peace Prize.

wider by her unconventional upbringing. She had been born far from Vienna, in the old Bohemian capital of Prague, in a wing of the Kinsky family's rambling Rococo palace. Her father, Count Franz Joseph Kinsky, was a minor son of the Kinsky line who had made a career as an army general. He had died at age 75 in 1843, shortly before his daughter's birth, leaving behind a six-year-old son and the pregnant Sophie, his commoner countess, who was 50 years younger than her spouse.

Bertha spent her early childhood almost entirely in adult company. A succession of foreign governesses came and went,

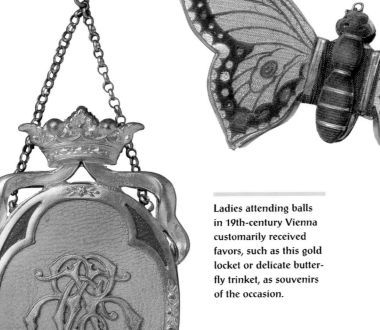

Ladies attending balls in 19th-century Vienna customarily received favors, such as this gold locket or delicate butterfly trinket, as souvenirs of the occasion.

giving her a reasonable knowledge of their native tongues but little understanding of the world outside. She spent most of her free hours watching her mother at the card table or indulging in romantic daydreams about her own indubitably rosy future.

When Bertha was 12, the Kinsky household received a breath of fresh air in the persons of Sophie's sister—who was also a widow—and her daughter, Elvira, who was the same age as Bertha herself. Bertha had never encountered anybody quite like Elvira. This newly discovered cousin was a precocious intellectual, a fledgling poetess determined to make her mark upon the world of letters. To Bertha's amazement, Elvira was far more interested in Shakespeare, Kant, and Hegel than in Bertha's fantasies about ball gowns and princely suitors.

Fascinated by this cultured cousin, Bertha decided to follow her example. She began to read. Although she never became quite as fierce a "bluestocking" as Elvira was, she was happy to make the acquaintance of the ancient philosophers, the German Romantic poets, and contemporary novelists. But when the time came, even unsophisticated Bertha knew better than to chat about her new intellectual enthusiasms with the other belles at the picknick ball. The typical convent-bred daughter of the aristocracy was firmly discouraged from such unladylike preoccupations. Her library, if she had one, was likely to consist of a few religious tracts and some scrupulously expurgated classics.

If any of Bertha's early romantic illusions still survived, the humiliations she suffered on the night of that first ball convinced her to bury them forever. As the carriage headed home through the dark city streets, the young countess turned to her mother and delivered an important announcement: "Mama, I have made

up my mind now, I will accept the proposal." Tomorrow, said Bertha, they would send word of her decision to Baron von Heine-Geldern, the man who for so long had been trying to win her hand in marriage.

The older woman's eyes lit up. Now, at last, her daughter was beginning to see sense. The baron might be a 52-year-old widower with a daughter only two years younger than Bertha herself, but, as everyone knew, he was also one of the richest men in Vienna. Von Heine-Geldern, owner of one of the city's most influential newspapers, belonged to the elite circle known as the "second society," a network of newly ennobled industrialists and financiers, high-level civil servants, senior military officers, and leading academics. These were self-made men, recently risen from the ranks of the bourgeoisie; many, like the baron himself, were Jewish. But no matter what honors or titles the emperor heaped upon them, these newcomers would never be accepted as equals by the old feudal nobility, with its family trees and landed wealth going back for generations.

Bertha's literary cousin, Elvira, must have been impressed when she learned that the baron's brother was the famous poet Heinrich Heine. And Sophie was even more impressed when the baron showered her daughter with jewels and costly keepsakes, took both ladies shopping for new furniture and a trousseau, and drove them out to see the palatial suburban villa he had chosen as a wedding present for his bride. Then, perhaps intoxicated by his own happiness, the baron made a fatal mistake. He put his arms around his young fiancée, cried, "Bertha, do you know how enchanting you are?"—and kissed her on the lips.

Bertha reeled back, horrified. It was, as she recalled years later, "the first romantic kiss a man ever gave me." But it came from a man old enough to be her father, a man for whom, she now realized, she felt no passion or desire. "No, never!" she told herself and broke off the engagement the next day.

Her mother wept as she saw the luxurious presents packed up for return to the baron's mansion, wailed over the social disgrace, begged her daughter to reconsider. Bertha stood firm. "I'd rather die!" she declared.

It was the first in a string of abortive engagements. After the von Heine-Geldern debacle, the widow's hopes rose when a Neapolitan prince offered to make Bertha his *principessa*. Once again, Bertha disappointed her mother by rejecting an elderly suitor; this one was not only rich but of impeccably ancient pedigree. The next proposal came during a visit to Paris and was from an attractive young Englishman, heir to a fat colonial fortune. There was a flurry of plans, including visits to important jewelers to select diamonds for her wedding diadem. But at the eleventh hour the Anglo-Saxon suitor, revealed as a fraud, disappeared.

Finally, Bertha fell in love with a young German prince named Adolf zu Sayn-Wittgenstein-Hohenstein. Adolf was, unbeknownst to Bertha, an irresponsible dreamer—and up to his ears in debt. He fantasized about a career as a singer on the New York stage, and his despairing family seemed all too eager to wave him off on the first available transatlantic liner. With promises of a speedy reunion, the lovers parted. But Adolf fell ill, died on the voyage, and was buried at sea.

Sophie dried her daughter's tears and turned back to her own strategies for improving the family fortunes. The old count had left only a modest legacy, augmented by a small monthly allowance from the Kinsky coffers. To compensate for the shortfall between her income and her aspirations, the widow turned to gambling.

Sophie believed herself endowed with clairvoyant powers that would make her lucky at roulette and invincible at cards. To test this theory, she paid frequent visits to casinos at the spas where Europe's upper classes went to socialize and take the waters.

Even when victory eluded her, the countess's trips continued, always with her daughter in tow. Useful new social contacts compensated for any losses in the gaming rooms. For Bertha these

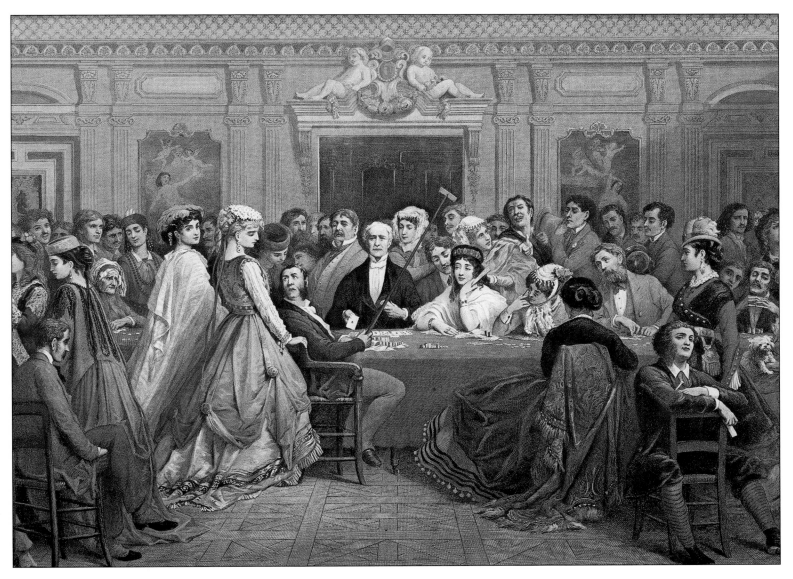

journeys provided a broadening, if unorthodox, education. She matured into a sophisticated woman of the world, fluent in four languages and able to discuss the issues of the day with everyone from itinerant millionaires to her new friend the princess of Mingrelia, who ruled a tiny principality in the distant Caucasus.

Gradually, all hopes of an advantageous marriage faded. Meanwhile, Bertha began to nurse a new ambition. She had taken singing lessons, treated her mother's friends to impromptu concerts, and been lavishly praised. The concert stage beckoned. Then a famous voice teacher gave her an audition and politely advised her to abandon dreams of stardom.

By the age of 30, Bertha had resigned herself to her unmarried state. She craved

independence; the time had come to escape her mother's shadow. But the morality of the day made it impossible for a virtuous single woman of her class to live alone, unchaperoned by parents, a married sibling, or some respectably aged female relative. So Bertha chose a path that most titled ladies would have considered unthinkable and hired herself out as a governess.

Her new employers were Baron and Baroness von Suttner, wealthy members of the social circle that she would have entered if she had married von Heine-Geldern. The von Suttners's four daughters, ranging in age from 15 to 20, adored her. They shared her love of music, admired her gift for foreign languages, and drank in the tales of her fascinating life in the spas and capitals of Europe. She soon became more like a member of the family than a paid employee. "I did not play up the dignity of my thirty years," she recalled. "Or the authority of my position. The five of us were playmates."

The von Suttners lived in opulent style in enormous apartments overlooking the river. There were tapestries on the walls, three salons, a lavender bedroom for the lady of the house, and a smoking room for the baron that was rendered suitably masculine by leather upholstery and wood-paneled walls. The floor below housed a small self-contained flat occupied by one of the von Suttners's two married sons as well as separate bachelor quarters for 23-year-old Arthur, who was studying law.

The von Suttners employed a doorman; a cook; several maids to assist in the kitchen, clean the rooms, and help the ladies dress; valets; and a coachman to convey the family on its excursions around the city or out of town. Hospitality was lavish, with dinner parties and afternoon visits for gossip and tea. When guests arrived, the porter sounded the bell as many times as custom required to signify gender or rank: one ring for a gentleman, two for a lady, a triple peal for an archduke.

Bertha fit comfortably into the household routine. Twice a week, during the season, she escorted her protégés to the opera to enhance their musical education. On fine evenings, after an early dinner, they enjoyed stately carriage drives through the Prater, the magnificently landscaped park where all Vienna came to walk, ride, see, and be seen.

In summer, when the upper classes fled en masse from the capital's oppressive heat, the family retreated to their castle, Harmannsdorf, 50 miles to the north. Bertha and the girls loved these annual migrations. "There is nothing more delicious," she recalled, "than to leave the hot, dusty city, and arrive at a beautiful castle where in every room there is a scent of freshness; where you are surrounded by park and forest; where you look forward to a long period of recreation and enjoyment of nature." Awaiting the family's pleasure were gardens and pavilions landscaped in both the French and the English styles, great stone vases and

statuary, pine groves to stroll in, and trips by pony cart to wilder woodland, accompanied by picnic baskets packed with all the delicacies of the season.

Lessons took second place to a convivial round of hunts, harvest festivals, dances, and amateur theatricals. In the castle park stood a private theater, with a proper stage and dressing rooms. Here the junior von Suttners put on elaborate plays and concerts for the benefit of family, friends, and the local peasantry.

"How happy, happy we were!" exclaimed Bertha. And in town or country the governess's greatest source of joy was an intense, enduring, and entirely mutual passion between herself and her students' brother Arthur, seven years her junior. "When he entered a room," she confessed, "it immediately grew twice as bright and warm as it was before."

Arthur began to spend considerably more time with Bertha and his sisters than he did with his law books. The girls were in on the secret; it was three years before Baroness von Suttner realized what was going on. When she did, she summoned Bertha for an

In their luxuriously appointed horse-drawn carriages, members of the Viennese nobility parade along the treelined central avenue of the Prater, a large, beautifully landscaped park on the eastern side of the city. The workers of Vienna also thronged to the Prater, especially to the beer gardens, coffeehouses, sideshows, and food vendors at the western end of the park.

THE PLEASURES OF CAFÉ SOCIETY

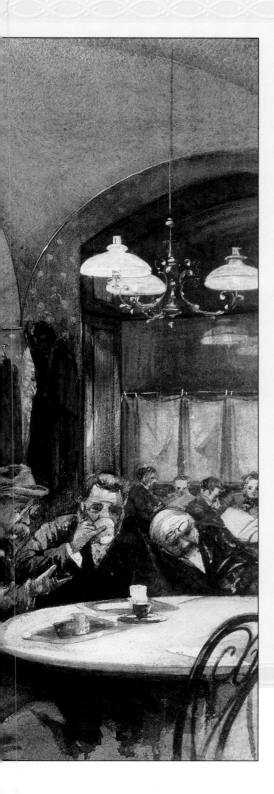

Viennese gentlemen read newspapers, drink coffee, chat, or simply doze in their chairs in the smoke-filled Café Griensteidl, which attracted so many famous and egotistical people that it was known as the "Café Megalomania."

The Viennese addiction to coffee is said to have begun in 1683 when Turkish invaders abandoned their siege of the city and left behind sacks of seemingly worthless green beans. An enterprising citizen who had lived among the Turks acquired the abandoned beans and roasted and brewed them to make coffee. Finding that his fellow Viennese enjoyed the drink, he established the city's first coffeehouse and made his fortune.

By the 19th century, the coffeehouse, or café, had become the heart of the social, political, and intellectual life of Vienna. In coffeehouses all across the city, patrons could order their brew just as they liked it: While most took it strong and black, some preferred black coffee with whipped cream on top and others a half milk, half coffee mixture. Once they paid their bill, customers could linger over their drink for as long as they wanted.

In this relaxed atmosphere, patrons indulged in all kinds of other pursuits. They could read; write; play cards, chess, or billiards; or discuss recent happenings in the worlds of politics, art, theater, and science. In certain establishments, especially those in the Prater, they could even enjoy concerts.

Coffeehouses sprang up to suit every taste. The grand Café Central, which offered 250 different newspapers, catered to writers and freethinkers and provided pens and paper for its customers. "There are writers," claimed one Viennese commentator, "who can only produce their quota of copy at the Café Central." One such writer virtually lived at the Central, leaving only to sleep in his tiny rented room; accepted as the eccentric-in-residence, he wrote, conversed with other patrons, took his meals, and received his mail at the café.

Sigmund Freud, the founder of psychoanalysis, enjoyed his morning coffee at the Café Landtmann, not far from the University of Vienna, while the Café Dobner, near the Theater an der Wien, was a favorite

haunt of actors. However, the foremost celebrities held court at the Café Griensteidl, the meeting place for politicians such as Karl Lueger and Victor Adler, as well as for writers, painters, and performers from the nearby Burgtheater. When the Café Griensteidl closed in 1896, it seemed to many to be the end of an era. Some of the Griensteidl's grieving patrons began to gather at the Café Central, while others moved on to the Café Museum, which was designed by the modernist architect Adolf Loos and was so austere that it was dubbed "Café Nihilism."

Sensibly attired Viennese matrons enjoy coffee and companionship in a room set aside for the use of women at a busy café. Seeing and being seen was more important at open-air cafés, such as the one shown at right, where a stylish young woman sitting with an elderly gentleman watches as the dapper young fellow at the next table enjoys a glass of wine and a cigarette.

interview and made it plain that even a governess possessed of an aristocratic title could not possibly entertain expectations of an alliance with her own employer's son.

Bertha understood the baroness's position. She might have been carried away by her love for Arthur, but she had never seriously expected to receive his parents' blessing. Both ladies agreed that Bertha should leave her post as soon as possible. But the baroness was not heartless; she had seen an advertisement in a newspaper for a position that might provide the perfect alternative: "A very wealthy, highly educated, older gentleman who lives in Paris, seeks a lady well versed in languages, also elderly, as secretary and for supervision of the household."

A more conventional person than Bertha might have been shocked and offended: Well-bred Viennese ladies, however desperate their economic circumstances, simply did not apply for jobs advertised in the press. But Bertha was too much a woman of the world to be cowed by social proscriptions. And, by the standards of her day, she did indeed count as an "elderly" lady. What's more, a post in Paris would take her safely away from Arthur. She wrote off at once and received a quick reply: The job was hers. After a tearful parting with Arthur von Suttner, Bertha left for France.

Her new employer was the noted Swedish chemist and industrialist Alfred Nobel, inventor of dynamite and future founder of the Nobel Prize. He was a shy man 10 years older than she was. They liked each other on sight and were delighted to discover they had intellectual interests in common. Bertha was impressed by Nobel's idealism and pleased that he cared as much for literature as she did. But even this new and stimulating friendship—and the likelihood of something even warmer developing between them—failed to soothe her heartache. She had barely spent two weeks in Paris when a telegram arrived from Arthur that declared, "Can't live without you!"

Bertha made her apologies to Alfred Nobel, who might have already been nursing some hope that this interesting new secretary could, in time, become his life's companion. But Bertha's feelings for him were strictly platonic. They

parted as friends, and Bertha paid a hasty visit to a nearby jeweler to sell a treasured piece of jewelry. With the proceeds she reimbursed Nobel for the expenses he had incurred in bringing her to Paris and then bought herself a train ticket home.

After a secret reunion with Arthur at the Hotel Metropole in Vienna, Bertha went to stay with friends and began to work out a strategy for their joint survival. There was no doubt that, with Bertha back in his life, the von Suttners would cut off Arthur without a penny.

She began sending letters to old friends in high places, resurrecting contacts from the days when she and her mother visited the spas. She wrote to the princess of Mingrelia, whose realm had recently been absorbed into the Russian Empire. The princess, well connected with the upper echelons of the tsarist regime, should certainly be able to open doors. The Caucasus, so Bertha told Arthur, was a land of opportunity, crying out for educated westerners to work in the imperial administration. After months of begging and borrowing, the lovers had raised enough money to elope. On June 12, 1876, they met at a church on the outskirts of the city, exchanged marriage vows, and fled Vienna for the East.

It was a journey into another world. Bertha and Arthur traveled down the Danube on a river steamer, overland by mail coach to the port of Odessa, and by ship across the Black Sea to the Georgian port of Batum. The princess of Mingrelia sent a minion to meet them at the dockside. The man wore a caftan, a dagger at his hip, and a belt of live cartridges crossed over his chest.

"Everything we saw and heard—and smelled," recalled Bertha, "was so exotic for us: the foreign people, the foreign costumes, the foreign construction of the buildings and—as far as smells were concerned—a very peculiar, not unpleasant scent of sun-dried buffalo manure." They found themselves in a land of fearless horsemen, acrobatic native dancers, extravagant hospitality, and precipitous mountain passes. But, in spite of the princess's warm welcome, she had no employment to offer them.

The newlyweds moved into a little house in the capital of Mingrelia and began to earn a modest living by giving private lessons in music, French, and German. It was not quite the glorious new beginning they had hoped for, but there was no turning back. "And that's how our school of life began," explained Bertha. "Work, study, the simplest secluded existence mixed with deprivations and, on the other hand, a cheerful mutual satisfaction with ourselves. Here we learned to share in the questions of humanity, here the need awoke in us to gather knowledge." Within a year their new homeland became embroiled in a war, as the Turks challenged the Russians' claim to the Caucasus. The teaching work dried up; their former students were too busy supporting the war effort, rolling bandages for the Red Cross or listening out for the distant rumble of guns. There were days, said Bertha, when "we even got to know the ghost, 'hunger.'"

Arthur earned a little money by sending war reports to newspapers back home. Once the hostilities were over, he kept writing, feeding his new editorial contacts with essays on the life and culture of the Caucasus.

Bertha thought that if Arthur could carve out a career as a freelance writer, then so could she. She decided to concentrate on what she knew best: life and love among the Austrian aristocracy. She worked hard to polish her craft, mailed her articles and book manuscripts off to western editors, and, when they came back rejected, sent them off again. Eventually this persistence paid off. German-language magazines began to publish her fiction in serial form. As her reputation and her confidence grew, she grappled with serious social and political themes—critiques of the Austrian upper classes, explorations of life in the machine age, and a passionate antiwar novel entitled *Lay Down Your Arms* that would become an international bestseller.

While Bertha and Arthur bent over their shared writing desk, the Russian and Austrian empires threatened to go to war

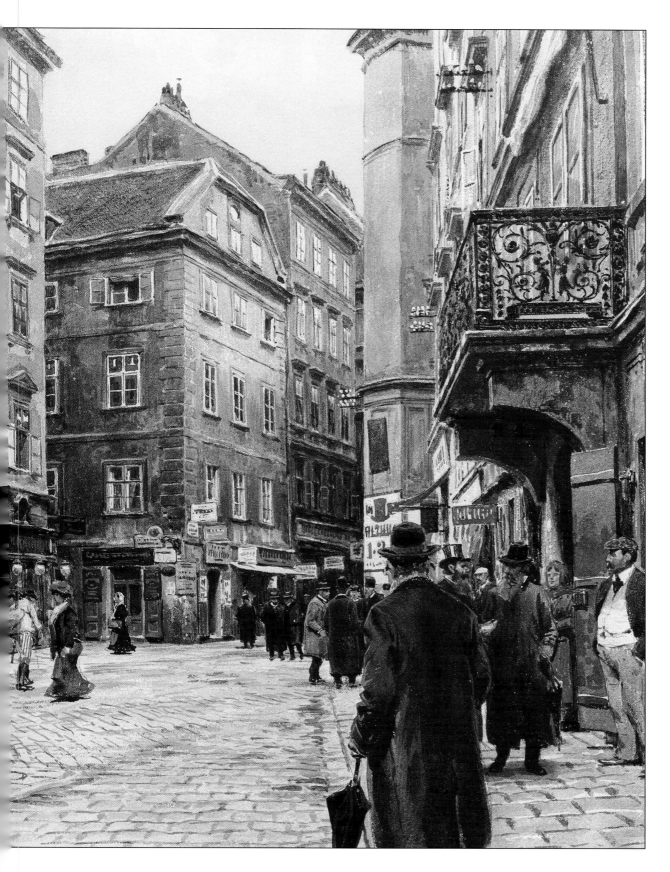

VIENNA'S JEWS

During the second half of the 19th century, there were about 150,000 Jews in Vienna. They inhabited most spheres of society, with the exception of the civil service and the aristocracy, and their contributions in the fields of finance, medicine, academia, journalism, the arts, and the law helped make *fin de siècle* Vienna the vibrant city that it was.

In contrast to these mostly liberal, integrated Jews, however, were a minority of Orthodox Jews determined to preserve a distinct identity. Referred to as *Ostjuden*—eastern Jews—most had emigrated to the capital from Galicia and Russian-occupied Poland. Like the bearded Jewish men at left, dressed traditionally in black from head to toe, they spoke Yiddish instead of German and sought to preserve the faith and traditions of their forebears while living in a cosmopolitan city.

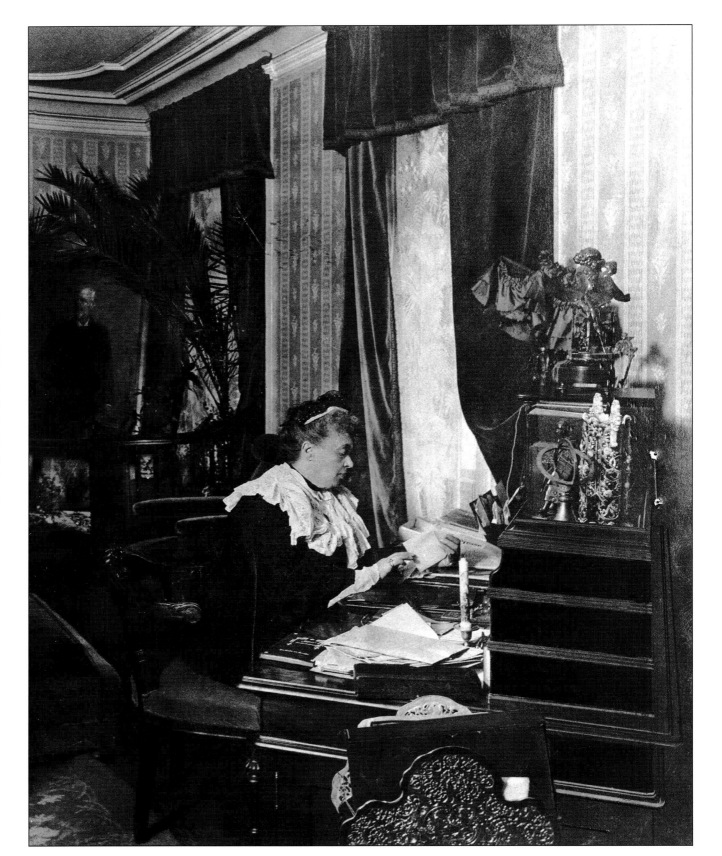

An older, widowed Bertha von Suttner sits working at her desk near a portrait of her beloved husband, Arthur. "Peace Bertha," as she was dubbed by the Austrian press, died just weeks before the outbreak of the war she had worked so hard to prevent. "The great European disaster is well on the way," she despaired in 1910, "the gunpowder will soon explode."

over control of the Balkan Peninsula. As subjects of the Habsburg emperor living in the tsar's dominions, the von Suttners found themselves in the perilous position of being considered enemy aliens. In 1885 they headed home. After nine years apart, their breach with the elder von Suttners was mended. "The parents," explained Bertha, "who now realized how loyally and happily we held together, how bravely we fended for ourselves without asking for their help, gave up their stubborn rancor and invited us to Harmannsdorf. We had meanwhile achieved an independent position in life and could therefore go back home without humiliation."

Bertha and Arthur arrived back in Austria wiser, if not much wealthier, than when they left it. Their lives as outsiders had sharpened their political and social perspectives. Although they were warmly welcomed to Castle Harmannsdorf and gratefully made themselves at home, they stood against everything the family and its friends held dear: They were religious freethinkers and social reformers who sat down to dinner every night with a tableful of pious ultraconservatives convinced of their God-given right to privilege and power.

"The circles we now move in," Bertha noted wryly, "do not exactly sympathize with our ideas." Fortunately the rest of the von Suttner household showed little inclination to engage in debate. "In fact I prefer for them to ignore my work entirely, far better than if they—from their point of view which is so utterly opposed to mine—wanted to enlighten me with opinions, advice, questions, and conclusions."

Until her death in 1914, Bertha would dedicate herself to liberal causes. She was an early feminist and, with Arthur, a fierce opponent of the anti-Semitism that was spreading like a cancer through Austrian society. But the campaign that dominated her life was the new movement for world peace. She became one of its most prominent activists—writing, lobbying heads of foreign governments, establishing pacifist societies at home and abroad, and organizing major international conferences on disarmament.

In 1905 Bertha von Suttner was awarded the Nobel Peace Prize, which had been established by her old friend and former employer, Alfred Nobel. Although she was the first Austrian to receive this honor, her conservative compatriots hardly noticed. And in the eyes of her Kinsky and von Suttner relatives, she was a traitor. "Unfortunately," she confessed, "the aristocrats are still our enemies in the peace movement.

"The circles we now move in do not exactly sympathize with our ideas."

I find the greatest opposition to my propaganda among my cousins. Generals, courtiers, treasurers, wives of officers all think this is about nihilism and anarchism because it talks about changing old customs. For them, everyone who wants to reform today's society-state (a state that offers them so many advantages) is criminal or insane."

But no matter how powerful her passion for social change, Bertha found it hard to shake off some of the old habits and attitudes of her class. Anyone who sent her a letter without inscribing the appropriate aristocratic title on the envelope was sharply corrected. And to the end of her days, she made sure that the wording on her calling cards reminded the world that the great liberal crusader was not only Baroness von Suttner but also "née Countess Kinsky."

The teenage Countess Kinsky had celebrated her entry into the society of the capital on the flower-bedecked dance floor at the picknick ball. Another young Czech girl, Adelheid Dworak, made her own Viennese debut in the far bleaker environment of a police station. Instead of a ball gown and slippers, Adelheid wore plain clothes and her only pair of shoes. But, like Bertha Kinsky, she too had an anxious parent at her side.

In accordance with the law, Adelheid and her mother, newly arrived from Bohemia, had gone to the police station to register as resident aliens. Mrs. Dworak could neither read nor write, so her daughter duly filled in the appropriate form. The sheet contained a column marked "Children"; Adelheid never even thought to enter her own name. At the age of 10 years and five months, she considered herself an adult working woman, with her childhood already far behind her.

Adelheid and her mother were part of a flood of working-class immigrants who turned their backs on the wretched poverty of rural villages and depressed provincial towns in the eastern parts of the empire and moved, by the hundreds of thousands, into Vienna. According to a census carried out in 1859, 490,000 people lived in the capital; by 1880 this figure had risen to 705,000. In 1890, with the city's boundaries redrawn to absorb its teeming suburbs, the population would reach 1,340,000, having almost tripled in size in just over 30 years.

Adelheid never regretted leaving her place of birth. Her only childhood mem-ories were of poverty, violence, hunger, and failed hopes. Her father was an alcoholic, prone to drinking up the meager wages he earned as a weaver, then coming home and battering his wife. One Christmas, when her mother had scraped together just enough money for a modest celebration, her father had staggered into the house in a drunken fury and hacked the tree to pieces with an ax.

Things got worse after Adelheid's father died of cancer. Even the smallest in the household had to earn their keep.

Almost as soon as Adelheid could thread a needle, she started doing piecework, sewing buttons onto strips of paper. Her favorite brother was taken from school to work in a factory at the age of 10 and spent his free time setting up pins for bowling at the village tavern and working as a beater during the hare–hunting season. When he succumbed to a lingering illness, Adelheid was devastated.

Soon afterward, Mrs. Dworak moved Adelheid and one of her brothers to Vienna, where work was said to be plentiful. Along with thousands of other newcomers, the Dworaks struggled to find a place to live in the increasingly crowded capital. Vienna was, overwhelmingly, a city of multiple dwellings. Only a tiny percentage of the population lived in single-family houses. In working-class districts, opportunistic landlords charged outrageous sums for tiny one- and two-room apartments. In the cramped warrens that the Viennese called "rent barracks," as many as four families might share a single room, with people sleeping on the floors or improvising temporary beds from tabletops.

To escape these claustrophobic quarters, people spent as much time as they could out in the streets and parks. For some, cafés and taverns provided a warm and well-lit home away from home. Offering a refuge from thousands of dank and fetid rent barracks, Vienna's vibrant coffeehouse culture flourished.

The tenements, lit only by candles or guttering oil lamps, had little or no heating and no plumbing of any kind. Barely a quarter of the city's households enjoyed the luxury of an indoor toilet. It was not unusual for a dozen tenement households to share a single privy on a landing or out in the yard. Some buildings provided a solitary water faucet on each floor; otherwise, tenants had to fetch their water from an outdoor pump or the nearest public fountain, carrying it up the stairs in wooden barrels.

Privacy was unknown. Neighbors waiting in line for a turn in the privy could hardly remain strangers. Crowded conditions and a sense of shared suffering bred their own kind of solidarity. A marital quarrel might turn into a community entertainment, but families in trouble knew there were others close by who would help when they could. Women, coming home after a long day's work to grapple with domestic dirt and chaos, took turns looking after each other's children.

To help make ends meet, families often sublet a corner of one room. Many sold the use of a bed with the understanding that its tenant would, when not actually sleeping, make himself scarce. The Dworaks's first home in Vienna was a single room shared with an elderly couple. But the old lady began casting meaningful glances at Adelheid and making remarks about young girls and rich men. Mrs. Dworak did not like it. As soon as she was able to scrape some money together, she found them another place to live.

A father, mother, and four children occupy this small room, a typical situation in the tenements that ringed the fringes of Vienna in the late 19th century. While such overcrowded dwellings often had no indoor plumbing, the building shown at right at least had a communal lavatory and water faucet in the hallway for the use of tenants.

Adelheid's new home was a windowless room, illuminated only by light from the corridor shining through a glass panel in the door. Adelheid and her mother shared one bed; the other held her brother and one of his workmates, whose rent for this accommodation helped defray the cost of the room. There was not much space to maneuver: The foot of one bed touched the head of the other.

One night when her brother was out, the rest of the household retired early. Mrs. Dworak was soon asleep, and Adelheid found herself dozing off. Then, as she recalled in a memoir written 30 years later, "I suddenly woke with a cry of terror. I had felt a hot breath above me."

She found the lodger leaning over her, about to climb from his own bed into hers.

Her mother, roused by Adelheid's screams, suddenly struck a match and caught the lodger in the act. Adelheid was horrified when, instead of evicting the man on the spot, her mother simply told him to find a new place by the end of the week. Adelheid had to endure several anxious, wakeful nights before her attacker finally departed.

As a full-time member of the work force, Adelheid needed all the sleep she could get. According to the law, she should have stayed in school until her 14th birthday. But her mother, like many other parents in the same situation, considered education a luxury they could not afford. The cost of living was high, and everybody's wages were low. Even the tiny contribution a child could make might spell the difference between a family's starvation and its survival.

soon as fashions changed. To sew the lace edging onto their petticoats or affix the silk rosebuds onto their gowns, they relied on a vast, invisible, and ill-paid army of Adelheids.

Because she was below the legal age for leaving school, Adelheid's only option was to sell her services to contractors who did not ask too many questions. These contractors paid a pittance, hiring and firing on a whim or according to fluctuations in the market. As she moved from one job to another, Adelheid soon discovered that the survival of whole families might depend entirely on their daughters' labor.

For many Viennese workers, a seven-day, 70-hour week was the norm. "We had to work continuously," Adelheid recalled, "without being allowed a moment's rest. . . . With what longing I looked at the clock when my pricked

"I must accustom you to everything, for you will never be a great lady."

The practice continued for generations to come. In 1908 a survey of Austrian schoolchildren indicated that over 40 percent of 11- and 12-year-olds were engaged in some kind of regular part-time employment. And even this figure took no account of the many underage workers who, like Adelheid, had dropped out of school and disappeared from the statistics.

Most of the jobs available to women were in the clothing trade. The city was full of small dressmaking businesses, textile merchants, and craft workshops supplying the necessary trimmings. The ladies who lived in the grand houses on the Ringstrasse—the broad avenue that enclosed the old city like a ring—and young countesses of the sort who had once snubbed Bertha Kinsky at the ball had a voracious appetite for new clothes in the latest modes and the financial means to replace them as

fingers pained me and when my whole body felt tired out!" And after a 12-hour day crocheting shawls under her employer's eye, Adelheid often took extra work home for the sake of earning just a little more money. But the family's room was often so frigid that she had to take refuge in bed, working under the covers to keep her fingers from cramping with cold.

When she was still just 11, Adelheid was apprenticed to a woman who made bead and lacework trimmings for ladies' gowns. The work was seasonal, sporadic, and, yet again, on a poorly paid piecework basis. But even when she had no orders to fill, Adelheid's new mistress found ways to keep her busy. Adelheid recalled, "I was made use of as a kind of Cinderella." She had to clean the woman's house and trudge off with a wooden barrel on her back to collect water from a distant

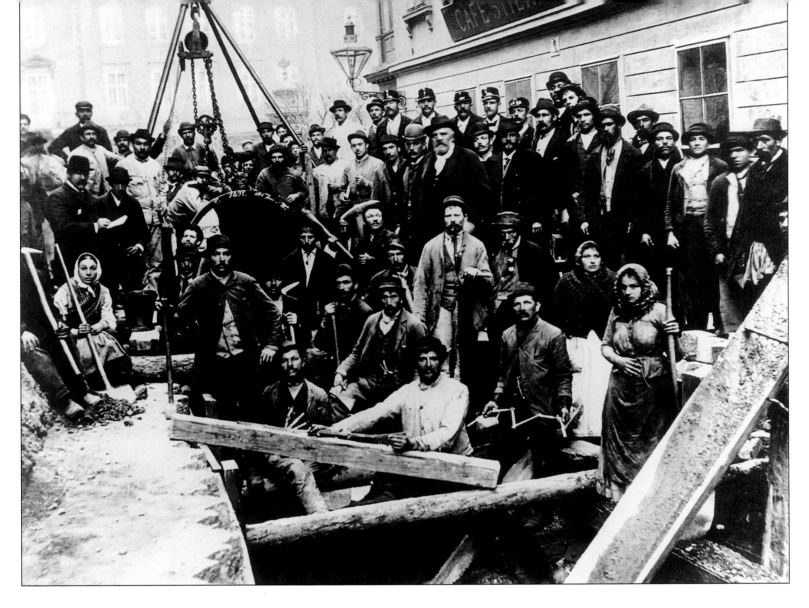

Construction workers, several of them women, interrupt building one of Vienna's sewers to pose for the camera. By the time this photograph was taken in 1897, immigrants from the farming areas of southern Bohemia and Moravia made up more than half the population of the Austrian capital, most finding employment in factories or as laborers and domestics.

fountain. These hardships were, according to Adelheid's employer, an educational experience. "I must accustom you to everything," the woman reminded her, "for you will never be a great lady."

After two years of this treatment, Adelheid decided she had had enough. She was 13 by then and appeared, by her own assessment, "almost grown up," no longer looking quite so obviously underage and ripe for easy exploitation. She found herself a job in a small bronze workshop, making chain links and learning how to solder with a gas-powered set of bellows. Her supervisors were kind to her and the work paid well, but it did not last. The gas from the bellows made her ill, causing extreme fatigue, fainting fits, and dizzy spells.

As Adelheid's physical condition deteriorated, her mental health suffered as well. Her working life was fraught with physical and mental stress; her dream life was haunted by memories of the night the lodger tried to rape her. After one particularly fierce anxiety attack, Mrs. Dworak took Adelheid to a hospital where the doctors found her "undernourished and bloodless to the last degree" and advised that she get "much exercise in the open air and good nourishment." Adelheid, hearing this seemingly simple prescription, sank into an even deeper despair. "How," she wondered, "was I to follow their orders?"

Thousands of other ailing city-dwellers found themselves in similar predicaments. Vienna's industrial labor force worked, as it lived, in cramped and unsanitary conditions. Tuberculosis was rife, gastric illnesses were endemic, and venereal disease was an ever-present threat in a city where poverty forced desperate women into prostitution.

Eventually, Adelheid suffered a total physical and mental collapse. After a period of treatment in a general hospital ward, she was sent to the public psychiatric clinic of Dr. Theodor Meynert, one of Vienna's leading mental health practitioners. For the exhausted Adelheid, the hospital regimen was bliss: a bed of her own with clean sheets, no shivering in line every morning while

THE LAUNDRY-MAIDS' BALL

Characterized by the upper echelons of society as carefree, witty, and fun-loving, the laundry-maid was celebrated as the embodiment of the *joie de vivre* of the Viennese. In the painting at right, *A Dance in the Drying-Grounds,* several laundry-maids take a break from their labors to dance to the music of a hurdy-gurdy.

Once a year they also had the opportunity to dance in a more formal setting, at the laundry-maids' ball during the carnival that preceded Lent. Originally intended for tradespeople, the ball was attended by Viennese of every class, all dressed appropriately for the event. Wearing her traditional working clothes—head scarf, sleeveless bodice, and striped stockings—a humble laundry-maid might find herself waltzing away the evening in the arms of a Viennese aristocrat dressed for the occasion as a city cabdriver.

waiting her turn at a communal privy, no endless working days, and all the time in the world to read—the pastime she loved best. In spite of her rudimentary education, Adelheid was passionate about books. She had always been a voracious reader of romances; now, thanks to loans from the library of a friendly doctor, she began to broaden her literary horizons.

But this idyll of literature and clean linen could not last forever. Soon she was back on the city streets, hunting for work. The effort nearly killed her; she found herself in the hospital again. The doctors decided she was so debilitated she was unlikely to be fit for work again. With no funds to pay for hospital care, she was transferred to the local poorhouse.

After several miserable days in a dormitory full of ancient, wheezing female paupers, Adelheid was informed that, as a foreigner residing in Vienna, she had no right to any support from the municipal funds. In such a case, explained the official who had come to deliver the news, the usual course of action was to deport the alien back to his or her native province.

Adelheid went into a panic. She sputtered out a barrage of tearful protestations. She had lived in the city since the age of 10; she did not know anybody back in Bohemia and had forgotten most of the Czech she had once known. Once he realized that Adelheid had a mother nearby who would look after her, the official decreed that she could stay in the city. In later years she recalled "the criminality of bureaucratic routine, which placed me, a child, deprived through labor and hunger of all childish pleasures, in a home for old and infirm women, and which—but for the presence of a thoughtful official—would have delivered me over to a fearful lot."

Mrs. Dworak was summoned to the poorhouse so that Adelheid could be formally released into her care. When she arrived, she looked even more miserable than her ailing daughter: She had been working in a textile mill, and her hands and arms were covered with festering sores caused by exposure to toxic dyes.

Blessed with the resilience of youth, Adelheid eventually defied the doctors' gloomy prognoses and recovered. After much searching she found a job in a cork factory, joining a staff of 300 women and 50 men. By her standards, and those of most Viennese, this was a very large establishment; more than four-fifths of the city's jobs were in small manufacturing or retail units employing fewer than five people.

It was a move that would have scandalized many of her old colleagues in the dressmaking trade. Even the humblest sweatshop apprentice looked down on the factory girls, who were considered "bad, disorderly, and depraved." To make sure that nobody identified her as one of these feckless creatures, Adelheid put every penny she could spare toward a new Sunday dress, a badge of respectability in the eyes of her fellow churchgoers.

But life on the factory floor soon dispelled her prejudices. She was assigned to the sorting room, where 60 women and girls sat at large tables assembling and labeling finished goods. Her new workmates turned out to be kind, friendly, and anything but irresponsible. Most of them struggled to support unemployed spouses, aged parents, and their own small children—who often had to be boarded out so that their mothers could work. They looked after each other in times of trouble, digging deep into their own nearly empty purses to rescue a workmate in distress.

"Yes, they did go dancing," asserted Adelheid; "they did have love affairs; others stood in a queue outside a theater from three in the afternoon till the evening, so as to be able to get a ticket at 30 kreuzer. In summer they went on excursions and walked for hours to save a few kreuzers' fare. Then they paid the price for a few breaths of country air, by having their feet ache for days. You can call it frivolity, if you want, or inordinate love of pleasure, or being loose, but who would have the face to do so?"

A job at the cork factory was regarded as one of the best a worker could hope for. No other business in the district paid as well. The working day lasted from seven in the morning to

seven at night, with an hour off for lunch and another 30-minute break in mid-afternoon. Yet, wrote Adelheid, "even here, in this paradise, all were badly nourished."

Women lucky enough to live nearby tried to save money by rushing home at lunchtime to wolf down a meal; others grudgingly paid over a portion of their hard-earned wages for a cheap sausage, a few scraps of cheese, or a bowl of greasy soup. "The smell of the fat was horrible," Adelheid recalled. But even these dubious delights were beyond the means of workers with needy families or a doctor's bill to pay, and these subsisted on little more than bread and beer.

Everyone lived in fear of the factory foreman. A supervisor's goodwill was the only thing that stood between a worker and starvation. In Adelheid's case, the boss was a petty tyrant who treated the women in the sorting room like slaves. The management, noting his ability to extract the maximum amount of work from his underlings, considered him a shining star. Still, as far as Adelheid was concerned, his dictatorial manner was preferable to the dangerous charm exuded by certain of his colleagues, who singled out vulnerable young women, offered them promotions in exchange for sexual favors, then fired them when the attraction waned.

Once she had adjusted to factory life, Adelheid felt that her circumstances had improved beyond all recognition. For the first time she was earning enough money to bring home a decent piece of meat for the family's Sunday dinner, along with a bottle of sweet wine to wash it down. And, at age 17, she was finally able to afford a Catholic confirmation ceremony: a blessing by the bishop, a ride in an open carriage, and a brand-new outfit for church—a white dress, fashionable shoes, sleek gloves, and a flowery hat, all paid for in installments.

Then something happened that totally changed Adelheid's way of looking at the world. Through her brother, she met a group of men who were involved in a new political movement called Social Democracy. They talked to her about the ways the capitalist system exploited

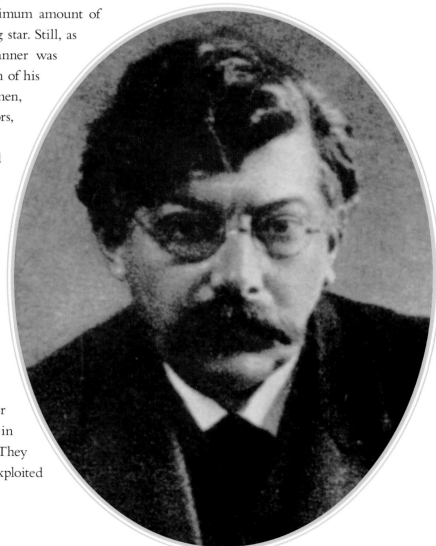

The moderate leader of the Social Democratic Party, Victor Adler, was appalled by the growing anti-Semitism he witnessed in Vienna and by the conditions of employment of the city's working poor, who often toiled 14 hours a day for low wages and without holidays. After a lifetime's work on behalf of the empire's poor and oppressed, Adler died in 1918, the year Austria became a republic.

workers, about the need for members of the labor force to organize themselves into unions, about the monarchy and the church as enemies of progress, about economics, philosophy, and the vision of a just and equal society.

The Social Democratic Party, founded in December 1888, had emerged from a coalition of anticapitalist groups that wanted to see society transformed by peaceful means instead of through violent revolution. One of the party's leading lights was a physician named Victor Adler. He was the son of a prosperous merchant from Prague and had, although in circumstances very different from Adelheid's own, made a similar migration from Bohemia to the imperial capital. Serving as a doctor for Vienna's working class, he became convinced that the only way to heal its multiple miseries was to make radical changes in the organization of society and the distribution of wealth.

Adler believed that education and intellectual ferment, rather than violent action, would help create the brave new world he dreamed of. He founded libraries, adult education classes, and workers' discussion groups and began publishing a monthly journal and a newspaper to make the ideals of Social Democracy accessible to workers and intellectuals alike. He was an eloquent orator and a charismatic figure, a man whose personal philanthropy recruited many new adherents to the cause.

Adelheid began to attend Social Democrat meetings. She soon declared that she too was not only a Social Democrat but a republican, eager to see an end to what she considered the parasitism of aristocrats and kings.

She had always been an enthusiastic newspaper reader, fascinated by politics and current events, but now she switched her loyalties from the conservative and monarchist Catholic press to the paper published by Adler's party. She also abandoned the old chivalric tales and romantic fiction that had once been her passion in favor of books like Friedrich Engels's *The Conditions of the Working Class* and other texts on world history.

As Adelheid embraced this new creed, the religious faith that had previously sustained her lost its appeal: "I endeavored to prove to my fellow workers that the creation of the world in six days was only a fairy tale, that there could not be an Omnipotent God, because, if there were, so many men would not have to suffer such hardships in their lives."

Adelheid now saw herself as a missionary of the new movement, with the Social Democratic newspaper as her gospel. The first time she went to party headquarters to buy her own copy of the paper as well as a stack she hoped to sell to her factory colleagues, she was awed by the place: "I felt as though I were entering a sanctuary." And as she had on the day of her confirmation, she wore her best dress for the occasion.

Until she discovered the Social Democrats, Adelheid had been regarded by her workmates as a shy and mildly eccentric creature. When coaxed, she would occasionally entertain them with a story out of one of her beloved books, but otherwise she had kept to herself. Now, ablaze with her new convictions, she came out of her shell with a vengeance. Few lunch hours or coffee breaks passed without a lecture on Social Democracy delivered by Adelheid.

She could hardly contain her excitement when, in the spring of 1890, the Socialist International called for an unprecedented collective action. Workers throughout Europe were asked to put down their tools on May 1 and take part in mass demonstrations to demand an eight-hour working day.

The authorities prepared for battle. The emperor Franz Josef bristled at the prospect of the illegal work stoppage and demonstrations by rebellious workers and demanded punishment and prison sentences for those who had planted these ideas in the minds of his humblest subjects. Victor Adler, as it happened, was already behind bars, jailed for four months for writing a newspaper article in support of an earlier strike.

The army and the police were put on full alert, waiting for

mayhem to erupt on the streets of Vienna. Wealthy burghers stocked their homes with enough food to withstand a siege or hid their valuables and took their families out of the city until the dreaded day had passed. Shopkeepers greeted the morning of May 1 by locking up their premises and bolting the shutters over their doors and windows. The shutters went up at the cork factory, too, for fear that passing agitators might lob missiles through the glass. Behind these barricades it was business as usual. The management, to Adelheid's horror, had decreed that anyone absent on May 1 need not come back to work until the following Monday, thereby losing a full three days' wages.

Even Adelheid, for all her fervor, could not afford to sacrifice that much money for the cause. So, dressed in her best clothes to mark the occasion, she spent a miserable day in the shuttered workroom, secretly wishing that an army of her Social Democrat comrades would invade the plant and forcibly liberate the workers inside. Meanwhile, the workers paraded by the thousands down the broad avenue that bisected the Prater. Men, women, and children waved red flags and sang songs of struggle. And although Vienna's demonstration was the largest of those held throughout Europe, the day ended without any incidents of riot or bloodshed.

When payday arrived, Adelheid was mortified to find that the management had bestowed a reward on everyone who had come to work on May 1. She donated her own bonus to the welfare fund established for workers penalized for taking part in the demonstration.

The owner of the cork factory considered himself a benevolent employer who deserved only gratitude from those whose labor provided his profits. One day Adelheid found herself summoned to his office. This was an unprecedented occurrence, and everybody stared at her as she left the floor.

Entering the inner sanctum, she found herself presented with a copy of the Social Democrat newspaper. Her employer pointed to a notice requesting donations for a new party publication

Enjoying a free concert, out-of-work laborers saunter in front of a marching military band that played during the daily changing of the palace guard outside the Hofburg. The large numbers of unemployed on the streets of Vienna sometimes created civil disorder. On the front page of the newspaper below, mounted police officers disperse unemployed people protesting in support of strikers at one of the city's factories.

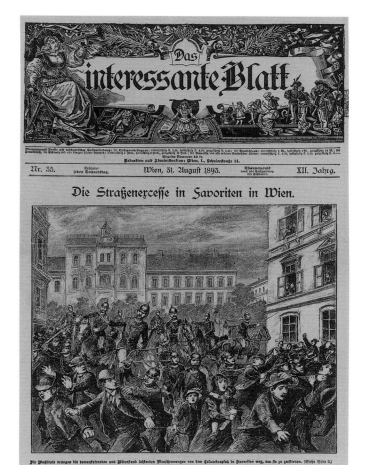

directed toward women, with her own name prominent on the list of those involved. "I can give you no orders as to how you spend your free time," he told her, "but I beg this one thing of you: Abandon any agitation for these objects in my factory. I likewise forbid any meeting for the support of your aims. I will have peace and quiet in my house."

Adelheid promised to behave herself in the future and keep her dangerous ideas to herself. This guarantee, however, did not extend to keeping quiet when the factory inspectors arrived to tour the plant.

In the 1880s, after decades of indifference, the Austrian parliament had introduced some rudimentary labor legislation. Employers were compelled to implement certain health and safety measures, to limit the workweek to six 11-hour days, and to refrain from employing children under the age of 14. But many of the regulations applied only to large factories, and enforcement was sporadic.

Adelheid found it fascinating that her own bosses always seemed to know when the factory inspectors were about to descend for one of their supposedly surprise investigations. Dark and dirty workshops were suddenly cleaned and illuminated. Those 13-year-old girls employed for a pittance were urged to show gratitude to the bosses who had so kindly bent the rules on their behalf by lying to the visitors about their ages. So Adelheid made sure to waylay the inspectors as they proceeded on their tour in order to point out these interesting anomalies.

Meanwhile, outside the factory, she became ever more active in the wider struggle for social change. One Sunday morning at a trade union meeting, she heard a male comrade on the platform attack female workers for their passivity and lack of commitment to the labor movement. Adelheid was outraged and felt the need to defend herself and her sex. When the chairman requested feedback from the floor, she amazed herself—and the 300 men and nine other women in the audience—by raising her hand.

No one had ever heard a female worker speak at a union meeting. Excited by this unprecedented development, the crowd broke into cheers. Adelheid suddenly felt overwhelmed and terrified. "As I mounted my steps to the platform, my eyes swam and my throat was parched—I felt as though I were choking." But she took a breath and launched into her first public oration. "I spoke of the sufferings, the sweating, and the mental poverty of working women," she recalled. "I spoke of all that I had experienced and had observed among my fellow workers. I demanded enlightenment, culture, and knowledge for my sex, and I begged the men to help us to them."

She received an ecstatic reception. The union officers begged her to write an article for their paper. It was the beginning of a new career. Despite her scanty formal education, she proved to be as eloquent on paper as she was on the podium. She joined the editorial staff of the movement's new paper for working women and became a full-time Social Democrat activist. When she left the cork factory, the management may have breathed a secret sigh of relief, but they wrote her an enthusiastic reference and wished her well.

To her mother's regret, even marriage—to a fellow socialist named Popp—did not curb Adelheid's political zeal. She soon became the most prominent woman in the Austrian labor movement, befriended by such luminaries as Friedrich Engels himself. Once she even brought the great man home to meet her mother. Try as he might, though, he failed to convince the resolutely conservative Mrs. Dworak that her daughter's activism was anything but a waste of time.

Adelheid Dworak-Popp and her comrades would find little cause to rejoice on April 20, 1897, when Vienna's newly elected mayor, Karl Lueger, celebrated his inauguration. To the Social Democrats, Lueger was a dangerous demagogue. But Vienna's conservative lower middle class—the shopkeepers, artisans, owners

A successful mayor of Vienna, it was said, must be *fesch*, or dashing, a requirement met by "handsome Karl" Lueger, shown here in his official portrait. Lueger founded the right-wing Christian Socialist Party, a group that appealed to a wide spectrum of Austrians in spite of its overt anti-Semitism. At right, a party flier calls the faithful to a meeting at the Vienna town hall in April 1897.

of small businesses—hailed him as a hero. They saw Lueger and his party, the Christian Social movement, as the scourge of those who threatened their livelihoods, questioned their values, or challenged the supremacy of the Roman Catholic Church.

On the day of his official swearing-in, Lueger's supporters descended upon Vienna's flag- and flower-bedecked city hall, the Rathaus. Delegates from craftsmen's guilds and Christian associations marched in tight ranks behind their groups' banners; senior churchmen, local worthies, imperial officials, members of the legal and medical fraternities, foreign emissaries and their ladies—all dressed to the nines—arrived in a stately procession of coaches and carriages.

Inside, the crush was considerable and the noise of excited conversation almost deafening. Then a trumpet fanfare announced the ceremonial entry of Dr. Lueger and his vice-mayors, who were preceded by Count Erich Kielmansegg, governor of Lower Austria, including Vienna, and official representative of the imperial power.

As the count administered the oath of office, Lueger's friends allowed themselves discreet, triumphant smiles. Although his fellow city councilors had elected him—four times in a row—to the mayoralty, Emperor Franz Josef, alarmed by Lueger's outspoken anti-Semitism, had repeatedly exercised his royal prerogative and vetoed the appointment. But after Lueger won a fifth vote, His Majesty finally decided he had to bow to the popular will.

When the time came for his inaugural speech, the new mayor chose his words carefully. Declaring himself the servant of "the desires of the people," he laid out his plans for the improvement of the city. He made only the most oblique references to the "Christian spirit" of the city's population, to unnamed economic profiteers, and to unspecified "foreign influences" as enemies of Vienna and "our fatherland Austria."

Addressing his rapt audience in the hall, Lueger remained the soul of discretion. But out in the neighborhoods where the Christian Social voters lived, everyone knew exactly what he meant. In one neighborhood, 40 of the new mayor's admirers now rampaged through the streets bellowing the chant that all Vienna knew as the Lueger March: "Dr. Lueger should rule, and the Jews should croak!"

The police, who came to break up this demonstration, already had their hands full: A bevy of the mayor's female supporters, known as "Lueger Amazons," had abandoned any pretensions to ladylike decorum and had clashed with members of the Social Democratic Women's Auxiliary.

In those neighborhoods dominated by Lueger voters, people sang and danced around bonfires or set lamps in their front windows to turn night into day; elsewhere, such as in the working-class districts and in the affluent city center—which was home to the Liberal-voting bourgeoisie—the shutters stayed closed, the streets remained quiet, and darkness reigned. Karl Lueger, looking out upon his city, could read these bands of light and darkness like a navigator's chart. They mapped the changes in the political landscape that had helped him rise to power.

Until the mid-1880s the only Austrians qualified to vote in municipal elections had been male householders, aged 24 years and older, who owned enough property to make them liable for payment of a substantial amount of tax. These wealthy citizens were the ones who elected the city councilors who, in turn, elected the mayor—subject, of course, to the emperor's approval. These voters had given their loyalty to the Liberal Party. With their control of the capital virtually unchallenged, the Liberals became prey to nepotism, bribery, and other forms of corruption.

But in 1885, after considerable agitation, the electoral system was reformed, and the franchise was extended to men who paid the very modest sum of five gulden in property tax. These new voters had no particular loyalty to their old Liberal masters and had plenty of grievances about the way the government was run. The city was growing fast and furiously, its population rising at an alarming rate and its suburbs being swallowed

The cover of this sheet music dedicated to the Frauenbund, the female contingent of Lueger's Christian Socialist Party, is adorned with the face of Emilie Platter, leader of the group. "There are no keener politicians in Europe than the ladies of Vienna," one foreign observer remarked of the so-called Lueger Amazons, "and none who wield more influence."

up into the new metropolis. The old infrastructure was strained to the breaking point, imposing ever-greater demands on the public purse. The new electorate included vast numbers of very worried men. In a time of economic uncertainty, these recently enfranchised shopkeepers and artisans felt menaced by the power of big business—bankers, financiers, large-scale manufacturers who controlled the cost of raw materials and mass-produced goods at prices too low for any traditional workshop to match. To make matters worse, these powerful, if shadowy, figures seemed to have the city's Liberals in their pockets.

At the other end of the social spectrum loomed a threat of a different kind—the non-German immigrants from the poorer parts of the empire. Viennese artisans regarded these newcomers with mingled contempt and fear: Hungry

that prized learning, were also well represented in professions such as medicine and teaching. There were Jews at every level of commerce, from newspaper proprietor to market stallholder. And there were indeed those who had translated traditional Jewish ethical concerns into a zeal for social reform.

Many Jews had lived in the Austrian heartland since Roman times; others had joined the more recent migrations into the Habsburg capital from the east. Whatever their origins or occupations, they all had one thing in common: They supplied Karl Lueger and the Christian Socialists with a convenient scapegoat that was both alien and familiar.

Lueger's ability to read and manipulate the anxieties of his lower-middle-class supporters was sharpened by his own modest background. He was, as he never failed

"He wielded his speech like a flag, then like a whip and then like a hammer."

for work at any price, they seemed likely to crowd native artisans out of the labor market altogether. And just as alarmingly, this alien labor force seemed to be a fertile breeding ground for socialism, atheism, and other ideas considered dangerous.

Karl Lueger played upon these anxieties like a virtuoso. In order to win the support of this growing constituency, he exploited their hostility toward Hungarians, Italians, and other aliens as well as their traditional and time-honored prejudice against Jews—who were stereotyped simultaneously as power-hungry capitalists, parasitic commercial middlemen, and dangerous political agitators.

There were, undeniably, many wealthy Jewish bankers and businessmen living alongside their Christian counterparts in opulent mansions on the Ringstrasse. Jews, raised in a culture

to remind people, one of Vienna's native sons. His father was a peasant who, after army service, moved into the city and found menial work at the Theresianum, Vienna's celebrated academy of classical learning, and then a custodian's job at the Vienna Polytechnic. The former soldier had some intellectual aspirations; he took advantage of his position to sit in on classes and pass examinations at the Polytechnic without neglecting his janitorial duties. His wife worked in a tobacconist's shop; its back rooms provided a childhood home for Karl and his two young sisters— the only three out of eight siblings to survive into adulthood.

When Karl reached school age, his father persuaded the Theresianum to accept him as a full-time student; unlike his wealthy classmates, who boarded in the institute's dormitories, he returned home to the tobacconist's shop every night. In spite of

the cramped quarters, his parents made sure he had the peace and space to study, and both coached him in his schoolwork. When young Karl ignored his books, his father would chide him by saying, "Now you'll never be first!" Their efforts were rewarded when he graduated with a doctorate in Roman and Canon Law at the age of 25.

Like many ambitious members of his profession, before and since, Lueger used his legal career as a springboard into politics. In 1875, at the age of 31, he was elected—as a Liberal—to the city council. Over the next 20 years he would spearhead a revolution from within, joining the opposition, then forging a new and more populist brand of politics whose adherents would wrest control from the old corrupt and complacent elite.

As his friends and foes agreed, Lueger knew how to charm the public. Besides having a persuasive way with words, he was a handsome, well-built man with a leonine head, a curly beard, and a candid expression. "In parliament," recalled one commentator, "he wielded his speech like a flag, then like a whip and then like a hammer."

His admirers delighted in his folksy manner; neither his classical education nor his swift ascent of the social ladder had erased his working-class Viennese accent. The Austrian capital had a dialect all its own, with distinctive cadences and a unique vocabulary that other German speakers found almost incomprehensible; every word that Lueger spoke reminded his listeners that he was a local boy who made good.

The whole city became his stage. He became a familiar figure in the coffeehouses of the central districts and in the neighborhood taverns of the outlying areas, where locals gathered to trade gossip and savor glasses of the latest vintage. And everywhere Lueger went, he opened his expressive eyes wide as he heard tales of woe, dispensed advice and sympathy, paid close attention to people whose opinions had never been sought before. The burghers loved it. The "five-gulden men" had found a spokesman and a hero.

Their wives and sisters loved him, too. His bachelor status enhanced the popularity of the politician everyone called "handsome Karl"; throughout a 15-year relationship with his mistress, Marianne Beskiba, Lueger managed to keep the liaison firmly out of public view. And despite his growing prestige, he continued to live in a tiny tenement flat with his widowed mother, waiting his turn at the communal sink on the landing until the day that he moved into the mayoral apartments in the Rathaus.

By 1895 Lueger had become the center of an unprecedented personality cult. His face adorned medals, matchbooks, pipes, beer mugs, china cups, and posters; his followers recited Lueger poems, chanted Lueger songs, and wore official Lueger regalia—white scarves bearing red crosses, white carnations in buttonholes, and virginal white dresses for the maidens who presented him with flowers at the Christian Social rallies.

With the cheers of these ecstatic supporters echoing in his ears, Vienna's new mayor set to work. His first priority was to take the major utilities—gas and electricity—into public ownership. The purpose of his municipal socialization program was to ensure that the revenues from these operations went straight into the city's coffers instead of lining the pockets of foreign and—as Lueger claimed—Jewish capitalists. The gas supply, for instance, had been in the hands of a firm called The English Imperial Continental Gas Association since 1843.

There was, the new mayor hastened to reassure voters, nothing intrinsically wrong with private profits, but the more money Vienna earned from its utilities, the less tax it would require from property owners to keep the city running. The bills householders paid to make the gas lamps in their parlors glow would help finance a host of new public works projects that would make their capital the envy of all the world.

A Viennese grocer arranges baskets and bags of colorful produce outside the entrance of his store, which is located on the ground floor of one of the city's apartment buildings. Shopkeepers and other members of the lower middle class were the key supporters of Karl Lueger's Christian Socialist Party.

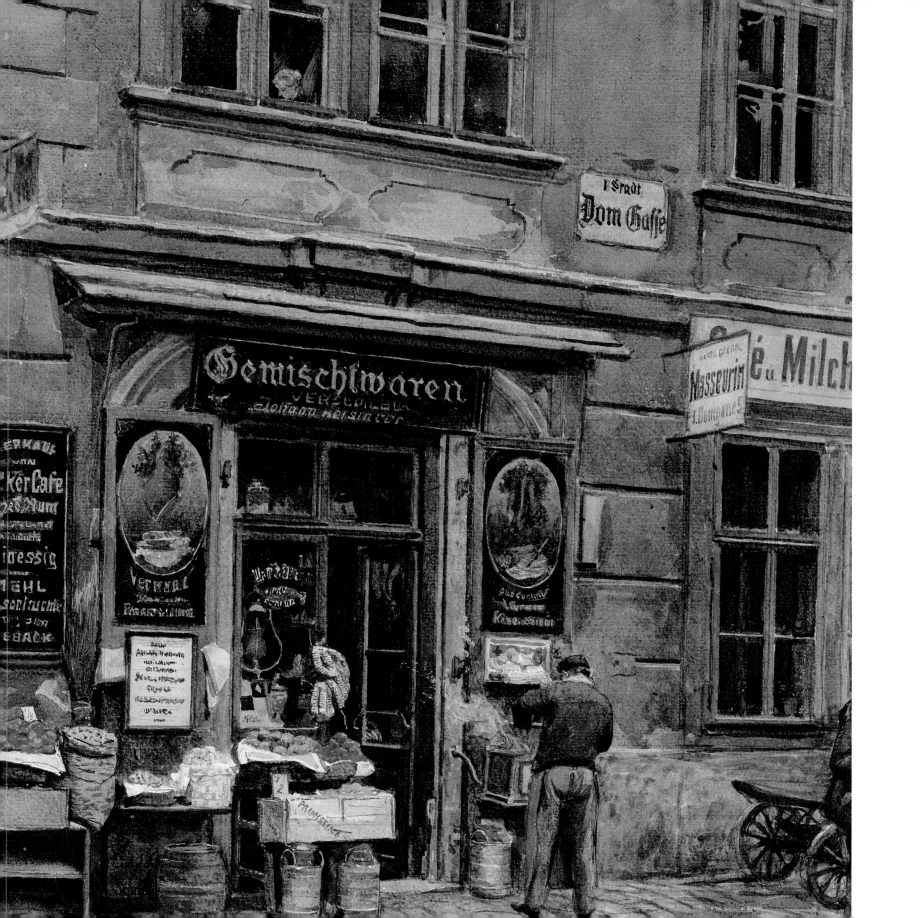

NIGHTS AT THE HEURIGE

As the summer sun sank toward the horizon, people from all walks of life left Vienna in streetcars and horse-drawn taxis, bound for the heurige that dotted the hillsides of the Vienna Woods. Named after the German word for "this year's," heurige were outdoor wine-drinking parlors that offered customers this year's wine, pressed on the premises from grapes from the proprietors' own vineyards.

The setting was casual, often just some wooden tables in the garden outside the vintner's farmhouse. Customers quaffed the pale golden wine out of sturdy glass steins and dined on cold meats, cheese, and salad purchased there or some bread and sausage brought from home. Vendors sold special treats like sugared figs on sticks and foil-wrapped wedges of a chocolate pastry called *Pischinger-torte* after the Viennese confectioner who invented it.

The heurige also provided *Schrammelmusik.* This musical genre, still popular today, featured lilting dance, march, and popular tunes played by a quartet composed of two violins, a guitar, and a clarinet or an accordion. In the congenial atmosphere of the heurige, the normally formal Viennese would talk and sing along with complete strangers until the early hours of the morning, when the musicians and the last streetcar returned to the city.

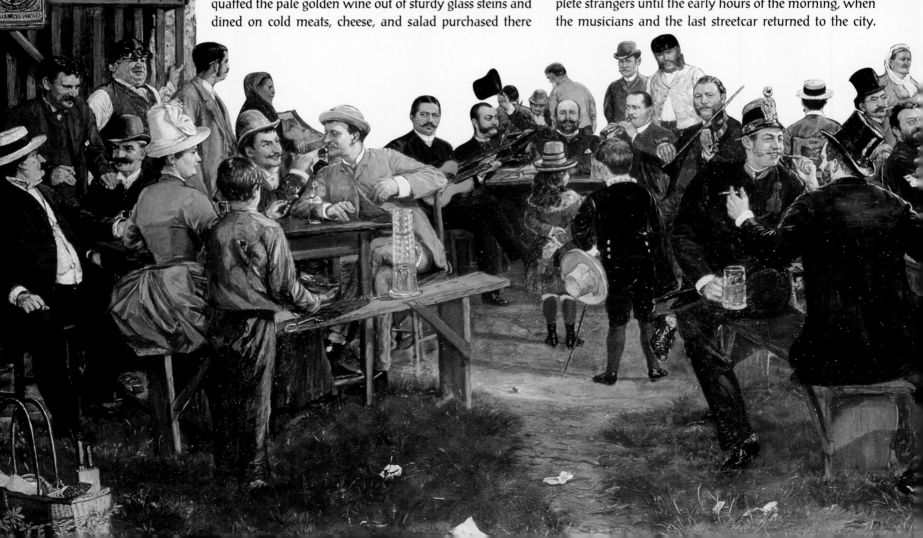

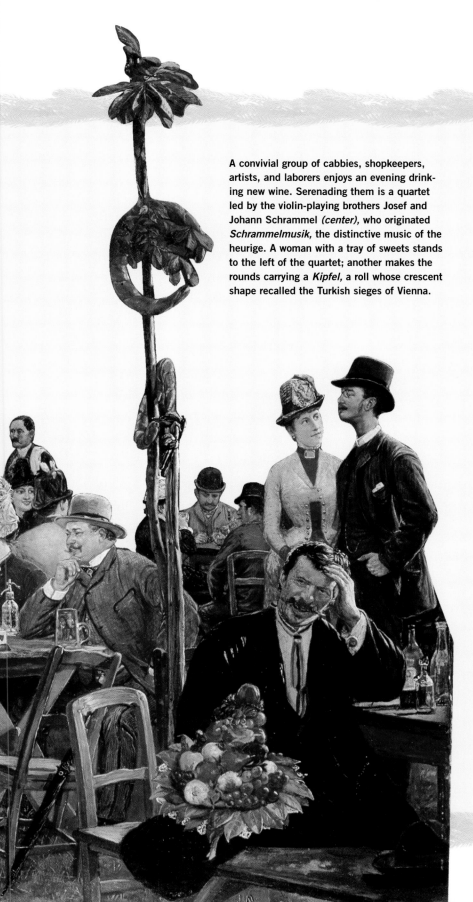

A convivial group of cabbies, shopkeepers, artists, and laborers enjoys an evening drinking new wine. Serenading them is a quartet led by the violin-playing brothers Josef and Johann Schrammel *(center),* who originated *Schrammelmusik,* the distinctive music of the heurige. A woman with a tray of sweets stands to the left of the quartet; another makes the rounds carrying a *Kipfel,* a roll whose crescent shape recalled the Turkish sieges of Vienna.

Vintners hung evergreen branches outside their farmhouses to signal that the new wine was pressed and available for sampling. Between sips, patrons would hum or sing along with the musicians who played at the heurige. Many of the sentimental songs in the entertainers' repertoire celebrated the joys of being Viennese or, like the lyrics reprinted below, looked back nostalgically on the Vienna of a bygone era.

Our Ring has lovely houses
Splendid palais where'er you look,
Large shop-windows, grand illuminations
Even an alley to ride along.
Omnibuses and horse-drawn coaches
For our traffic have we now
But the good old times will never,
Never ever come again.

By the turn of the century, these initiatives began to bear fruit. The municipal gasworks was up and running, and people noticed that the supply was more consistent and the quality of the gas far better than in the old days. New electric arc lamps, powered by the city's own generating plant, suffused the central squares and boulevards with a magical nocturnal glow.

To get around their ever-increasing metropolitan area, most ordinary Viennese—ones who could not afford private carriages—relied on horse-drawn trams and omnibuses. In the pre-Lueger era, the city's fleet, as observed by visitor Maria Hornor Lansdale, was made up of "forlorn old vehicles." They were, she lamented, not only unreliable but also "lumbering, dirty, musty, unspeakable."

Lueger, deviating from his municipal-ownership policy, liquidated the old tramway company and gave the contract to a private firm based in Berlin. Opponents said he had gone back on his word; the transportation workers grumbled

that their pay and conditions were far worse than under the old regime. Nevertheless, the public was pleased: The network expanded, horse power began to give way to electricity, new suburban stations were added, and the services ran on time.

Of all these enterprises, the project closest to Lueger's heart was the improvement of the water supply. For decades the city had relied on a reservoir fed by a single mountain spring. But as the population grew, so did the demand for water. Plans for a second mountain spring reservoir had been shelved eight times in 30 years. Lueger finally tore up the experts' reports and took himself off into the hills until he found an ideal water

source in the Styrian Alps, on land owned by a monastic order. An aqueduct 100 miles long would be required to carry the water to Vienna. The mayor brooked no resistance from his councilmen, and at a ceremony in 1901, he pushed down the plunger to ignite the first charge of dynamite. By 1910, a full year ahead of schedule, the work was done.

As a bonus, the increased supply would satisfy the mayor's wish to see Vienna's glorious fountains working again. Most of these once-magnificent landmarks had languished, dry and dusty, for far too long; those that managed to function at all, he lamented, produced a flow "so trifling that the Männeken Piss [Fountain] in Brussels looks like an abundantly flowing current" in comparison.

To give the Viennese more breathing room, the mayor created several new parks. The cramped capital desperately needed this green space, but Lueger's critics noted that the initiative also restricted the amount of land available for new housing. With the demand for apartments far exceeding supply, the private landlords—most of them staunch Lueger supporters—could continue to charge extremely high rents.

In this new era of populist politics, Lueger had a genius for wooing the electorate. Every social event became a public relations coup. He turned up at christenings to kiss the babies, comforted grieving relatives at funerals, raised a glass at countless wedding receptions. On great public occasions he basked in the crowd's adulation. He scored a

memorable triumph at the open-
ing of the city's "Procession
of Flowers" festival, the *Blu-
menkorso:* When his carriage
arrived in the Prater, he at-
tracted as much applause
and attention as Emperor
Franz Josef himself.

None of his official
visits were complete with-
out flags, floral tributes, and
ranks of well-drilled school-
children cheering his arrival.
Some of the mayor's less-admiring
contemporaries thought that he was
becoming all too regal, as evidenced by his
taste for pomp and ceremony. "What differenti-
ates Dr. Lueger indeed from a Monarch?" demanded the radical
politician Karl Hermann Wolf. "In his own mind he imagines
himself to be an imperial ruler." Local dignitaries, Wolf noted
wryly, would all but swoon as they were ushered into the great
man's presence, when—in the words of the pro-Lueger news-
paper *Deutsches Volksblatt*—they "had the honor to be introduced
to Mayor Lueger."

Accustomed to such deference, the mayor received a nasty
shock in February 1903 when he arrived at the church in the
Hofburg Palace for the memorial service of a Habsburg arch-
duchess. As he took his seat, a courtier approached to inform
him that he had not actually been invited; the announcement he
had received was simply an official notice of the royal lady's
death. Lueger found himself escorted, politely but firmly, out of
the sanctuary.

The mayor was furious. "I had to turn around and pass all
the rows of people," he complained, in a formal letter of protest

Lueger greets Franz Josef at a Vienna railroad station upon the emperor's return from a trip to Budapest in 1908. Though initially cool to Lueger, the emperor was forced to acknowledge the overwhelming popularity of the so-called *Volkskaiser,* or "People's King." Lueger's political career was commemorated with a medallion *(inset)* bearing his image and the words "Mayor Dr. Karl Lueger 1844-1910."

about "this extremely unpleasant incident." In spite of this humiliation—and the recent memory of those imperial vetoes—he knew his duty as a patriotic Austrian. Even the blood in his veins, asserted Lueger, ran in the official colors of the Habsburg monarchy: "If you cut me, you'll find black and yellow."

Meanwhile, he continued to build up his Christian Social power base. To bolster the Christian Social movement, he fostered youth groups, professional associations, burghers' clubs, and a Women's League, the *Frauenbund,* dedicated to such activities

as organized boycotts of Jewish-owned shops. These female supporters made up in passion what they lacked in actual voting rights. Emerging in a fever of excitement from their frequent pro-Lueger rallies, they marched along the sidewalks wielding their umbrellas like spears and roaring *"Hoch Lueger"*—"Up with Lueger"—in the faces of the people they passed.

On one memorable occasion, a train carrying a party of Frauenbund members on a trip to the countryside stopped alongside one chartered by a socialist group for a similar purpose. After an exchange of jeers and insults, the pro-Lueger ladies turned their backs to the windows, bent over, lifted their skirts, and wagged their hindquarters at the leftists. Reporting the fracas, the socialist press excoriated the hypocrisy of "the Christian women who always said so much about morals and morality. A worker's wife would never do such a thing."

As further franchise reforms brought waves of new voters into the political arena, the ideological differences between the two mass movements, Christian Socialist and Social Democrat, escalated into all-out war. In the autumn of 1904, the mayor's party decided to honor his 60th birthday with an elaborate round of public festivities. They planned a giant rally of Christian Social supporters, a celebratory Roman Catholic Mass, and other ceremonial expressions of public joy, culminating in a huge torchlight procession along the Ringstrasse.

The Christian Social faithful whipped themselves into a frenzy of fund-raising. They collected contributions toward a new charitable foundation to be established in Lueger's name, and they presented every student in the city with a specially printed book of tributes to the mayor. In pro-Lueger neighborhoods, city workers made house-to-house collections.

The Social Democrats decided to spoil the party. They mobilized their own activists to stage mass demonstrations in front of the houses of Christian Social leaders, carrying enormous red flags inscribed "Down with Lueger, long live the working class!"

They threatened to swamp the Ringstrasse on the night of Lueger's birthday parade, promising to outnumber the Christian Socialist burghers many times over.

On October 19, just four days before the scheduled procession, the police department, fearing that mayhem would ensue, insisted that the Christian Socialists cancel the event. Lueger was appalled, but he complied. And on the 23rd he grew even angrier, for the Social Democrats celebrated their victory by rubbing salt into his wounds. They turned up on the Ringstrasse in the tens of thousands to mock the mayor and his absent followers by shouting anti-Lueger slogans. The gathering was raucous, but the police—to the mayor's fury—chose not to intervene.

But if the city's proletariat declined to honor him, Mayor Lueger found consolation in another quarter. In 1906 Emperor Franz Josef paid his own reluctant tribute to Vienna's popular mayor by conferring on him the honorary rank of imperial privy councilor and therefore giving him the right to use the honorific of "Excellency."

Although Lueger might have considered himself a populist, he was not immune to enjoying the cachet that possession of this title conferred. Never again, on any of his official visits to the Hofburg Palace, would he suffer the humiliation that he had experienced when he attended the archduchess's memorial service. But as Lueger reminded the friends and acquaintances who came to congratulate him, the glory was not his alone: "From the point of view of Vienna's interests I have always felt quite bitter about the fact that I must always sit at the low end of the Imperial table. Now it will be different—I am a Privy Councilor of His Majesty, and therefore an Excellency. I, as Mayor of Vienna, will sit near the head of the table, and that will be an honor for the city of Vienna."

And perhaps more important than Lueger would care to admit, a genuine social triumph for a janitor's son.

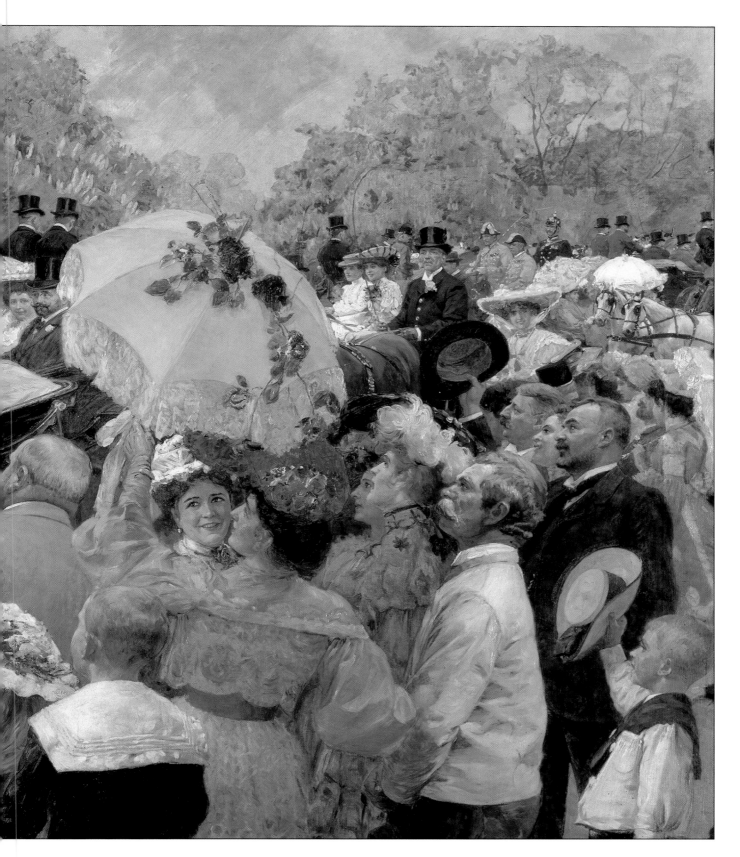

Surrounded by a throng of admiring supporters, Mayor Lueger enjoys a triumphant ride through the Prater during Vienna's spring festival, the "Procession of Flowers." The majority of the city's voters never lost faith in "handsome Karl," who remained Vienna's mayor until his death in 1910.

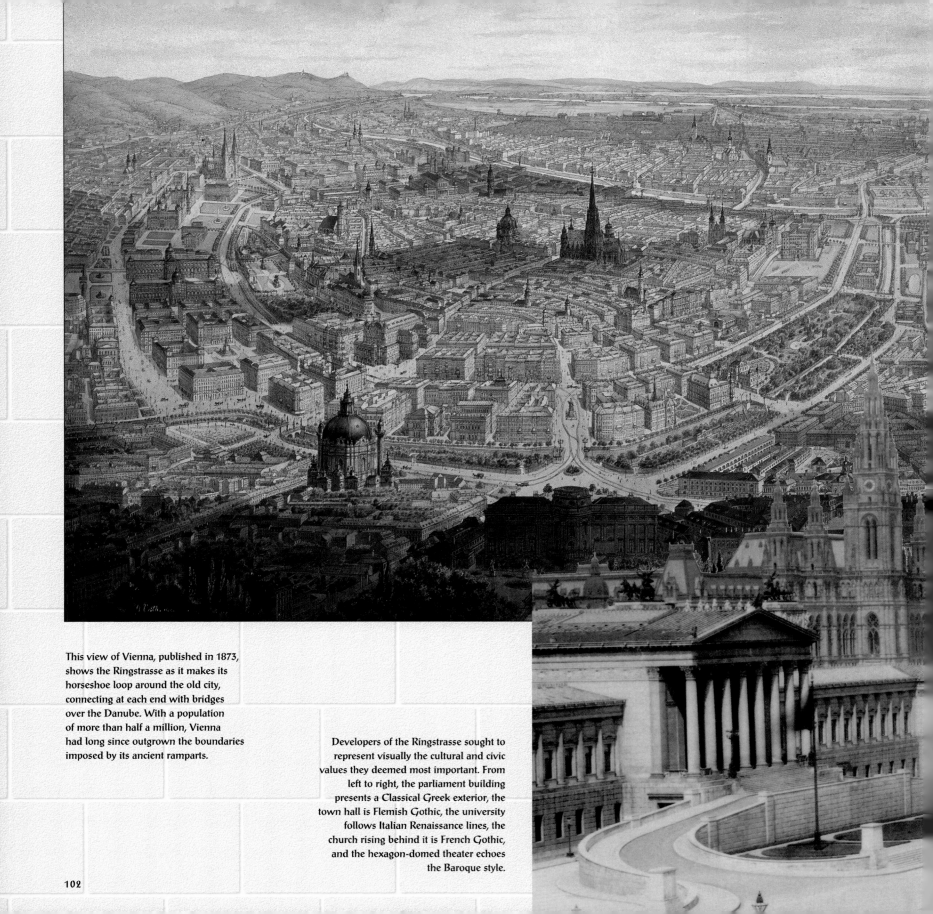

This view of Vienna, published in 1873, shows the Ringstrasse as it makes its horseshoe loop around the old city, connecting at each end with bridges over the Danube. With a population of more than half a million, Vienna had long since outgrown the boundaries imposed by its ancient ramparts.

Developers of the Ringstrasse sought to represent visually the cultural and civic values they deemed most important. From left to right, the parliament building presents a Classical Greek exterior, the town hall is Flemish Gothic, the university follows Italian Renaissance lines, the church rising behind it is French Gothic, and the hexagon-domed theater echoes the Baroque style.

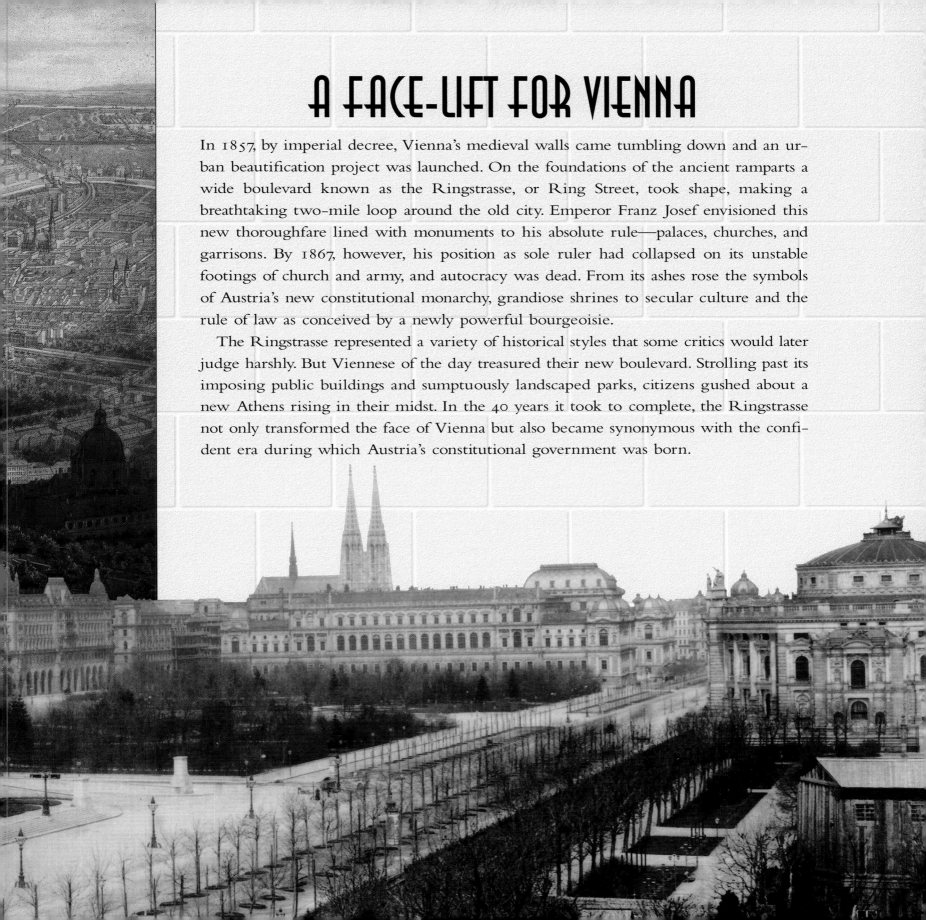

A FACE-LIFT FOR VIENNA

In 1857, by imperial decree, Vienna's medieval walls came tumbling down and an urban beautification project was launched. On the foundations of the ancient ramparts a wide boulevard known as the Ringstrasse, or Ring Street, took shape, making a breathtaking two-mile loop around the old city. Emperor Franz Josef envisioned this new thoroughfare lined with monuments to his absolute rule—palaces, churches, and garrisons. By 1867, however, his position as sole ruler had collapsed on its unstable footings of church and army, and autocracy was dead. From its ashes rose the symbols of Austria's new constitutional monarchy, grandiose shrines to secular culture and the rule of law as conceived by a newly powerful bourgeoisie.

The Ringstrasse represented a variety of historical styles that some critics would later judge harshly. But Viennese of the day treasured their new boulevard. Strolling past its imposing public buildings and sumptuously landscaped parks, citizens gushed about a new Athens rising in their midst. In the 40 years it took to complete, the Ringstrasse not only transformed the face of Vienna but also became synonymous with the confident era during which Austria's constitutional government was born.

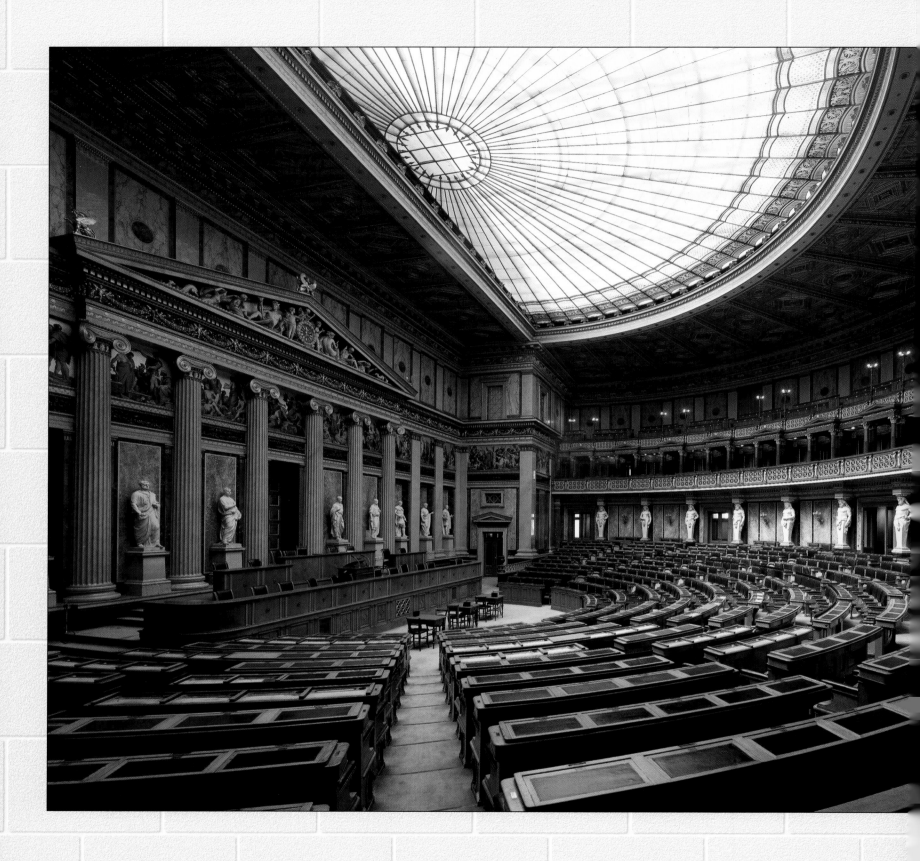

VIENNA'S TEMPLE OF LAW

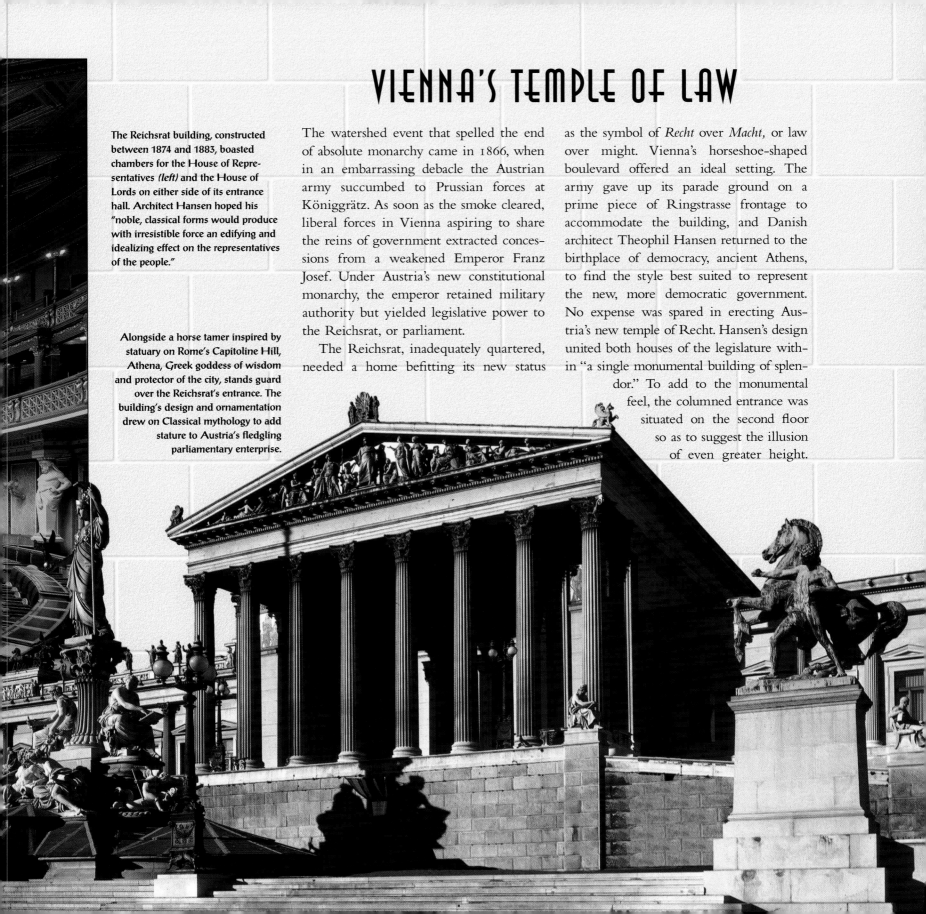

The Reichsrat building, constructed between 1874 and 1883, boasted chambers for the House of Representatives *(left)* and the House of Lords on either side of its entrance hall. Architect Hansen hoped his "noble, classical forms would produce with irresistible force an edifying and idealizing effect on the representatives of the people."

Alongside a horse tamer inspired by statuary on Rome's Capitoline Hill, Athena, Greek goddess of wisdom and protector of the city, stands guard over the Reichsrat's entrance. The building's design and ornamentation drew on Classical mythology to add stature to Austria's fledgling parliamentary enterprise.

The watershed event that spelled the end of absolute monarchy came in 1866, when in an embarrassing debacle the Austrian army succumbed to Prussian forces at Königgrätz. As soon as the smoke cleared, liberal forces in Vienna aspiring to share the reins of government extracted concessions from a weakened Emperor Franz Josef. Under Austria's new constitutional monarchy, the emperor retained military authority but yielded legislative power to the Reichsrat, or parliament.

The Reichsrat, inadequately quartered, needed a home befitting its new status as the symbol of *Recht* over *Macht,* or law over might. Vienna's horseshoe-shaped boulevard offered an ideal setting. The army gave up its parade ground on a prime piece of Ringstrasse frontage to accommodate the building, and Danish architect Theophil Hansen returned to the birthplace of democracy, ancient Athens, to find the style best suited to represent the new, more democratic government. No expense was spared in erecting Austria's new temple of Recht. Hansen's design united both houses of the legislature within "a single monumental building of splendor." To add to the monumental feel, the columned entrance was situated on the second floor so as to suggest the illusion of even greater height.

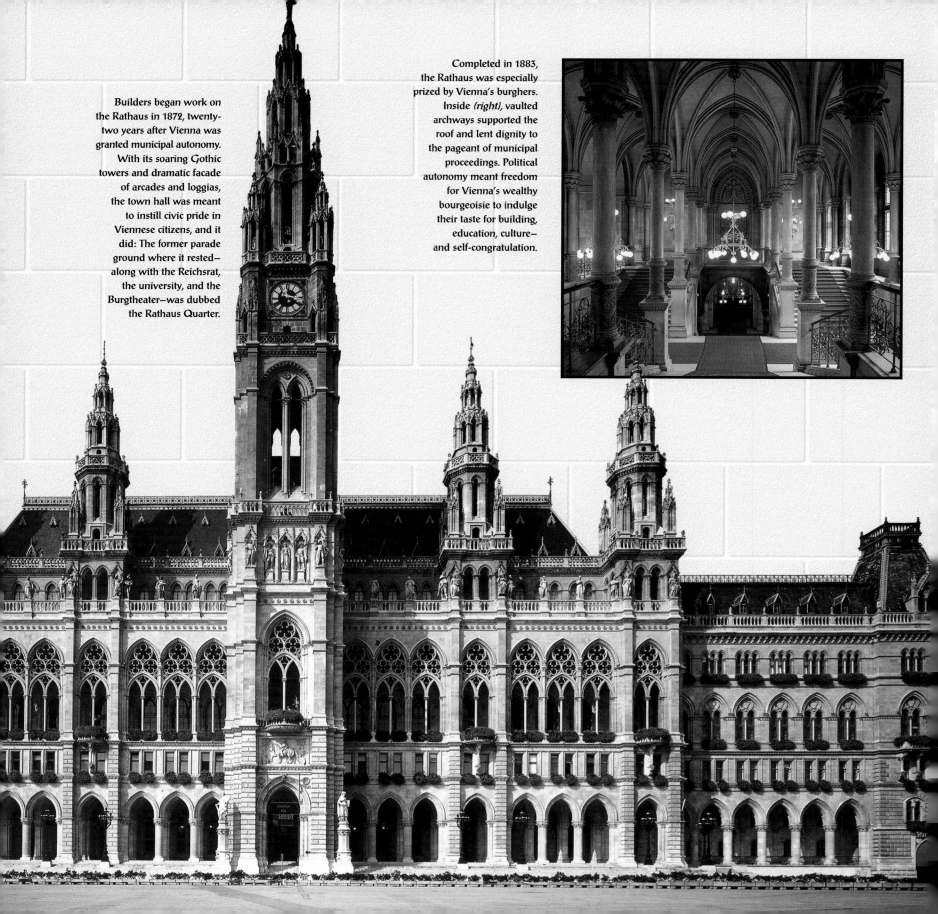

Builders began work on the Rathaus in 1872, twenty-two years after Vienna was granted municipal autonomy. With its soaring Gothic towers and dramatic facade of arcades and loggias, the town hall was meant to instill civic pride in Viennese citizens, and it did: The former parade ground where it rested—along with the Reichsrat, the university, and the Burgtheater—was dubbed the Rathaus Quarter.

Completed in 1883, the Rathaus was especially prized by Vienna's burghers. Inside *(right),* vaulted archways supported the roof and lent dignity to the pageant of municipal proceedings. Political autonomy meant freedom for Vienna's wealthy bourgeoisie to indulge their taste for building, education, culture— and self-congratulation.

EVOKING GOTHIC GLORY

A second edifice on the former parade ground, adjacent to the Reichsrat building, was the seat of municipal government: Vienna's Rathaus, or town hall *(far left)*. In the Middle Ages, Vienna had started out as a free commune, but its self-government was eclipsed by Austria's long era of auto-cratic rule. After casting about for a style that would be suitable for the town hall, architect Friedrich von Schmidt chose a massive variation of Flemish late Gothic style, thereby proclaiming Vienna's affinity with the proudly independent towns of medieval Flanders.

Another one of the Ringstrasse's neo-Gothic structures was the Votive Church, or Votivkirche. In 1853, when Franz Josef narrowly escaped death at the hands of a would-be assassin, his mother Sophie proposed that the Votive Church be built to thank God for sparing his life. Started in 1856 before the decline of imperial power and financed by public subscription under the royal family's leadership, the Votive Church symbolized the unity of crown, clergy, and army against what Vienna's wishful archbishop called, at the church's cornerstone-laying ceremony, the "wounded tiger of Revolution."

The Votive Church, shown in this water-color, was modeled after France's great Gothic cathedrals. Serving as church to Vienna's military garrison, it was criticized by liberals for representing "the rule of the saber and religion."

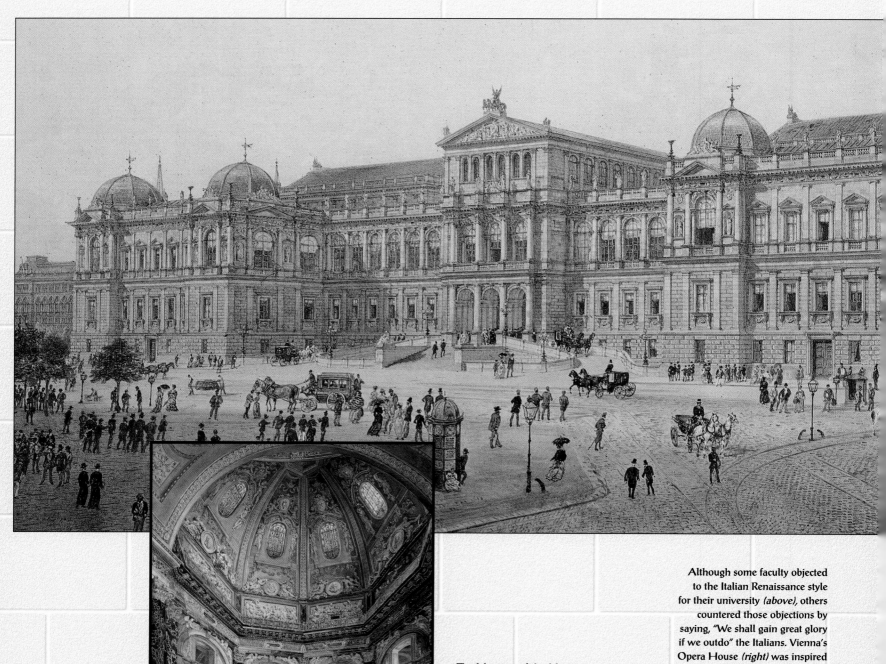

The Museum of Art History, shown at left, its dome dwarfing Franz Josef and a group of visiting dignitaries, brought culture to the common man. Opened in 1891, it was designed to show off the Habsburg art collection, previously sequestered in the imperial palace. But with acres of echoing marble, busily detailed decor, and silk-draped frames, the design smothered the art it was meant to air.

Although some faculty objected to the Italian Renaissance style for their university *(above)*, others countered those objections by saying, "We shall gain great glory if we outdo" the Italians. Vienna's Opera House *(right)* was inspired by the dramatic French Renaissance style. Its architects died thinking their work had failed, but the Opera House would become the Ringstrasse's most cherished building.

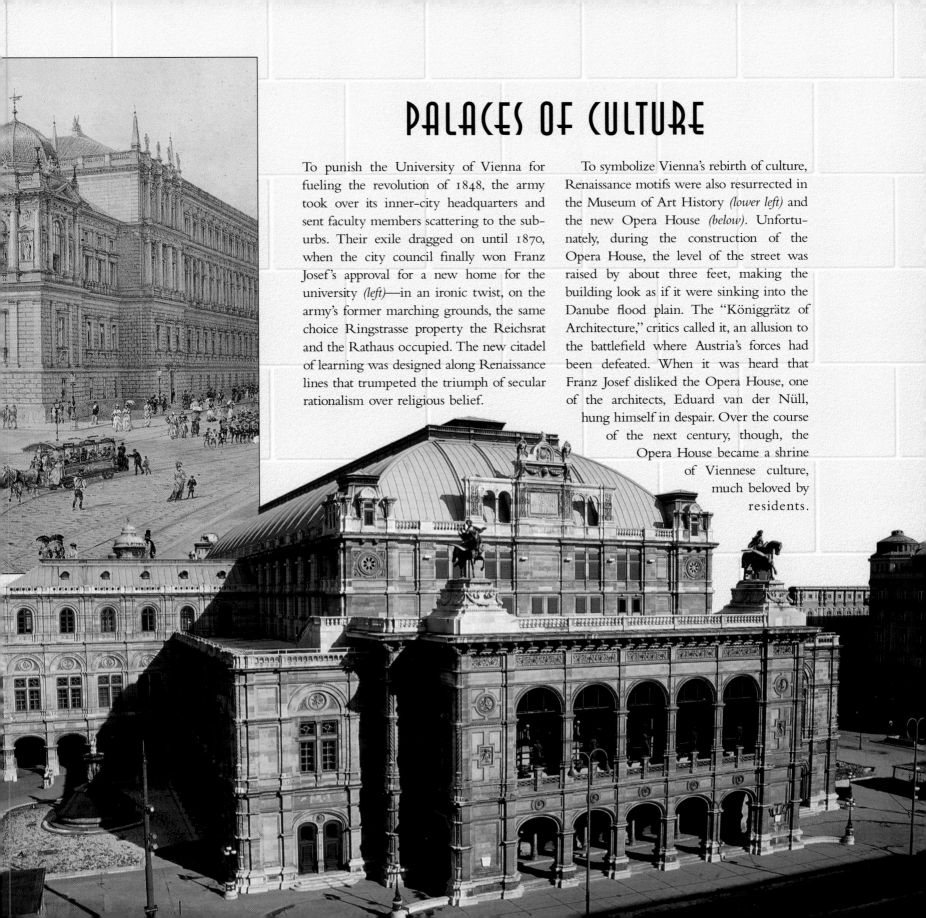

PALACES OF CULTURE

To punish the University of Vienna for fueling the revolution of 1848, the army took over its inner-city headquarters and sent faculty members scattering to the suburbs. Their exile dragged on until 1870, when the city council finally won Franz Josef's approval for a new home for the university *(left)*—in an ironic twist, on the army's former marching grounds, the same choice Ringstrasse property the Reichsrat and the Rathaus occupied. The new citadel of learning was designed along Renaissance lines that trumpeted the triumph of secular rationalism over religious belief.

To symbolize Vienna's rebirth of culture, Renaissance motifs were also resurrected in the Museum of Art History *(lower left)* and the new Opera House *(below)*. Unfortunately, during the construction of the Opera House, the level of the street was raised by about three feet, making the building look as if it were sinking into the Danube flood plain. The "Königgrätz of Architecture," critics called it, an allusion to the battlefield where Austria's forces had been defeated. When it was heard that Franz Josef disliked the Opera House, one of the architects, Eduard van der Null, hung himself in despair. Over the course of the next century, though, the Opera House became a shrine of Viennese culture, much beloved by residents.

THE MIRROR OF SOCIETY

When workers broke ground for a new theater on the Ringstrasse, there was much at stake. So attached were the Viennese to their beloved old imperial theater that at the end of the final performance frenzied audience members tore off pieces of the curtain to keep as mementos. In the eyes of *fin de siècle* Vienna, the stage was a mirror of society: It taught proper manners, good taste, and correct pronun-ciation, in addition to representing art at its loftiest height. As one observer recalled, "A nimbus of respect encircled like a halo everything that had even the faintest connection with the Imperial theater."

In a fit of optimistic historicism, archi-tects Gottfried Semper and Karl von Hasenauer chose early Baroque to conjure up the period when the stage became an acceptable meeting place for royalty and commoners. The new Burgtheater opened in 1888 after 14 years of construction, but it was a bitter disappointment. Despite the theater's lavish facade, acoustics were poor, entrances were small, and 32 boxes lacked a decent view of the stage. But no cost was too great for theater-loving Vienna: In 1897 this edifice of high culture was completely rebuilt. Finally, after 23 long, anxious years, the Viennese had a usable stage upon which the spectacle of their lives could unfold.

With its curving facade, ornate columns, and heroic statuary, the Burgtheater was Austria's premiere stage for serious drama. It was also one of the few milieus where aristocrat and commoner regularly mingled.

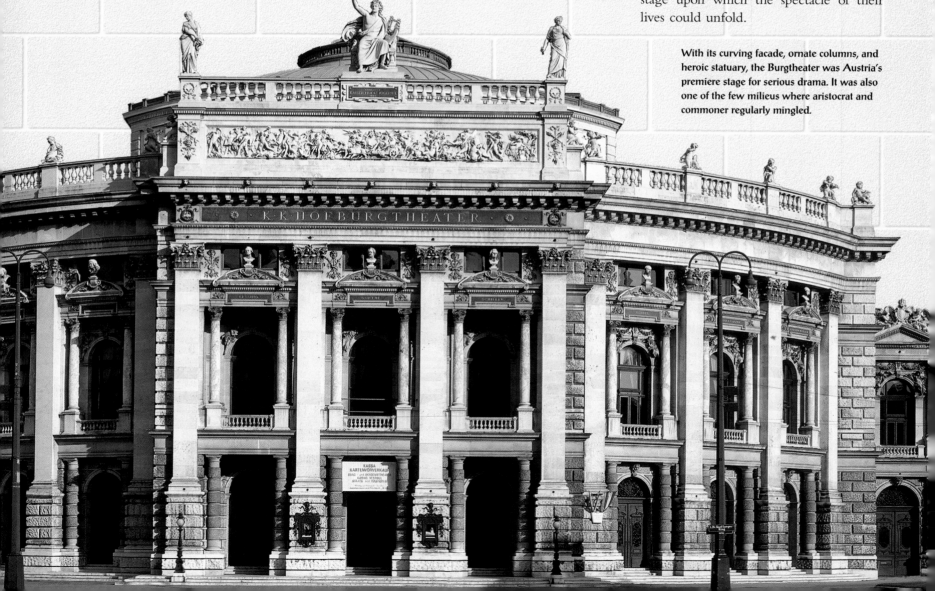

Gustav Klimt was one of the artists hired to paint frescoes for the Burgtheater commemorating the history of the stage. These panels of Klimt's above a grand staircase present the historical, the mythological, and the fanciful in a visual scramble that reflects the Ringstrasse's spirit of eclecticism—or what critics would call a lack of unifying vision. For their work on the frescoes, Klimt and his colleagues won the emperor's Gold Order of Merit.

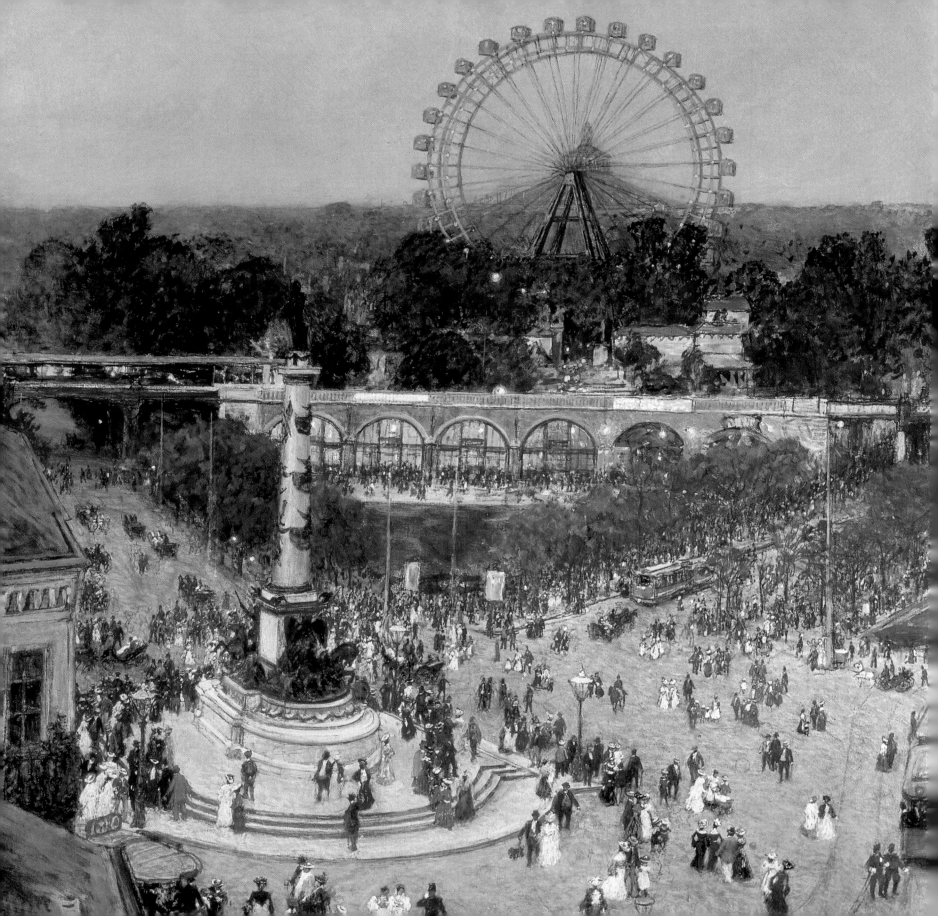

THE VERY SOUND OF AUSTRIA

Pleasure-seekers stream into the Prater, the enormous Vienna park that was home to the *Riesenrad,* the giant Ferris wheel built in 1898. At night the Prater looked like a fairyland with its colored lamps and electric lights, and the sound of Strauss waltzes drifting through the air from the park's bandstands added to the sense of enchantment.

He had been married twice and was now in his 58th year of life. But, as he liked to tell his friends, Johann Strauss—Vienna's undisputed Waltz King—was having his "third youth." And when he visited Budapest in February 1883 to conduct the Hungarian premiere of his operetta *The Merry War,* the reason for his exhilaration was on his arm: his new young love, Adele Deutsch.

Strauss and Adele made a striking couple. She was 27 years old, with raven hair and warm, dark eyes and obvious affection for her much older lover. In her vivacity and grace of movement, she embodied the feminine spirit that Strauss celebrated in his music. Strauss himself looked half his age. He was erect and trim, always so fastidiously dressed that it was said he never wore any necktie more than four times. Besides, he had recently shaved off his luxuriant side whiskers, though he had kept his mustache, its ends turned fashionably up, and dyed his graying hair a sleek, rich black.

One evening during their stay in Budapest, Strauss and Adele attended a dinner party held in the composer's honor. Among the distinguished dinner guests was the great Hungarian composer Franz Liszt. Strauss had met Liszt many years before and even dedicated a

waltz to him. That evening Strauss stood at the piano and turned the pages while Liszt played. Then, to Liszt's great pleasure, Strauss sat down at the keyboard and played his newest—and still unpublished—waltz. Later on, a Gypsy band struck up, and the festivities continued until four o'clock in the morning. Practically everyone danced, all except the Waltz King, who had to admit he had never gotten the hang of it.

A few days later, still feeling the intoxicating effects of that delightful evening, Strauss paid a visit to the eminent novelist Mór Jókai. The meeting between the Viennese Waltz King and the prolific Hungarian novelist was a fruitful one. "You were right," Strauss later told Adele, who had suggested he meet Jókai. "The man has given me ten subjects for operettas. My head is still burning with all the projects." He was most entranced by a new novel Jókai described to him about a beautiful Gypsy girl. Strauss loved the music of Gypsy bands, and Hungarian rhythms had always influenced his music. Here, he was certain, was the project that could rejuvenate him creatively in the same way that Adele had given him his "third youth."

It was not that Johann Strauss had lacked for success in a city that prided itself on the cultivation of the arts. For four decades people in Vienna and all across Europe—if not Strauss himself— had been dancing to his tunes. He modestly gave the ambiance of the city credit for his accomplishments. "In its air," he said, "float the melodies which my ear has caught, my heart has drunk in, and my hand has written down." But no less an authority than the German composer Richard Wagner once toasted him as "the most musical brain I've ever known." Of late, though, that brain had been going through a somewhat barren phase, and Strauss's musical triumphs had been few and far between.

It was a frustrating time for a man who had been successful from the outset of his career in music in

1844, when he began to conduct his own small orchestra in Vienna. Still a few days short of his 19th birthday, he was already challenging the city's ruling king of music, who happened to be his father, also named Johann. Together with Joseph Lanner, Johann the elder had developed the waltz—from the German *waltzen,* "to revolve"—from a slow 18th-century Austrian folk dance known as the ländler. Johann the elder and Lanner sped up the tempo so that couples could whirl between the downbeats of 3/4 time. Compared to the stately minuet formerly favored by the aristocracy, the swirling waltz seemed almost subversive, with one critic going so far as to label it "a scandalous dance."

Johann the elder was pathologically jealous of his son's musical gifts, however, and Johann the younger must have felt a secret satisfaction at dethroning him. When he was a boy, his father had forbidden him to study music at all; with his mother's connivance, he was able to take violin lessons secretly. By the time young Johann was 18, such secrecy was no longer necessary: His father had deserted his wife and five children for his mistress, a young milliner, with whom he had five more children.

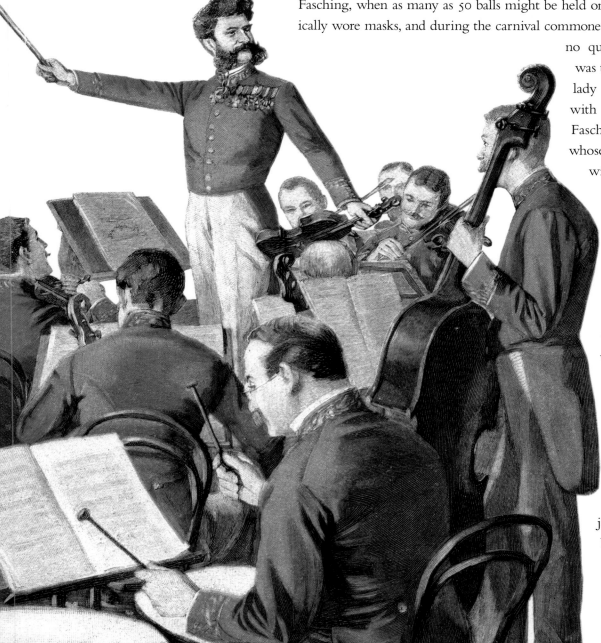

Like his father before him, the younger Johann became one of Vienna's best-known and busiest public figures. And like the waltz itself, he was in constant motion. He eventually formed four orchestras, and they frequently all played on the same night. A coach drawn by two horses whisked him between engagements. He would lead one orchestra in a couple of dances, conducting with the bow of his violin instead of a baton, and then race on to the next orchestra's booking.

The most frantic time of all was the pre-Lenten carnival of merrymaking known as Fasching, when as many as 50 balls might be held on a single evening. Participants typically wore masks, and during the carnival commoners could waltz with aristocrats with no questions asked, as all conversation was taboo. A man could dance with any lady he chose simply by presenting her with a rose. All levels of society staged Fasching balls, even the laundry-maids, whose popular soirees typically swarmed with army officers and aristocratic dandies. On such festive evenings, whirling about in the arms of strangers, the Viennese relaxed their rigid class structure and just enjoyed the democratizing influence of the waltz.

A prominent composer like young Johann was expected to write a new waltz for each important ball. Ideas for pieces came to him in torrents. He would write down musical phrases and scraps of melody on his handkerchief, the back of a menu, the cuffs of his shirt. Once he jerked awake in the middle of the night and jotted down an idea right on his bedsheet, only to lose it the next

morning when the sheet was tossed into the dirty laundry and washed. During Fasching he often composed right up until the last minute, with copyists waiting in the next room to write down the score for the various instrumental parts.

Strauss wrote as many as 300 waltzes, polkas, marches, and quadrilles during the first two decades of his career. For a ball held by a famous club of writers and journalists, he wrote a piece called *Morning Papers.* For the city's stockbrokers he composed the *Transaction Waltz* and for students of Vienna's medical school the *Fast Pulse Waltz.* Jurists received the *Due Process Polka.* For the ball sponsored by the city's technical college, he penned a number of appropriately titled pieces such as the *Electro-Magnetic Polka* and the *Fly Wheels Waltz,* as well as a waltz named *Accelerations* whose opening actually imitated the whirring sound of wheels.

Strauss's demanding schedule eased up a bit when, on August 27, 1862, he married Henriette Treffz, known as Jetty. A former singer eight years his senior, Jetty was also a woman of means, and Strauss's newfound wealth allowed him to retire from the ballroom circuit in 1864. Now that he had given up conducting, he could devote himself entirely to composition. The waltz, he determined, would be heard, like symphonic music, in the concert hall as well as the dance hall. One piece fit for both venues was inspired by a poem that, despite the river's yellow-green waters, extolled the "beautiful blue Danube." With its opening D-major theme suggesting the majestic flow of the great river, *The Blue Danube,* one of Strauss's biographers later observed, was "the very sound of Austria."

Another challenge soon confronted Strauss. The new musical theatrical form known as the operetta—from the Italian diminutive for opera—had been popularized in Paris by the composer Jacques Offenbach. At Jetty's urging, the Waltz King agreed to compose an operetta. His early efforts were disappointing. Teamed up with mediocre writers, he

A publicity poster for *The Gypsy Baron* highlights the elaborate staging of Strauss's operetta, a tale of an impoverished nobleman falling in love with a beautiful young Gypsy woman that also includes hidden treasure, a fortuneteller, and soldiers marching off to war. Often copied but never outdone, *The Gypsy Baron* became the prototype of the Austro-Hungarian operetta.

produced three straight flops. Then he got together with a pair of Prussian librettists who were trying to turn an original play written by one of their countrymen into an operetta. Impressed with the librettists' text, Strauss plunged into the score, toiling day and night for six weeks with creative fervor. The resulting farcical comedy, *Die Fledermaus*—"The Bat"—gently chided Vienna's new upper middle class for its aristocratic pretensions. The operetta opened in the Austrian capital on April 5, 1874, and later became a hit in Paris, London, New York, and Berlin.

After this stunning success, however, Strauss stumbled through failure after failure over the next nine years. His personal life was in some turmoil during this time, too. In 1878 his wife died of a stroke, and just seven weeks after her death he impulsively wed Angelika Dittrich, a pretty,

Adele and Strauss had been living together for a year when they made their trip to Budapest in early 1883. As Adele had hoped, Strauss's meeting there with the writer Mór Jókai had proved inspirational, and soon the composer was excited at the prospect of making an operetta out of Jókai's most recent novel. Jókai suggested the operetta be called *The Gypsy Baron* and recommended that Strauss contact a Hungarian librettist living in Vienna, a journalist by the name of Ignatz Schnitzer. Strauss did so. He found Schnitzer to be talented, imaginative, and easy to work with, and the two men endlessly discussed characters and motivation so that the music and the lyrics would mesh seamlessly.

The pairing of Hungarian writer and Austrian composer turned out to be highly appropriate, musically and politically. The plot of the operetta began among the

"To every age its art and to art its freedom."

blonde, blue-eyed Prussian actress 25 years his junior. The marriage did not last. In 1882, after an unhappy four years together, she abandoned him for a theater director closer to her own age.

Lonely again, Strauss turned to Adele Deutsch, a young and attractive widow with a two-year-old daughter named Alice. Strauss, who had known Adele since she was a little girl in pigtails, could not make her his third wife, however; in Catholic Austria divorce was virtually impossible to obtain, and the church refused to dissolve his marriage to Dittrich. Strauss sought papal permission to divorce, and when this was refused Adele simply moved in with Johann. The church might not recognize their union, but Viennese society regarded such arrangements with tolerance. Still, if they ever wanted to marry, Strauss would have to give up both his religion and his citizenship.

Gypsies of Hungary and ended in the city of Vienna. The score borrowed from the music of many peoples of the empire but especially the Gypsy songs of Hungary and the waltz of Vienna. *The Gypsy Baron* thus performed a symbolic act of reconciliation between the two nations forming the so-called Dual Monarchy.

Progress on *The Gypsy Baron* proved slow, however. Around this time Strauss suffered a bout of failing health, and his doctors ordered him to stop composing for a while. Forced to spend time resting at the Bohemian spa of Franzensbad, he complained in a letter to Schnitzer of "the torment which the enforced leisure is causing me just now." But, as he later confided to Schnitzer, he still managed to sneak in a little work: "I would memorize a few of your lyrics before going on a solitary long walk in the woods, and there I would write the melodies on my starched cuffs."

The staging of *The Gypsy Baron* was further delayed by Strauss's concern for theatrical detail. He made suggestions for revisions in the lyrics and recommendations for costumes and stage setting. His concern was contagious. The artistic director, Franz Jauner, even traveled to Hungary to purchase authentic costumes and other articles from Gypsies. Jauner was determined to make the Gypsy village so realistic that the audience would feel that they were actually there.

Finally, in October 1885—more than two and a half years after Strauss's seminal meeting with Mór Jókai—*The Gypsy Baron* was ready. But for what? The dress rehearsal was a disaster, and at the party afterward at Jauner's house, people conspicuously avoided Strauss. They were certain he had created another failure. But the naysayers were wrong: When Strauss stood at the conductor's podium of the Theater an der Wien for the premiere on the eve of his 60th birthday, everything went stunningly well. At least half of the songs brought encores, and at the end of each act the cheering crowd called for Strauss himself. After pausing for a short time offstage, the conductor answered every call. He "appeared on these occasions so happily preoccupied," said one of the rave reviews, "everybody supposed that during these intervals he had just completed another new operetta in his head."

But Strauss more likely was preoccupied with another matter. Having reached the summit of his musical career, he wanted now to formalize his relationship with Adele. Less than two weeks after the opening of *The Gypsy Baron,* he took the first step on the convoluted path to marrying her: The man whose music epitomized Vienna applied for release from his Austrian citizenship.

Fortunately for Strauss, he had established friendships with many members of the Protestant aristocracy in Germany, particularly in the duchy of Saxe-Coburg-Gotha. He once had dedicated a polka to the reigning duke of the principality, Ernst II, who himself composed operas and was a great admirer of the Waltz King. Through the duke's good offices, Strauss was granted citizenship in Saxe-Coburg-Gotha and converted to the Lutheran faith. The duke formally dissolved Strauss's previous marriage, and on August 15, 1887, Johann and Adele were officially married. After taking a brief honeymoon at the palace as personal guests of Duke Ernst, they returned to their native city of Vienna, where they were now, technically, both considered foreigners.

"The things one does for a woman," Strauss once joked to Adele about what they had had to go through to be married. But it was the things Adele did for him that brought stability and peace of mind to the composer. Like his first wife, Jetty, she served

Although Strauss preferred to write his music while standing up, he was not always as serene as he appears in this 1894 photograph taken at his villa in Ischl. One German journalist described how the maestro composed with the same nervous energy with which he conducted, tearing around his rooms "in a velvet suit and top boots, his hair in a mess."

as his manager. She took care of press relations, courting the most important critics. She tended to his correspondence and even copied his scores when necessary. Most of all, she created in their elegant town house in central Vienna a quietly ordered domesticity in which he felt comfortable and could go on composing.

Strauss worked every day, even Sundays and holidays. He slept until about 9:00 a.m. and then spent the rest of the morning sketching out musical ideas. Adele kept paper and pencils in every room in case an idea came to him at any point during the day. For the most part, though, he composed standing at a high desk in his downstairs study. Everyone had strict orders from Adele not to disturb him. Next to the desk was a bell that rang upstairs when Strauss wanted to summon her to listen to a new melody. He might take a break by going next-door to his billiard room for a solitary game or into the kitchen to chat and banter with the cook. Sometimes he played in the garden with his young stepdaughter, Alice, obligingly crawling around on hands and knees in his immaculate white flannel trousers.

Strauss loved to compose when it was raining and overcast, especially when he was at his country villa in Ischl. "Rain, nothing but rain and busy gurgling sounds of the nearby brook," he wrote a friend. "To write music in a well heated room, there is nothing more beautiful. I am happy to hear the crackling of the tiled stove. The worse it gets outside, the better I feel here. I want no sunshine while I work."

After taking the afternoon and evening off, Strauss would resume work in the quiet of the night, usually staying up until around two o'clock in the morning, orchestrating the ideas he had jotted down in the morning. He loved privacy but dreaded isolation. He felt secure when Adele was asleep in the quiet house. Although he had a reputation as a philanderer in earlier times, he was firmly faithful to Adele and liked to brag that they were never separated from each other for more than 24 hours at a time. Standing at his desk, he would pause in the middle of a

score to scribble little notes of endearment to her: "You are the queen of my happiness, of my life!" read one. When Adele awoke in the morning, she sometimes found several of them on her bedside table.

Once a bon vivant who loved parties and going out, Strauss was now content with the company of a few close friends. Someone usually dropped by in the afternoon for *jause,* the Austrian equivalent of afternoon tea, or to play billiards or cards, all of which provided a welcome break from music. In his home he insisted on imitating the informal atmosphere of a Vienna coffeehouse off the Kohlmarkt or the Graben, serving wine and sausages to his friends and offering them good cigars while he puffed on his meerschaum pipe. The only rule was an avoidance of discussions about serious matters, which invariably so upset Strauss he could not compose for days.

A frequent visitor to the Strauss home was the German composer Johannes Brahms. The solemn Brahms and the suave Strauss—so far apart musically and temperamentally—would sit in the garden for long afternoons scarcely speaking a word but enjoying each other's company. Sometimes, to the host's delight, Brahms would sit at the piano and improvise fugues based on Strauss waltzes. Brahms, a bear of a man with a long, gray beard, affected a gruff manner and biting sarcasm with others but treated Adele and Strauss with affection. He liked to joke that both composers were "in service at the Court of Adele— Brahms for fugues, Strauss for waltzes."

In January 1893 Strauss's operetta *Princess Ninetta* opened at the Theater an der Wien. The premiere was enhanced by the presence of Emperor Franz Josef, who had not been to the Theater an der Wien for 25 years. Like most Viennese, Strauss greatly admired the sovereign and in 1888 had composed the *Emperor Waltz* in tribute to Franz Josef's 40th anniversary on the throne.

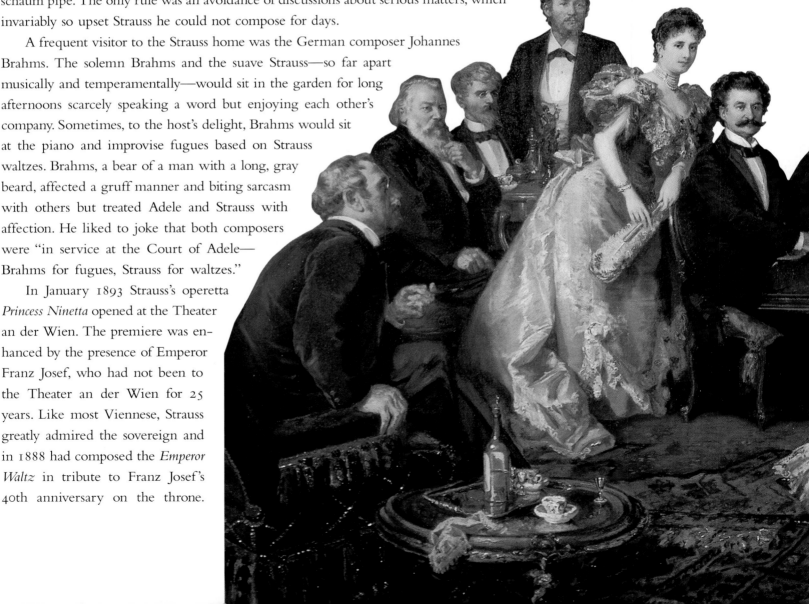

In this painting, *An Evening with Johann Strauss,* the composer is at the piano surrounded by his family and friends, most of whom were artists, writers, and musicians. Behind Strauss are his wife, Adele, and the German composer Johannes Brahms *(second from left);* on the far right stands Strauss's brother Eduard. Strauss's stepdaughter, Alice, sits on the sofa holding a fan.

Then as now, Strauss was no longer a subject of the emperor but was a citizen of Saxe-Coburg-Gotha. However, he was on friendly terms with Franz Josef and even shared the same tailor. After the second act of *Princess Ninetta,* he was summoned to the royal box. "Your music doesn't get older," the emperor told him graciously, "and neither do you."

Strauss's popularity had reached its peak. In a poll taken in Vienna in 1890, he had been named the third most popular person in all of Europe—behind only England's Queen Victoria and

Germany's chancellor, Otto von Bismarck. Within the Austrian Empire itself he probably would have placed first. In a sense, his music helped hold together the empire's disparate parts. Czechs, Poles, and Hungarians all heard something of their own melodies in his polkas and waltzes. His music was such a unifying force that the Viennese would later quip that Emperor Franz Josef ruled until the death of Johann Strauss.

That death came on June 3, 1899, some 19 years before the

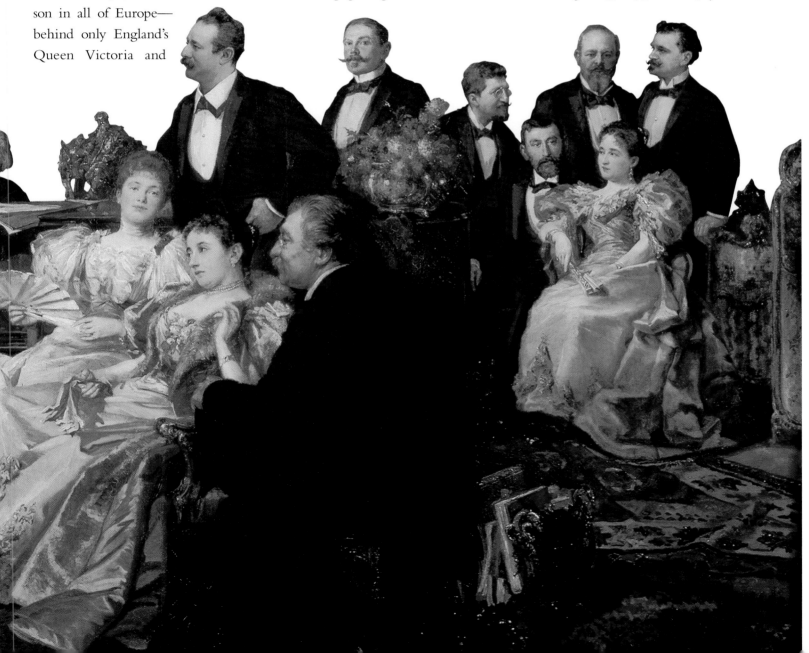

THE SILVER AGE OF OPERETTA

No one loved the romantically sentimental plots and lighthearted music of the "little opera" as much as the Viennese. But it took them a while to love *The Merry Widow,* a work that, after the death of Johann Strauss and the end of operetta's golden age, came to epitomize a new, "silver age" of the Viennese operetta.

Hopes were not high for the opening night of *The Merry Widow* on the evening of December 30, 1905: The show had been given only leftover sets and props and shabby costumes, and after hearing the music for the first time, the manager of the Theater an der Wien offered composer Franz Lehár money to withdraw the work. The low expectations proved justified. After 100 performances, *The Merry Widow—*

a tale in which a wealthy heiress feigns poverty in order to charm a young count who is determined not to be labeled a fortune hunter—closed.

The operetta had a successful summer run in a suburban Vienna theater, however, and in the fall of 1906 the Theater an der Wien decided to give it a second chance, complete with new sets and costumes. The result was a smashing success. Within five years *The Merry Widow* was playing to sellout crowds, not only on German-speaking stages but also translated into 10 languages and performed in theaters all over the world. "If I have written music that has found an echo among the peoples of the world," wrote Lehár, "it was not merely with the aim of providing entertainment. I wanted to appeal to people's emotions and touch their hearts." More than half a million performances later, *The Merry Widow* continues today to enchant theatergoers, who see in its scenes of political intrigues and glamorous balls a kind of window into *fin de siècle* Vienna itself.

Franz Lehár stands next to his leading actors, Louis Treumann and Mizzi Günther, who are wearing costumes from the folk-dance scene of *The Merry Widow*. Günther believed so strongly in the operetta that she bought costumes for her role with her own money.

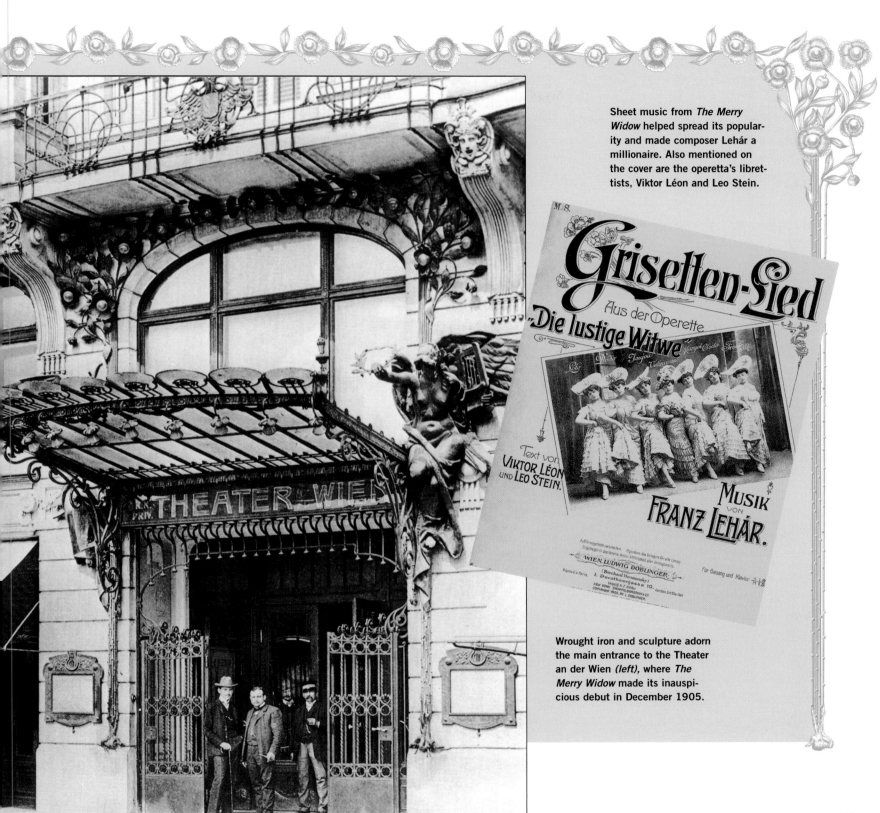

Sheet music from *The Merry Widow* helped spread its popularity and made composer Lehár a millionaire. Also mentioned on the cover are the operetta's librettists, Viktor Léon and Leo Stein.

Wrought iron and sculpture adorn the main entrance to the Theater an der Wien *(left)*, where *The Merry Widow* made its inauspicious debut in December 1905.

end of the empire. He died of pneumonia in Adele's arms that afternoon shortly after four o'clock. The news quickly spread throughout Vienna. In the *Volksgarten,* or "People's Garden," near the Hofburg Palace, an open-air concert was under way. It was a benefit to raise money for a monument to the elder Johann and his fellow musical pioneer, Joseph Lanner. Someone stepped up to the podium and whispered in the ear of the conductor, Eduard Kremser. Quietly, Kremser ordered a change in the program. Mournfully, as if at a funeral, the opening strains of *The Blue Danube* wafted over the park, its tempo slowed, the playing soft. The audience stood, many of them in tears. Without a word having been said, they knew their beloved Waltz King was dead.

In April 1897, two years before Strauss's death, a group of young artists shocked Vienna by rebelling against the cultural establishment of which the great composer was such a mainstay. More than a score of painters and architects seceded from the mainstream association of artists headquartered at the *Künstlerhaus,* or "Artists' House," to form their own avant-garde alliance. This act of rebellion quickly became known as the Secession and the rebels themselves, the Secessionists. The philosophy of the group was summed up in its motto: "To every age its art and to art its freedom."

The leader of the Secessionists scarcely fit the mold of an artistic bomb-thrower. Gustav Klimt was a gentle, earthy, reserved man not given to revolutionary rhetoric. He was, in fact, an up-and-coming member of the art establishment, a painter of traditional historical murals commissioned by Emperor Franz Josef himself. Though he was 34 years old, with black hair beginning to thin on top, he still lived at home with his mother and two sisters. Beneath the conventional surface, however, bubbled radical ferment. He was a bohemian in his personal life and increasingly a freethinker about art. Reaching out for the new as he transformed his own painting style, he would thrust himself into the center of the quarrels and controversy suddenly roil-

ing the heretofore calm waters of Vienna's realm of visual arts.

Klimt was the eldest son of a goldsmith and engraver of modest circumstances. But instead of following in his father's footsteps and becoming a master craftsman himself, he won admission to a government-sponsored art school when he was 14. There, he learned to paint, acquired knowledge of the history of art, and studied contemporary artists.

The epicenter of the "Makart style"—the mode of painting and decorating that swept Vienna in the 1870s—was artist Hans Makart's huge studio *(above)*. Makart furnished it with oversize canvases, opulent tapestries and carpets, chandeliers made of antlers, and bronze figurines and other costly *objets d'art*. The studio attracted hordes of visitors curious to see this artistic showpiece and site of legendary parties.

The most powerful artistic influence of the day was that of Hans Makart, who epitomized the historical painting style then in vogue. Makart's fascination with historical matters extended to costumes. When Klimt was a 17-year-old student in 1879, he was one of many art students pulled from the schools to help in the preparation of the lavishly costumed procession of 43 floats and 14,000 people Makart staged to mark the emperor's 25th wedding anniversary. With the same flair for the dramatic that characterized the parties he had in his government-provided studio, Makart placed himself at the front of the procession dressed in black and riding on a white charger. He was also the arbiter of interior design for the upper middle class of Vienna, dictating the use of carved and inlaid furniture and heavy draperies. Even housewives of lesser means often prominently displayed the so-called Makart bouquet—a grouping of thistles or bulrushes combined with a paper fan and peacock feather.

By the time Klimt had completed art school, he and two of his classmates had formed their own studio to pursue commissions in the kind of historical decoration at which Makart excelled. Calling themselves the Company of Artists, Klimt, his younger brother Ernst, and Franz Matsch painted murals for theaters and other public buildings. They abandoned any idea of individual artistic identity and prided themselves on being painter-decorators with an interchangeable unity of style. After the death of Hans Makart in 1884, they inherited his commission to depict the history of drama in 10 ceiling paintings over the two grand stairways in the new Burgtheater. They did so with

dispatch and distinction, using themselves, family, and friends as models. For their work they received a Gold Order of Merit from the emperor, who was subsidizing the new theater, and an even more interesting commission: Matsch and the Klimt brothers were to render paintings that memorialized the old Burgtheater before it was torn down.

Klimt tackled the challenging task of re-creating the audience that had attended the theater's final performance six years earlier. That audience had been so emotionally aroused by the impending demise of the building where Mozart had first presented his *Marriage of Figaro* that they ripped apart the stage for souvenirs. In order to portray the faces of recognizable patrons, Klimt conducted individual sittings. Appearing in the painting became a mark of social status, and people clamored for the chance to sit for Klimt. His final painting of the audience crammed onto a 32-by-36-inch canvas more than 100 individual portraits of prominent Viennese, including the emperor's brother Archduke Karl Ludwig, the actress Katharina Schratt, Johannes Brahms, the celebrated actor Alexander Girardi, and the future mayor of Vienna Karl Lueger. This assignment brought Klimt a lasting reputation as a painter of beautiful women as well as the 1890 Emperor's Prize, which came with a handsome purse that allowed him for the first time to travel abroad.

Direct exposure to the new developments in European art, particularly French Impressionism, opened Klimt to the idea of experimenting in his own painting. He was struggling to find a personal style and to free himself from both the surface brilliance of Hans Makart's historical decoration and the intentional unity of the Company of Artists. After completing some 40 murals for the lobby of Vienna's new Museum of Art History, the Company began to crumble. One partner, his brother Ernst, died in 1892. The other, Franz Matsch, relied upon his relationship with a Burgtheater actress to meet the elite of Vienna and become the portrait painter of high society, eventually winning a hereditary title in 1912. Gustav, by contrast, gave up his promising career as an architectural decorator and chose the path of controversy.

The young rebels who began to gather around Klimt gravitated to him for his radical views rather than because of any innovative accomplishment in his art. "The essence of innovation seemed to him to be not a new technique but a new attitude," art historian Hans Tietze wrote later. "He visualized a sort of Nazarene brotherhood in which selfless devotion to art took precedence over all other interests."

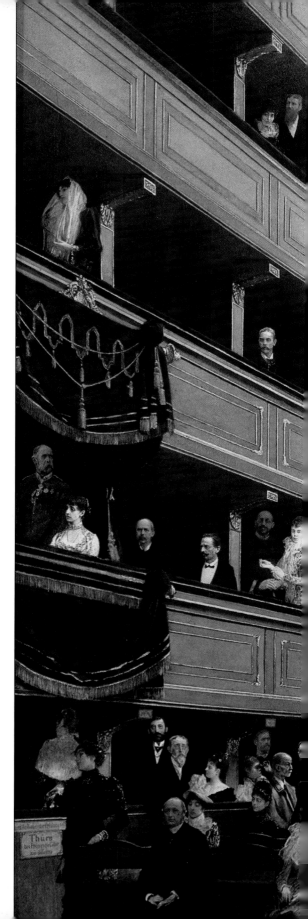

The Burgtheater was a place where spectators went to learn "how one ought to dress, how to walk into a room, how to converse, which words one might employ as a man of good taste and which to avoid." Gustav Klimt's painting of the last performance at the old theater captures the faces of Vienna's elite.

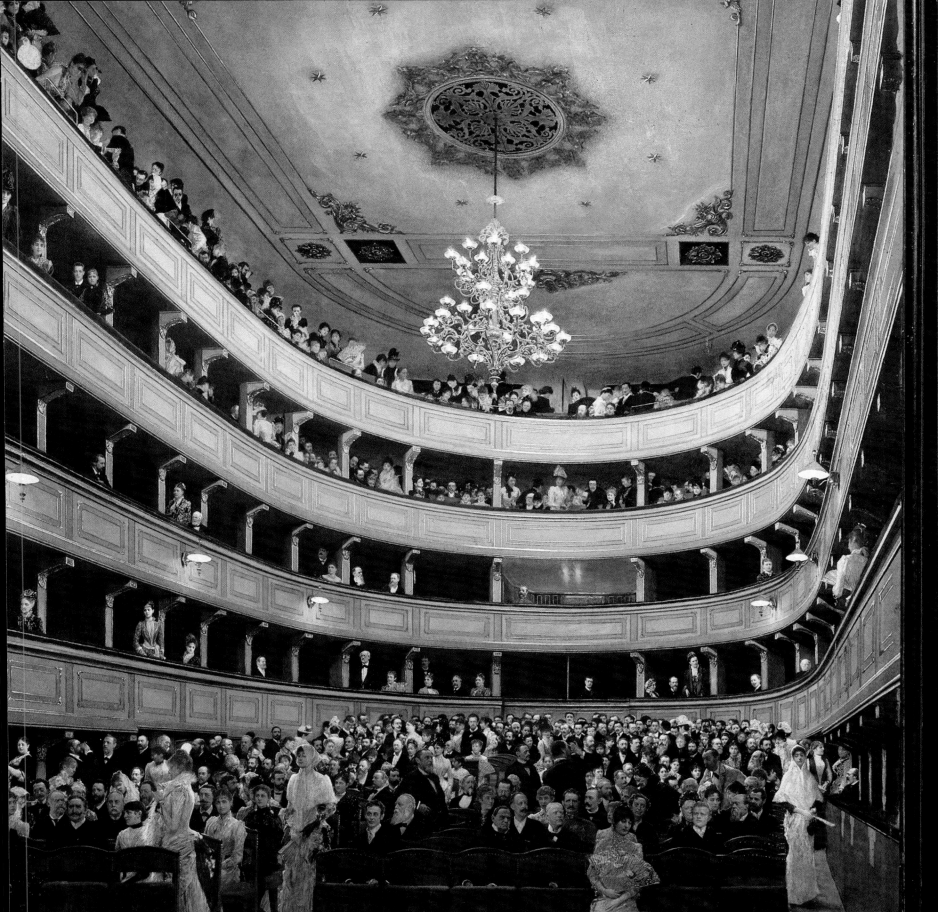

Both the climate of the times in Vienna and their own principles precipitated the secession of these young artists from Vienna's Society of Visual Artists in 1897. They were influenced by the new art—Art Nouveau—which was all the rage in Paris, London, and other European centers and which contrasted dramatically with the narrow historical and realistic approach of mainstream Viennese artists. They objected to the commercialism that motivated the society's exhibitions at the Künstlerhaus; they thought artistic merit rather than marketability should determine what was shown. And they also resented the way conservative older members excluded up-and-coming artists from key offices in the society. Perhaps the final straw was the custom of hanging paintings so high at the exhibitions that nobody could really see them.

To propagate their ideas, the Secessionists elected Klimt president and decided to publish their own journal of avant-garde art. The monthly journal took the dramatic name *Ver Sacrum*—"Sacred Spring"—after an ancient Roman ritual for the consecration of youth in times of national danger. It featured art criticism, poems by such prominent writers as Rainer Maria Rilke, and illustrations by Klimt and others. The Secessionists also decided to build an exhibition hall. Designed by member Joseph Olbrich with help from Klimt, the hall was constructed in just six months on free land provided by the city. Inside, it contained a vast open space in which the artists pioneered the use of movable partitions; outside, it was a striking edifice of basic geometric forms crowned by a dome of gilded ironwork shaped like laurel leaves.

In the spring of 1898, even before their own building was completed, the Secessionists staged their first public show in borrowed space on the premises of the Horticultural Society on the prestigious Ringstrasse. The exhibit featured work by foreign artists as well as members. For all their revolutionary pronouncements, the Secessionists

In the poster at left, designed by Klimt for the 1898 Secessionist exhibition, the goddess Athena looks on as the mythological hero Theseus, representing the avant-garde artists of the Secession, slays the Minotaur, the artistic establishment. Klimt also contributed to the design of the Secession building *(below)*, an exhibition hall that, thanks to its golden dome, soon acquired the unexalted nickname "the golden cabbage."

were delighted when the emperor visited the show. Working-class people visited, too, during special Sunday-morning guided tours. Between March 26 and June 15, some 57,000 people visited the exhibit and 218 paintings were sold. Klimt made certain the show was talked about in Vienna by designing a poster for it that offended the censors. The poster portrayed characters from Greek mythology: the young man, Theseus—symbolizing the forces of innovation—slaying the old monster, the Minotaur. The only problem was that Theseus was nude, and the censors forced Klimt to hide his nakedness by adding a couple of covering trees.

Klimt's burgeoning creative exuberance bred an even greater scandal. For a government commission received when he was still an establishment artist, he prepared three paintings for the ceiling of the Great Hall of the new University of Vienna. Each represented one of three faculties of the university: Philosophy, Medicine, and Jurisprudence. Rather than glorifying these disciplines, however, Klimt portrayed—again utilizing much nudity—the kind of darker, instinctual forces being probed by another Viennese maverick, the psychoanalyst Sigmund Freud. Beginning in 1900 with the unveiling of Klimt's *Philosophy* at a Secession exhibit, the paintings caused a public furor. They were debated in parliament and protested by academics. "We are not opposed to nakedness or to the freedom of art," declared one of the university's professors, "but we are opposed to ugly art." This assertion led a Klimt partisan to lecture on the topic of "What Is Ugly?"

Klimt himself, though he had devoted precious years to the project, tried to preserve his equanimity. "I don't want to spend months defending it to the masses," he announced in one of Vienna's morning newspapers. "I'm not bothered about how many it pleases, but whom it pleases." In response to the criticism, Klimt created a painting in which the broad feminine backside of the main figure confronted the viewer. He entitled it *Goldfish*—but only after friends dissuaded him from calling it *To My Critics*. The commissioned paintings for the new university were

never installed on the ceiling of its Great Hall. With the help of a wealthy patron, Klimt bought them back from the Ministry of Culture by reimbursing the considerable sum advanced him. Klimt was now liberated from the restrictions inherent in government commissions and other official patronage.

During the spring of 1902, Klimt generated new debate with his contribution to the Secession's celebrated Beethoven exhibition. An homage to Ludwig van Beethoven, the exhibition featured a monumental 10-foot-tall sculpture of the composer by the Leipzig sculptor Max Klinger. Austria's own Gustav Mahler agreed to conduct a trumpet fanfare with a theme from Beethoven's Ninth Symphony to open the exhibition. And members of the Secession contributed numerous works in honor of their city's great German-born composer.

As his offering, Klimt painted a sequence of three frescoes inspired by the Ninth Symphony. This frieze, which covered the upper sections of three walls of a room, was eight feet tall and more than 100 feet long. An allegory illustrating the power of art over adversity, the Beethoven frieze again drew on motifs from Greek mythology and made use of intense color and a lot of nudity. Critical reception was sharply divided. Some thought it a major achievement. On the other hand, one Vienna newspaper condemned it as "painted pornography." A Berlin newspaper wrote of the "disordered array of nastiness." And a critic in Frankfurt concluded that "Klimt has once more produced a work of art that calls for a doctor and two keepers."

How Klimt reacted to such attacks was illustrated before the show opened. One day he was

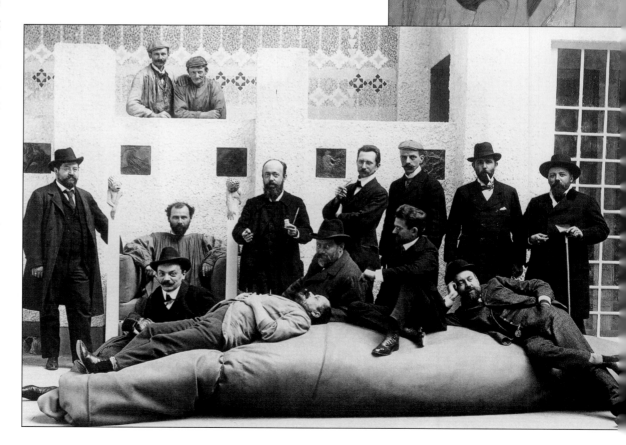

standing on the scaffolding applying the finishing touches to the Beethoven frieze when a visitor entered the room. He was Count Karl Lanckoronski, the influential owner of a collection of old master paintings. The aristocratic visitor looked up at Klimt's frescoes and uttered a single word in his shrill voice: "Hideous!" Klimt turned around, stepped to the edge of the scaffolding, and calmly gazed down as Lanckoronski made a hurried exit. The painter smiled briefly at some of his colleagues and then went back to work.

One distinguished guest at the exhibition was more impressed by Klimt's frieze. The great French sculptor Auguste Rodin walked past Klinger's Beethoven sculpture without making any comment but was effusive about Klimt's frescoes. Later, Rodin chatted with Klimt and several other Secessionists on the terrace of a coffeehouse in the Prater while someone played Schubert on the piano. The Frenchman praised the exhibition, the music, the two beautiful women seated nearby—and what he called "all this gay, childlike happiness." Turning to Klimt, he asked, "What is the reason for it all?" Klimt replied with a single word: "Austria!"

After the Beethoven exhibition Klimt's focus began to change. Abandoning the big, bold, and controversial public allegorical projects, he withdrew into the private sphere. His depiction of the audience at the old Burgtheater more than a decade earlier had demonstrated his extraordinary flair for painting women. Now he began to accept commissions from wealthy industrialists to paint their wives. These portraits, along with his private paintings showing sensuous women in erotic poses, were compelling and strikingly innovative. He used vibrant, lurid color and anticipated the future uses of collage with his lavish application of gold leaf.

As in his ceiling paintings and frescoes, Klimt's symbols and decorative motifs were taken from ancient history. But his figures were drawn from life and carefully detailed, and sometimes he made 100 or more preliminary drawings for a single portrait. Piles of sketches littered his studio, scattered by the eight or nine cats he kept there. When a

visitor expressed concern that the cats would ruin the drawings, the painter reassured him, "No matter if they crumple or tear a few of the leaves—they piss on the others and that's the best fixative!"

The sketches, which functioned as notes in preparation for Klimt's paintings, were often based on the female models who frequented his studio. "There was always a model waiting in the next room, sometimes several," a contemporary noted, "so that he could pick and choose what he wanted for the endless variations on the theme of 'woman'. . . . He might just draw a face, a hand, a torso, or one slight movement perceived from nature's inexhaustible source."

Klimt's studio, which was some distance away from the apartment where he lived with his mother and sisters, apparently served more than one purpose. The female models he used in his paintings often confided private problems to the painter, who had a reputation for being personally and financially generous. Klimt, it seems, had sexual relationships with many of these young women, and after his death no fewer than 14 of them levied claims against his estate on behalf of children they alleged he had fathered.

Two children he did support during his life were those he had with Mizzi Zimmerman, a beautiful model of modest origins with whom Klimt carried on a long affair. On the two occasions when Mizzi was pregnant by him, he incorporated the theme into a number of his paintings. He also took responsibility for the baby boy born to another of his models, Maria Ucicka, a laundry-maid from Prague. In addition, Klimt had a liaison with at least one of the high-society women he had painted—Adele Bloch-Bauer, the young wife of an elderly banker and sugar manufacturer.

His portrait of Adele Bloch-Bauer and several other pictures of women were among 16 Klimt paintings featured in the largest exhibition ever held in Vienna. Known as the *Kunstschau*, or "Art Show," it was staged in 1908 by a splinter group of Secessionists who, under Klimt, had seceded from the rest of the Secessionists after failing to resolve prolonged artistic differences of opinion. The 54-room pavilion for the show was erected as a temporary structure on the site intended for a new concert house. Klimt had his own room, dubbed by one critic the "Gustav Klimt cathedral of modern art." The critic Peter Altenberg wrote of Klimt's work there with the highest praise: "These portraits of women embody the most tender romanticism of nature. They are as poets rapturously dream of them—gentle, delicate beings, who never fade, yet never find salvation!" But the most popular painting in the show, *The Kiss,* portrayed a man and a woman. At least one art historian would later suggest that the male figure was Klimt and the other his friend Emilie Flöge.

Whatever the truth of that assertion, Emilie Flöge was the most important woman in Klimt's life. A couturier whose clients came from the same wealthy class of women whom he painted, she was a tall, slender, attractive woman—and an independent one. She was an excellent businesswoman who loved to drive about in her Austrian-built Steyr automobile, which was painted yellow and black.

Emilie was the younger sister of Helene, his brother's widow. Klimt first met and painted Emilie in 1891, the year before his brother Ernst's death. She was 17, a dozen years younger than the painter, and they became close lifelong friends. In 1904, Emilie—together with Helene and their eldest sister, Pauline—launched a fashion house. It was situated on the Mariahilferstrasse, one of the main shopping streets just off the Ringstrasse. With Klimt's encouragement, fellow Secessionists designed and furnished the main salon daringly in the modern manner instead of in the Victorian style favored by most fashion establishments. The room was decorated in stark black and

In Gustav Klimt's most famous painting, *The Kiss,* two kneeling lovers, lost in their own world, embrace on a flower-covered precipice. The painting's lavish use of gold decoration recalls the Byzantine mosaics that Klimt saw on a trip he made to the ancient Italian city of Ravenna in 1903.

white and had a gray felt floor in place of the usual wood parquet, so patrons could walk about barefoot while trying on dresses without getting a chill. The changing rooms were equipped with the up-to-date feature of adjustable mirrors to allow clients to see themselves from all angles.

Only the wealthy could afford to shop at Sisters Flöge. Every year Emilie traveled to the fashion shows of London and Paris and brought home designs and materials from such notable houses as that of Coco Chanel. Sisters Flöge employed as many as 80 seamstresses. Ironically, among the garments they turned out was so-called reform clothing. The very antithesis of the high fashion that made Sisters Flöge one of Vienna's leading salons, reform garments were loose-fitting smocks without waists. They were favored by feminist reformers in the United States, Britain, and Germany who were rebelling against the constraints of tight-fitting corsets. Flöge and Klimt collaborated on the design of these smocks that came to symbolize independence from bourgeois convention. Klimt himself regularly wore one, as did Emilie when relaxing and away from the world of fashion.

Klimt and Emilie spent as much time together as possible. Like everyone else in Vienna who could afford it, every summer they fled the heat of the city for villas, resorts, and hotels in the country. During the summer months, Klimt and Emilie vacationed together at Lake Atter in Upper Austria. And when they were apart, Klimt wrote her constantly, sometimes three or four times a day, but almost always sent postcards rather than letters because of his self-confessed "pathological inhibition about writing." Though he usually referred to her affectionately by the pet name of Midi, the postcards told of the weather or other mundane matters and contained no words of love.

In fact, even their closest friends never knew for certain the nature of the Klimt-Flöge relationship. Some thought it only platonic; others insisted it was romantic and, perhaps, sexual. They never married, perhaps because Emilie was just as reluctant to

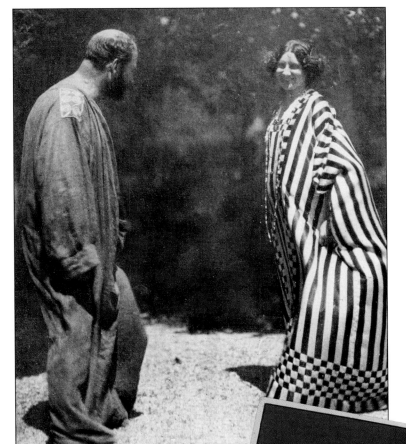

relinquish her freedom as Klimt was, but in many ways they were as close as man and wife. Later, in 1918, when Klimt suffered a stroke that would claim his life, the first words he stammered were, "Send for Emilie."

One afternoon soon after the turn of the century, a university student named Stefan Zweig nervously entered the offices of Vienna's leading daily newspaper, the *Neue Freie Presse*. Zweig was one of those young Viennese who, like the Secessionists, hungered after the new—"for something," he later explained, "that belonged to us alone, and not to the world of our fathers." In his hand was an article on poetry that he hoped the newspaper would publish. In early 1901, Zweig had only recently turned 19, and though he had already published several short stories, essays, and poems in literary journals, he had never dared to offer anything to such a powerful and widely read publication.

The paper especially prided itself on a feature known as the feuilleton. A breezy essay typically on a literary topic, the feuilleton appeared on the bottom half of the front page, demarcated from the assortment of political and other news of the day by a heavy printer's rule. The idea of the feuilleton was to match the verve and sparkle of coffeehouse conversation, and, like that of the operetta, its appeal cut across the divisions of social class. Literary lights of Europe such as Ibsen, Strindberg, and Shaw contributed feuilletons to the paper. Young Zweig was hoping against hope that his article could appear in this section. Summoning his courage and clutching his manuscript, Zweig climbed the iron circular staircase that led to the office of the feuilleton editor, Theodor Herzl, whom Zweig described as "the first man of world importance whom I had encountered in my life."

Above, Klimt and Emilie Flöge cavort in the garden of Klimt's studio wearing their "reform" robes; Emilie wears a more elegant version in Klimt's portrait of her at left. Flöge apparently disliked the painting, and Klimt sold it to a Vienna museum. Either Klimt's or Emilie's mother objected to the sale and demanded a replacement, as the painter informed Flöge in the postcard at right: "Mother is indignantly commissioning me to make a new PORTRAIT *as quickly as possible.*"

THE FATHER OF PSYCHOANALYSIS

For 12 years the administrators of the University of Vienna passed over for promotion a nontenured assistant professor by the name of Sigmund Freud. Though anti-Semitism played a part in their decision, the administrators had another reason: He was too interested in sex.

The son of loving parents, Freud was born into a large Jewish family from Moravia with strong religious roots. Recognizing their son's brilliance, his parents provided him with a room in which he could study alone. Young Sigmund lived up to their expectations. In 1881 he received his medical degree from the University of Vienna and four years later was appointed assistant professor of neuropathology.

By the time the university saw fit to promote him in the late 1890s, Freud had become fascinated by the mysteries of the mind. The cornerstone of his theory, which would shape the exploration of the mind in the 20th century, was that all human beings possess an "unconscious," a realm in which repressed feelings, ideas, and drives are hidden from the conscious mind. As he argued in *The Interpretation of Dreams,* clues to the unconscious workings of the mind came from all forms of human expression—from the most innocuous slips of the tongue to the most fantastic of dreams. To uncover the unconscious, he developed the techniques of psychoanalysis, a "talking cure" in which he encouraged patients to lie on his couch and "free-associate," uttering whatever thoughts came to mind, no matter how absurd or outrageous.

Freud formulated some startling theories, among them the Oedipus complex, which asserted that a young boy forms an erotic attachment to his mother and a hatred of his father. Such ideas shocked Viennese society. But by the time of his death in 1939, Freud's theories had become as influential as they were controversial.

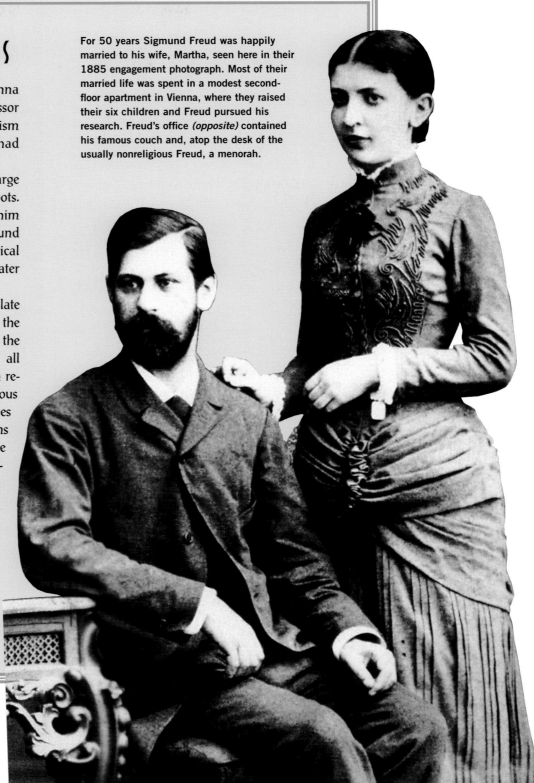

For 50 years Sigmund Freud was happily married to his wife, Martha, seen here in their 1885 engagement photograph. Most of their married life was spent in a modest second-floor apartment in Vienna, where they raised their six children and Freud pursued his research. Freud's office *(opposite)* contained his famous couch and, atop the desk of the usually nonreligious Freud, a menorah.

As the newspaper's Paris correspondent, Herzl had covered the court-martial of Alfred Dreyfus, a French army officer convicted of treason simply, Herzl and others concluded, because he was a Jew. Appalled at such anti-Semitism, Herzl decided that Jewish assimilation in Europe would never be possible and published a widely circulated pamphlet, *The Jewish State,* advocating the establishment of a Jewish homeland in Palestine. Known as Zionism, the idea of a Jewish national state had real appeal for poverty-stricken Jews in Poland and Russia; however, it held little interest for the prosperous Jews of Vienna, who were fervent supporters of assimilation. Herzl's own newspaper, the *Neue Freie Presse,* was published and edited by Jews yet never so much as mentioned the Zionist cause.

Reaching the top of the staircase, Stefan Zweig was directed to a narrow office where Herzl greeted him with an extended hand. "I think that I have heard or read your name somewhere," Herzl said. "Poetry, isn't it?" Zweig replied affirmatively and handed him the manuscript. To Zweig's astonishment, Herzl began reading it right then. He read it all the way through. Then he put the pages in an envelope and wrote on it with a blue pencil. Only then did he inform Zweig of what he had decided: "I am happy to tell you that your fine piece is accepted for the feuilleton of the *Neue Freie Presse.*"

Zweig would go on to become one of the world's best-known men of letters—a poet, dramatist, essayist, and biographer whose work was translated into many languages—but he later expressed guilt at not having joined Herzl's Zionist crusade. Devoted to the arts, Stefan Zweig had little time for politics—or for anything else. "One was not a real Viennese," he wrote in his autobiography, "without this love for culture, without this sense, aesthetic and critical at once, of the holiest exuberance of life."

His fascination with literature, theater, and the other arts had enabled him to endure Viennese secondary school, known as the *gymnasium.* In eight years at the Maximilian Gymnasium in

Vienna, he spent seemingly endless hours studying geometry, physics, and languages—five of them in all, including Latin and Greek—doled out by teachers who made learning dull and pointless. "For us school was compulsion, ennui, dreariness," he recalled. "We sat in pairs like galley slaves, on low wooden benches that twisted our spines, and we sat until our bones ached."

It was the high culture of Vienna that provided refuge—and inspiration—for Zweig and his gymnasium classmates. Frequently they would skip afternoon classes to wait in line for standing-room tickets to premieres at the Burgtheater. Sometimes they would visit the theater's barbershop, where they would pick up gossip about the actors while having their hair cut. And they would smuggle books by Nietzsche and Strindberg into school and hide them under their desks, conceal poems by Rilke between the covers of their Latin grammars, and copy by hand favorite poems into their math notebooks.

Young and old gather in Vienna's Wurstel-prater *(below)*, an amusement park in the Prater that counted among its attractions puppet shows, merry-go-rounds, great boat-shaped swings, a water slide, and coin-operated horoscope machines. For a small charge, the "International Matchmaking Bureau" *(left)* would predict the appearance, age, and occupation of a future spouse.

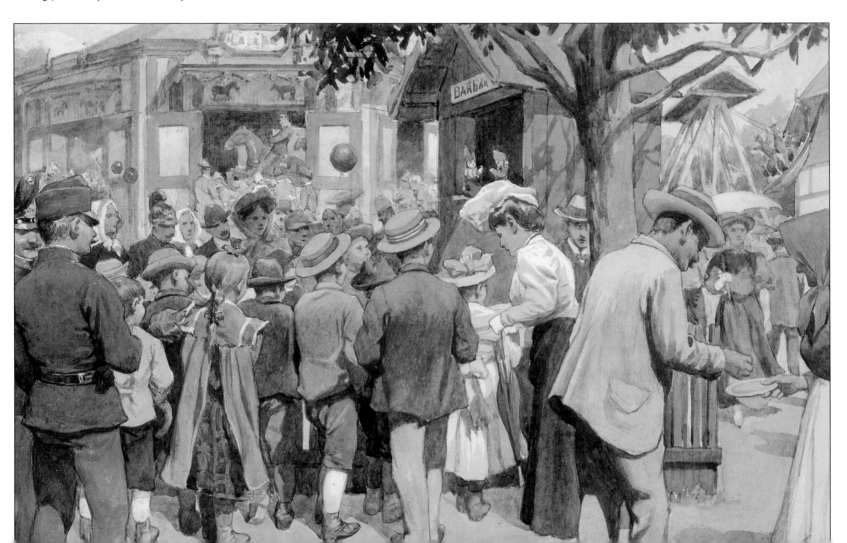

With the money his parents gave him for dancing lessons, Zweig bought books. And to supplement his reading material, he frequented the coffeehouses where newspapers and magazines from Germany, France, England, Italy, and America could be found. These were heady days for Zweig and his young companions: "We had a passion to be the first to discover the latest, the newest, the most extravagant, the unusual."

At age 16, Zweig had his first poems printed in a Berlin magazine. He was pleased by the achievement but still felt light-years behind his idol, Hugo von Hofmannsthal. Seven years older than Zweig, Hofmannsthal was Vienna's true *Wunderkind,* the "one figure that fascinated, enticed, roused, and captivated us." The "miracle of Hofmannsthal," as Zweig put it, "proved tangibly that a poet was possible in our time, in our city, in our midst. For after all, his father, a banker, came from the same Jewish middle class as the rest of us." And the poetic prodigy "had gone to a similarly sterile *Gymnasium.*"

On entering the University of Vienna in 1899, Zweig felt liberated. As a young man of the upper middle class, he could now expect to enjoy certain sexual freedoms. But before he could indulge these freedoms, a youth might, at the insistence of his father, meet with the family physician for instruction in sexual matters. Zweig was probably around 15 or 16 when he received such a talk from his own doctor, who, he recalled, "polished his glasses unnecessarily before he began his lecture on the dangers of venereal diseases."

Some fathers took a more direct—and less theoretical—approach: According to Zweig, "they engaged a pretty servant girl for the house whose task it was to give the young lad some practical experience." When the youth was a little older, he might make his own arrangements with a so-called *süsses Mädel*—a shopgirl, secretary, or laundry-maid who would grant sexual favors with no strings attached. And if such "sweet girls" were not available, there were always the prostitutes, who were allowed by the police to carry on their trade more or less unhindered in certain parts of the city.

More important for young Zweig, the university gave him unfettered freedom to pursue his "endeavors in art." He noted with interest that many among the 6,000 or so students at the university chose to sacrifice their newfound freedom by accepting the constraints imposed by fraternal associations. The members of such groups, here and at other German-speaking universities, clung to medieval traditions: They sang drinking songs, learned to empty a heavy stein of beer in one gulp, and actively sought duels at the drop of an insult. Facial scars and disfigured noses resulting from such encounters were borne with pride, along with the colored ribbons and caps signifying membership in their particular fraternity. "Whenever we met one of these beribboned hordes," Zweig wrote, "we prudently turned the corner; for to us, who cherished the freedom of the individual as the most sacred of all things, this passion for the aggressive . . . too plainly manifested the worst and the most dangerous elements of the German spirit. . . . The mere sight of these rude militarized cliques, these slashed, bold, provoking faces, spoiled my visits to the university rooms."

In fact, Zweig rarely visited the university rooms. He had selected philosophy as his major course of study because it would inconvenience him the least: "The actual performance required in this domain was the smallest possible, and attendance at lectures and seminars . . . was the easiest to evade." Instead of going to lectures, he read voraciously, wrote prolifically, and cultivated copious literary contacts and friendships in the coffeehouses of Vienna.

Though his parents were extremely wealthy and he had his own legacy from his grandparents, Zweig lived in a modest room. A late-morning visitor there would find him unshaven and half-dressed, the bed unmade as if he had just risen. Unwashed coffee cups, piles of books and manuscripts, and the butts and

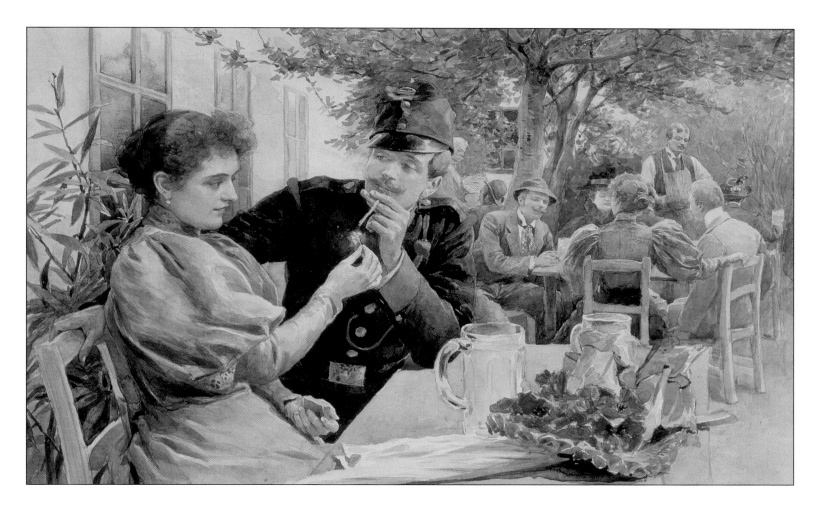

A soldier enjoys a cigarette and a drink at an outdoor wine parlor in the company of his *süsses Mädel,* or "sweet girl." Such young single women, who were typically from the lower middle class, enjoyed short-lived relationships with bourgeois men they had little hope of marrying. Life for these young women was often hard and dreary, and they sought diversion from their 12-hour workdays in the thrill of being entertained by a gentleman.

ashes of cigars and cigarettes littered the room. All this was a sign not of late-night dissipation but of the fact that he had already that day accomplished several hours of serious reading or writing. And he loved it: "I can recall but few moments as happy as those first years when I was a university student without a university."

Still, Zweig remained on close terms with his family. He ate lunch with them every day at their apartment right off the Ringstrasse. His parents, Moritz and Ida, were typical of Vienna's Jewish bourgeoisie. Since 1867, when the Jews of the empire had received full civic equality, opportunities had opened up for greater participation in economic and cultural life. Those Jews who grew wealthy like Moritz Zweig, a textile industry magnate, gradually broke away from strict religious observance and immersed themselves in Vienna's mainstream. Stefan felt that his parents and grandparents had largely lost their specifically Jewish character. "They were," he wrote, "passionate followers of the religion of the time, 'progress.'"

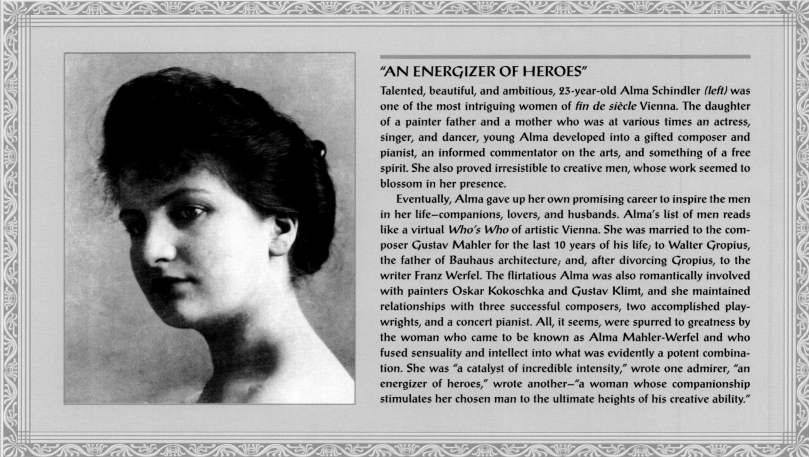

"AN ENERGIZER OF HEROES"

Talented, beautiful, and ambitious, 23-year-old Alma Schindler *(left)* was one of the most intriguing women of *fin de siècle* Vienna. The daughter of a painter father and a mother who was at various times an actress, singer, and dancer, young Alma developed into a gifted composer and pianist, an informed commentator on the arts, and something of a free spirit. She also proved irresistible to creative men, whose work seemed to blossom in her presence.

Eventually, Alma gave up her own promising career to inspire the men in her life—companions, lovers, and husbands. Alma's list of men reads like a virtual *Who's Who* of artistic Vienna. She was married to the composer Gustav Mahler for the last 10 years of his life; to Walter Gropius, the father of Bauhaus architecture; and, after divorcing Gropius, to the writer Franz Werfel. The flirtatious Alma was also romantically involved with painters Oskar Kokoschka and Gustav Klimt, and she maintained relationships with three successful composers, two accomplished playwrights, and a concert pianist. All, it seems, were spurred to greatness by the woman who came to be known as Alma Mahler-Werfel and who fused sensuality and intellect into what was evidently a potent combination. She was "a catalyst of incredible intensity," wrote one admirer, "an energizer of heroes," wrote another—"a woman whose companionship stimulates her chosen man to the ultimate heights of his creative ability."

All the same, the Zweigs were never allowed to fully forget the fact that they were Jews. For one thing, the relatively mild anti-Jewish prejudice of earlier times, which focused on opposition to the Jewish religion, was now giving way to a more virulent anti-Semitism supposedly based on racial characteristics. To divert attention from his Jewishness and his wealth, Moritz Zweig was solid, conservative, and discreet—"having it," as Stefan put it, "and not showing it." He never borrowed money, and his accounts were always in the black at the Kreditanstalt—the Rothschild bank. In contrast to his wife, who loved jewelry and expensive gowns, he dressed simply in a sober black coat and striped trousers, traveled second class on trains, and rented a horse-drawn carriage occasionally but did not own one. Like his emperor, he smoked cheap cheroots instead of expensive cigars. He avoided dining at the Hotel Sacher, the meeting place of Vienna's elite, fearing that the act of sitting near an aristocrat might cause the latter some offense.

Stefan was the beneficiary of the Jewish bourgeoisie's emphasis on high culture. Like other Jews of their class, his family attended the theater and concerts, bought books, and went to art galleries. Because their elder son, Alfred, had gone into the family business, Stefan could fulfill what he described as his parents' "desire to rise above mere money." At first, they had looked upon his writing indulgently, regarding it as "harmless play" and "safer than cards or dalliance." But they were impressed by his rapid-fire accomplishments before he had reached

the age of 20—publication of a book of verses during his first year at the university and the appearance of his feuilleton in the *Neue Freie Presse* during his second year. In fact, feuilletons penned by their son began to appear with some regularity on the front page of that prestigious newspaper, and at the Burgtheater members of the audience now pointed him out. As Stefan himself put it, "I was soon in danger of becoming a local celebrity."

In light of their son's success, the Zweigs readily agreed to his proposal that he spend a semester of his third year at the University of Berlin. He had no intention of actually studying there, of course. He wanted to escape from the security of what he called the "good" society that enveloped him in Vienna and to experience a "bad" society. In Berlin, which he found less tradition-bound than the Austrian capital, he hobnobbed with bohemians of all types before returning to Vienna to cram four years of studies into a few months. He completed his dissertation and took his final examination—the only one required—with an understanding professor who knew his literary work. Zweig passed with honors and proudly announced to friends and family his promotion to doctor of philosophy.

By now Zweig's mind was preoccupied with the fate of Europe, where hints and rumors of war increased daily. "Again and again a spark would appear," he recalled. "Each one could have ignited the piled-up explosives." His sense of foreboding increased one day in the spring of 1913 after a chance encounter. On a street in Vienna he ran into Bertha von Suttner, the 70-year-old writer and pacifist who had influenced Alfred Nobel's decision to establish the Peace Prize and had been its recipient in 1905. Usually calm and deliberate, she approached Zweig in great agitation. "The people have no idea what is going on!" she exclaimed. "The war is already upon us, and once again they have hidden and kept it from us. Why don't you do something, you young people? . . . Unite! Don't always let us few old women to whom no one listens do everything."

An incident the following spring, during a visit to France, reminded Zweig of the "prophetic clarity" of this "old lady, who was not taken seriously in Vienna." Sitting in a movie theater in the city of Tours, surrounded by workers, soldiers, and other ordinary folk, Zweig experienced firsthand "how deeply the poison of the propaganda of hate" was seeping through Europe. The newsreel that preceded the Charlie Chaplin feature showed

The writer Stefan Zweig was a student at the University of Vienna when this photograph was taken around the turn of the century. "I pity those who were not young during those last years of confidence in Europe," Zweig wrote in his autobiography, *The World of Yesterday.* Yet Zweig would commit suicide in Brazil in 1942, unable to conquer his despair over the outbreak of yet another world war.

THE END OF AN ARCHDUKE

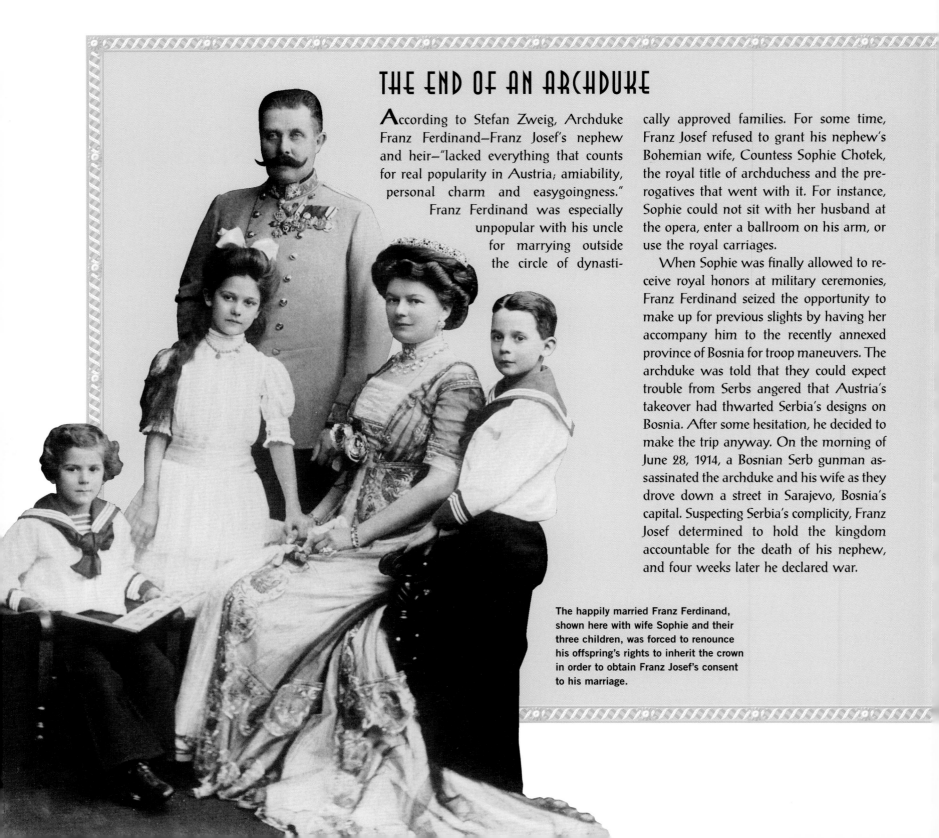

According to Stefan Zweig, Archduke Franz Ferdinand—Franz Josef's nephew and heir—"lacked everything that counts for real popularity in Austria; amiability, personal charm and easygoingness." Franz Ferdinand was especially unpopular with his uncle for marrying outside the circle of dynastically approved families. For some time, Franz Josef refused to grant his nephew's Bohemian wife, Countess Sophie Chotek, the royal title of archduchess and the prerogatives that went with it. For instance, Sophie could not sit with her husband at the opera, enter a ballroom on his arm, or use the royal carriages.

When Sophie was finally allowed to receive royal honors at military ceremonies, Franz Ferdinand seized the opportunity to make up for previous slights by having her accompany him to the recently annexed province of Bosnia for troop maneuvers. The archduke was told that they could expect trouble from Serbs angered that Austria's takeover had thwarted Serbia's designs on Bosnia. After some hesitation, he decided to make the trip anyway. On the morning of June 28, 1914, a Bosnian Serb gunman assassinated the archduke and his wife as they drove down a street in Sarajevo, Bosnia's capital. Suspecting Serbia's complicity, Franz Josef determined to hold the kingdom accountable for the death of his nephew, and four weeks later he declared war.

The happily married Franz Ferdinand, shown here with wife Sophie and their three children, was forced to renounce his offspring's rights to inherit the crown in order to obtain Franz Josef's consent to his marriage.

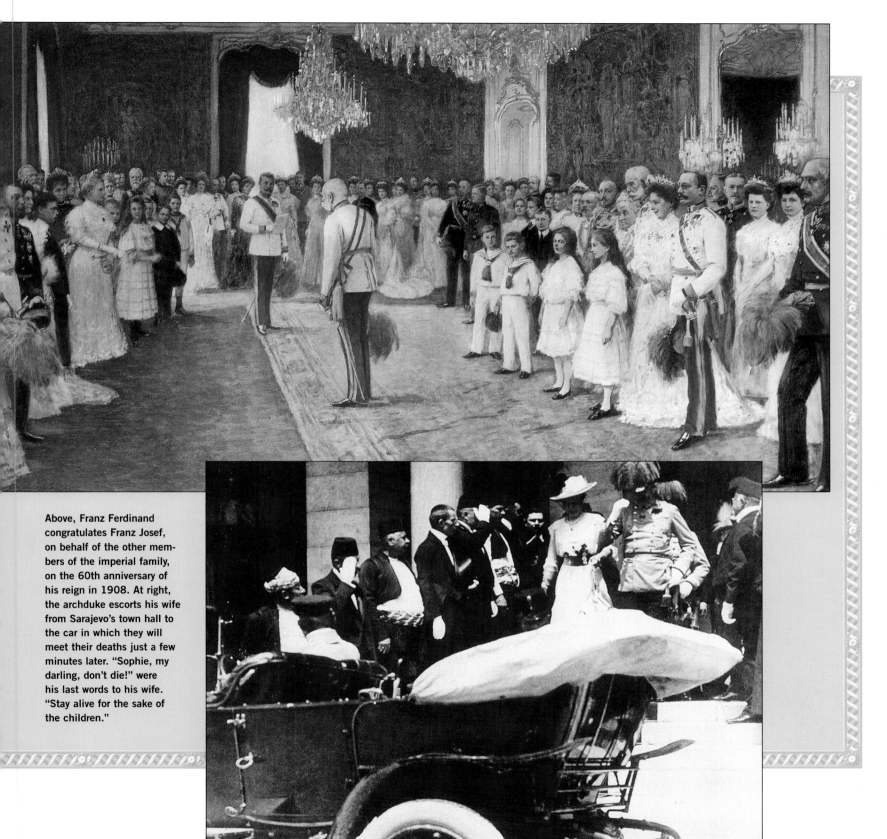

Above, Franz Ferdinand congratulates Franz Josef, on behalf of the other members of the imperial family, on the 60th anniversary of his reign in 1908. At right, the archduke escorts his wife from Sarajevo's town hall to the car in which they will meet their deaths just a few minutes later. "Sophie, my darling, don't die!" were his last words to his wife. "Stay alive for the sake of the children."

Emperor Franz Josef welcoming Kaiser Wilhelm of Germany at a Vienna train station. The sight of the doddering 83-year-old emperor with his white whiskers elicited good-natured laughs from the French audience. But when the German kaiser stepped from the train—with his uniform immaculate and his mustache curled upward at the ends—the mood of the audience changed immediately. "A spontaneous wild whistling and stamping of feet began in the dark hall," recalled Zweig. "Everybody yelled and whistled, men, women and children, as if they had been personally insulted." Zweig was stunned at the intensity of this outburst of hostility toward the German. "I was frightened to the depths of my heart," he admitted. "I shuddered at the thought that this hatred had eaten its way deep into the provinces, deep into the hearts of the simple, naïve people."

Not long afterward, on June 29, 1914, Zweig was back at home in Austria enjoying a sunny day in the resort town of Baden near Vienna. He was in his 33rd year, and he said he felt as though "the world offered itself to me like a fruit, beautiful and rich with promise, in that radiant summer." He sat on a bench near a park, reading a book. In the distance he could hear a band playing. "In light summer dress, gay and carefree, the crowds moved about to the music in the park. . . . It was a day made to be happy."

Suddenly the music stopped. Zweig noticed that people were crowding around the bandstand, where an announcement had just been posted. He walked over to investigate. It turned out to be the text of a telegram announcing that Archduke Franz Ferdinand, heir apparent to the throne of the Austro-Hungarian Empire, and his wife had been assassinated in Sarajevo. The shots that rang out in that small Balkan city, said Zweig, "shattered the world of security and creative reason in which we had been educated, grown up and been at home—shattered it like a hollow vessel of clay." A month after the assassinations, Europe would be at war.

Under the twin spires of the Votive Church, an Austrian regiment marches out of Vienna in the winter of 1914, to the cheers of the populace and the music of a military band. After Franz Ferdinand's assassination, both Austria and Serbia and their respective allies had mobilized for war. United under a common cause, Viennese of all types—including many famous painters, musicians, and writers—flocked to the imperial colors, convinced that the war that began in July 1914 would be brief. Instead, the grim conflict would drag on for four years and destroy the centuries-old Habsburg empire.

THE VIENNA WORKSHOP

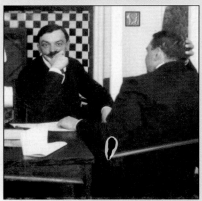

Josef Hoffmann *(top left)*, Fritz Wärndorfer *(top right)*, and Koloman Moser *(above, with Wärndorfer)* sought to make beautiful, useful objects for the modern world.

"We have lost touch with the culture of our forefathers," lamented architect Josef Hoffmann and graphic artist Koloman Moser. "The hand of the craftsman has been replaced by the machine, the craftsman himself by the businessman. To swim against the tide would be madness." But bucking the current was exactly what Hoffmann and Moser set out to do. Critical of "shoddy mass production and the unthinking imitation of old styles," they conceived of a cooperative workplace where modern designers and old-world craftsmen could "create good, simple articles of household use." In 1903, with financial help from banker and friend Fritz Wärndorfer, the Wiener Werkstätte, or Vienna Workshop, was born.

Inspired by the English Arts and Crafts Movement of William Morris, the Vienna Workshop founders wanted to meld beauty and functionality. "Utility is our prime consideration," Hoffmann wrote. "Our strength must lie in good proportions and use of materials."

Although the Workshop aimed to produce items affordable to all, their scorn for the assembly line made their products beyond the means of all but the wealthiest clients. Nevertheless, Hoffmann and Moser succeeded in their goal of awakening interest in elegant simplicity, and they changed the face of modern everyday aesthetics.

Concerned about working conditions and eager to put their designs to use, Hoffmann and Moser created well-ventilated, well-lit workspaces, such as the bookbindery at right, for their craftsmen and designers. The overhead lights, worktables, stools, and even the wastebaskets were Wiener Werkstätte originals. The various areas were color coordinated, down to the order forms and accounting ledgers for each: The metal workshop, for example, was red, the bookbindery gray, and the carpenter shop blue.

Josef Hoffmann designed this monogrammed, geometric silverware for Fritz Wärndorfer and his wife, Lilly.

The punched metal, checkerboard pattern of the pedestals of this two-tiered flower vase was a favorite design motif of the Vienna Workshop.

ART IN EVERYDAY LIFE

"It cannot possibly be sufficient to buy pictures, even the most beautiful," declared Josef Hoffmann about the place of art in people's lives. Instead, he claimed, artful design should permeate "our cities, our houses, our rooms, our cupboards, our utensils, our jewelry" and even "our speech and sentiments."

The Workshop's ambitious goals extended to the dining table, one of many opportunities for artistic involvement in daily life. According to a catalog for a Workshop tableware exhibit in 1906, table settings were "too important a matter to be left to serving-maid or butler." Such high-handed ideas led one critic to remark, "In order to carve meat in the new style it is necessary to have ruler and compasses; the dumplings are turned on the wheel and the only pure dough-nuts are the poppy-seed ones in the new improved style of Kolo Moser."

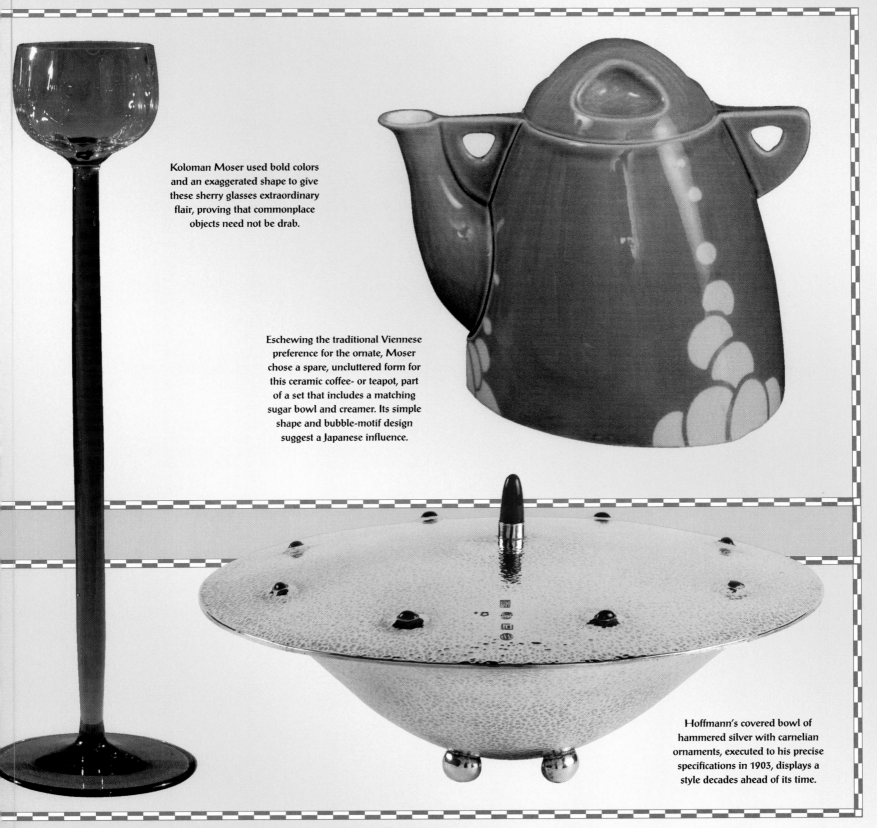

Koloman Moser used bold colors and an exaggerated shape to give these sherry glasses extraordinary flair, proving that commonplace objects need not be drab.

Eschewing the traditional Viennese preference for the ornate, Moser chose a spare, uncluttered form for this ceramic coffee- or teapot, part of a set that includes a matching sugar bowl and creamer. Its simple shape and bubble-motif design suggest a Japanese influence.

Hoffmann's covered bowl of hammered silver with carnelian ornaments, executed to his precise specifications in 1903, displays a style decades ahead of its time.

151

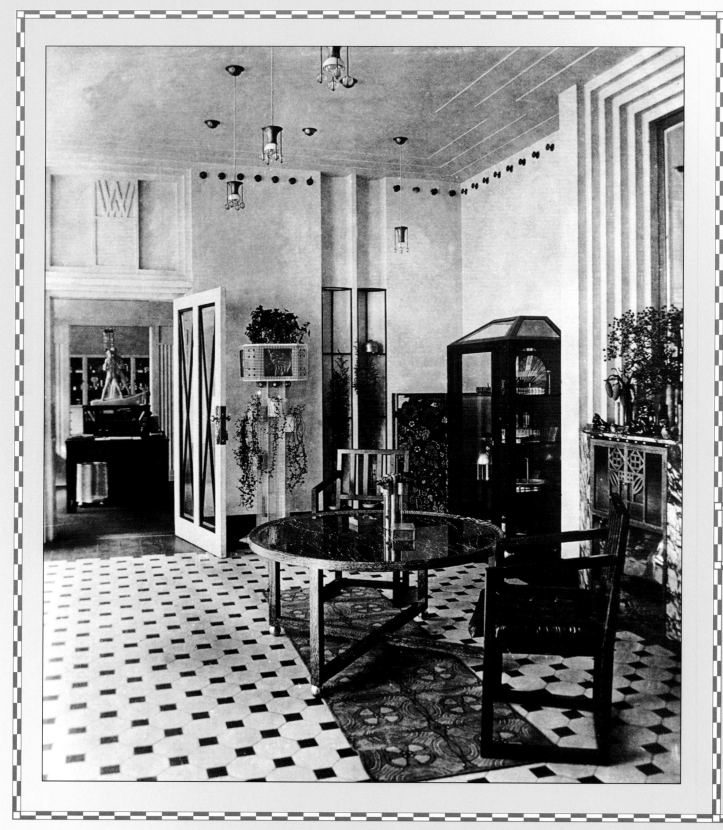

By 1904, the Work-
shop had expanded to
include a showroom
(left) where customers
could see its creations
in context. From the
tile floor to the plant
stands to the ceiling
lights to the trademark
above the doorway,
everything bore
the distinctive
Workshop stamp.

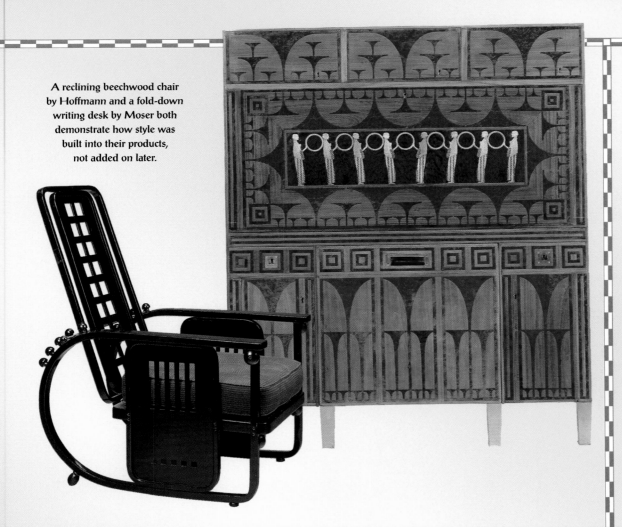

A reclining beechwood chair by Hoffmann and a fold-down writing desk by Moser both demonstrate how style was built into their products, not added on later.

After designing an armoire, Hoffmann decorated the key that opened it, using a rose motif that appeared frequently on Workshop furniture.

FORM AND FUNCTION

From such household objects, the Wiener Werkstätte moved on to designing on a larger scale. Additional money from Wärn-dorfer and commissions from wealthy friends kept the Workshop afloat as Moser and Hoffmann began to design starkly elegant, well-proportioned furniture and then entire buildings in Workshop style. No detail was too small to escape their attention; for one large commission—the design, construction, and furnishing of a luxurious sanatorium—they even designed the braid on the upholstery.

The enormousness of these projects and their myriad details did not keep the designers from their mission of melding form and function. Mirrors created for the dining room of Fritz Wärndorfer's new villa were both beautiful and flattering to the user. When Gustav Klimt saw them, he remarked, "Well, and what is there left for us painters to do?"

Josef Hoffmann created this silver brooch, using a variety of geometric shapes for the design and semiprecious stones—lapis lazuli, malachite, coral, and moonstone—for color.

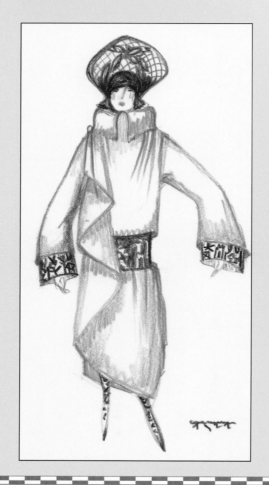

Two designs for ladies' coats by Eduard Josef Wimmer-Wisgrill for the Vienna Workshop feature bold color, eye-catching patterns, black-and-white trim, and dramatic hats. The outfit on the right includes a matching muff.

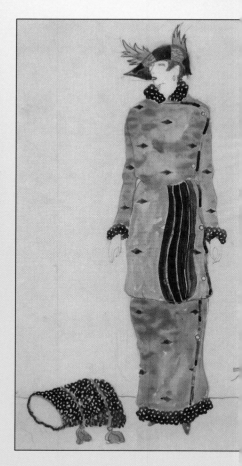

FREEDOM AND STYLE

After 1907, the Vienna Workshop took off in a new direction. A new master designer, Eduard Josef Wimmer-Wisgrill, joined the collaborative and began a fashion department. Conventional women's clothing in the early 1900s distorted the body with bustles, crinolines, and restrictive undergarments. As early feminists began to protest the laws that denied them the vote, they also revolted against clothes that denied them freedom of movement.

The first new feminist fashions were comfortable but rather ugly, and the Vienna Workshop saw an opportunity to create women's clothing that satisfied the desire for both freedom and style. Clothing designed by the Workshop had the added advantage of harmonizing with the furniture and utensils that would be used in a Workshop-designed home; wealthy female clients no longer clashed with their new surroundings.

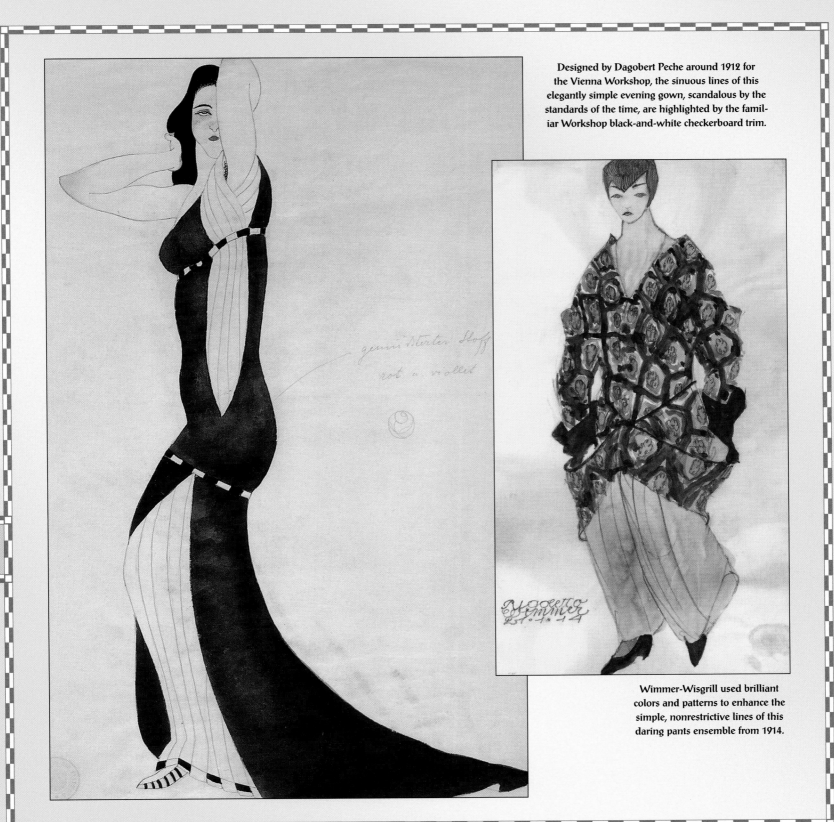

Designed by Dagobert Peche around 1912 for the Vienna Workshop, the sinuous lines of this elegantly simple evening gown, scandalous by the standards of the time, are highlighted by the familiar Workshop black-and-white checkerboard trim.

Wimmer-Wisgrill used brilliant colors and patterns to enhance the simple, nonrestrictive lines of this daring pants ensemble from 1914.

A postcard advertising the Wiener Werkstätte's Cabaret Fledermaus features the small bar and the exuberantly tiled wall behind it.

Bertold Lüffler designed the poster at left for the cabaret, and young avant-garde artist Oskar Kokoschka created the lithograph below for the program for the precinematic image-projection show of his allegorical tale, *The Speckled Egg,* which appeared first at the Fledermaus.

A TOTAL WORK OF ART

From the beginning, the founders of the Wiener Werkstätte had dreamed of creating a *Gesamtkunstwerk,* or total work of art, one in which all of the elements of a project are designed to exist in artistic harmony with one another. In 1907, they realized this dream by designing, building, decorating, advertising, and operating the *Kabarett Fledermaus,* a café-theater that was modeled on the cafés in the Montmartre area of Paris. It soon became a reg-ular gathering place for the brilliant circle of young artists and writers in Vienna.

The cabaret consisted of only two small rooms below ground level: a barroom and a theater. Fritz Wärndorfer took on the operation of the cabaret, and he chose the plays and poetry readings to be performed there. Most of the offerings reflected Wärndorfer's personal taste, such as avant-garde works by Peter Altenberg, Hermann Bahr, Egon Friedell, and Oskar Kokoschka.

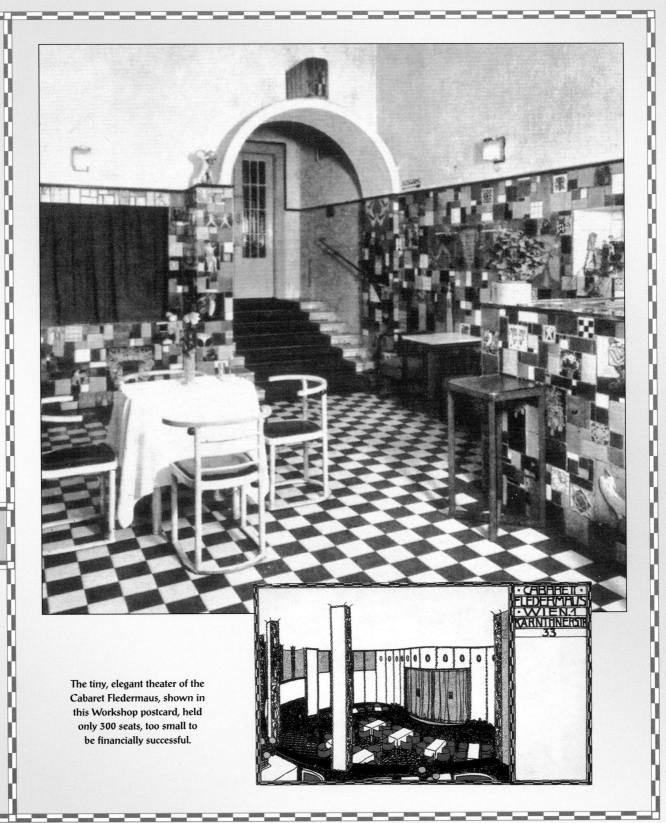

Entering the Fledermaus, patrons stepped down into the barroom *(right)* where Hoffmann vases with fresh flowers stood on each table. The walls were a riot of color and pattern, covered by ceramic tiles of various sizes, many decorated with caricatures, jokes, symbols, and lampoons—"the most entertaining picture-book imaginable," observed one patron.

CABARETT FLEDERMAUS WIEN.1 KÄRNTHNERSTR 33

The tiny, elegant theater of the Cabaret Fledermaus, shown in this Workshop postcard, held only 300 seats, too small to be financially successful.

GLOSSARY

Absolute monarchy: a state ruled by a king, queen, emperor, or empress, usually for life, in which the ruler has total, unlimited power and authority over the state and its citizens.

Anarchy: a social and political theory advocating no governmental authority; civic and political disorder due to the absence of governmental structure or authority.

Anti-Semitism: prejudice against, hostility toward, or discrimination against Jews as a religious, racial, or ethnic group.

Archduchess: the wife or widow of an archduke; a princess of the Austrian imperial family.

Archduke: a prince of the Austrian imperial family.

Art Nouveau: literally, "new art." A style of fine and applied art fashionable in much of Europe and America between about 1890 and 1910, characterized in part by the use of flowing, undulating lines and extensive use of floral and foliate motifs.

Austrian Empire: (1804-1867) the official name of the territory under Habsburg rule, beginning in 1804 when Francis II, the last Holy Roman Emperor, proclaimed himself also to be Francis I, hereditary emperor of Austria. The Austrian Empire existed until 1867, when it became the Austro-Hungarian Empire.

Austro-Hungarian Empire: (1867-1918) also known as the Dual Monarchy. The name given the Habsburg territories after March 1867, when the Austro-Hungarian Compromise of 1867 was ratified by the Hungarian Reichsrat, until the dissolution of the empire in 1918.

Baroque: a style of art and architecture that began in Italy in the latter half of the 16th century and spread through much of Europe, characterized in part by its grandeur, richness, drama, vitality, and complexity of design.

Bluestocking: a woman with strong scholarly, literary, or intellectual abilities and interests.

Blumenkorso: literally, "Procession of Flowers." A popular Viennese festival in the late 19th and early 20th centuries.

Bohemia: central European region, the historical capital of which was Prague; part of the Holy Roman Empire (950-1526), an independent kingdom (1198-1526), part of the Austrian Empire (1526-1918), and today the western and central portion of the Czech Republic.

Bohemians: the West Slavic, Roman Catholic natives of Bohemia. Also, a person with artistic or literary interests who lives an unconventional life and adopts manners or mores different from those of society at large.

Bourgeoisie: the middle class; a group of people socially lower than the nobility but higher than the laboring class.

Burgher: a member of the urban middle class, particularly one who is wealthy.

Caftan: in the Middle East, a man's loose, ankle-length garment, open at the front, with long, wide sleeves, usually worn with a sash.

Canon law: the body of ecclesiastical law in a Christian church governing the faith and practice of the church and its members.

Chamberlain: a steward or attendant in the household of a sovereign or noble; a high-ranking official in a royal court.

Chancellor: a high-ranking, powerful official serving an emperor, king, prince, or noble; duties included secretarial, legal, administrative, and political functions as well as keeping the political entity's great seal.

Cheroot: a cigar with open, untapered ends.

Christian Social Movement: a political movement in the mid-19th century that attempted to apply Christian principles to modern industrial life.

Christian Social Party: right-wing political party founded in the 1890s by Karl Lueger, mayor of Vienna, that advocated municipal socialism, promoted Catholicism, and was overtly anti-Semitic.

Congress of Vienna: the international assembly held in Vienna in 1814-1815 to reorganize Europe after the Napoleonic Wars; the congress redrew the map of Europe, created the German Confederation to replace the Holy Roman Empire, and formulated rules of diplomacy still followed today.

Cotillion: a lively French ballroom dance, popular in 18th- and 19th-century Europe, performed in groups of four couples, in which the head couple leads the others through a series of elaborate steps.

Counter Reformation: in Austria, an effort by the Habsburg Holy Roman emperors in the late 16th and early-to-mid 17th century to suppress Protestantism and promote Catholicism by whatever means necessary.

Couturier: one who designs, makes, and sells fashionable, custom-made clothing for women.

Croats: a Slavic, Roman Catholic people living in Croatia, who were historically among the most loyal subjects of the Habsburgs.

Czechs: a Slavic, Roman Catholic people who were one of the two main ethnic groups in Bohemia.

Diaspora: the geographic dispersion of an originally homogeneous people.

Dual Monarchy of Austria-Hungary: another name for the Austro-Hungarian Empire.

Duchess: the wife or widow of a duke; a woman who holds the title to a duchy in her own right.

Duchy: the territory of a duke or duchess.

Emperor: the supreme ruler of an empire.

Empress: the wife or widow of an emperor; the female ruler of an empire in her own right.

Fasching: in Austria and Bavaria, the name given the Roman Catholic pre-Lenten carnival festivities that included satirical plays and speeches, parades, feasts, masked balls, and general merrymaking.

Fesch: literally, "dashing." Audacious, energetic, and gallant; elegant in appearance and manner.

Feuilleton: a section of a European newspaper devoted to light fiction or literature, criticism and reviews, and other generally entertaining articles; an article appearing in such a section.

Fin de siècle: relating to the final years of the 19th century, generally referring to the literary and artistic climate of world-weariness and sophistication.

Five-gulden men: the name given less-prosperous property owners in Vienna, who paid five gulden in property taxes, a nominal sum that gave them the right to vote in municipal elections.

Frauenbund: the female contingent, or Women's League, of the Austrian Christian Social Party under Karl Lueger; also called Lueger's Amazons.

Free-association: the uncensored, spontaneous expression of thoughts, ideas, impressions, and emotions as they enter the conscious mind; a psychoanalytic technique using such expressions to reveal repressed thoughts and emotions.

Fresco: the art of painting on a fresh skim coat of plaster before it dries, using pigments dissolved in water so that the painting becomes part of the wall; a painting executed in this manner.

Fugue: a complex musical composition for voices or instruments, in which one, two, or occasionally more melodic themes are systematically repeated in accordance with specific rules.

German Confederation: (1815-1866) the loosely federated, Austrian-dominated German political entity created by the Congress of Vienna to replace the extinct Holy Roman Empire, consisting of 35 monarchies and four free cities, with most retaining their internal sovereignty. Destroyed in 1866 by the Seven Weeks' War (Austro-Prussian War); replaced by the North German Confederation (1867-1871) and then the German Empire (1871-1918), both dominated by Prussia.

German Empire: (1871-1918) the Prussia-dominated successor state to the North German Confederation; the empire was dismantled at the end of World War I.

Gesamtkunstwerk: literally, "total work of art." The concept under which all elements of a building (architecture, sculpture, paintings, and furnishings) are combined to create a unified, artistically harmonious whole.

Gothic: a style of architecture, painting, sculpture, and music prevalent in northern Europe from the 12th through the 15th centuries; the architecture style characterized by pointed arches, flying buttresses, and rib vaulting.

Grand chamberlain: a high-ranking official of the Austrian imperial court in charge of household servants, responsible for the court library and the crown jewels, and who granted petitioners the right to appear before the emperor.

Grand master: the most powerful of the Austrian emperor's courtiers, in charge of court ceremonies, the emperor's travels, music, gardens, hunting grounds, and crown-owned lands.

Gulden: literally, "golden"; also called the Austrian florin. A gold coin, minted by many nations and states, and widely used in Europe.

Gymnasium: an academic high school in some European countries, especially Germany, that prepares its students for the university.

Gypsies: a nomadic people, originally from the border between Iran and India, who migrated to Europe in the 14th or 15th century.

Habsburgs: also known as the House of Habsburg. A German royal family, one of the principal sovereign European dynasties, prominent and powerful from the 13th century to the 20th century, which through war, marriage, and diplomacy acquired vast territories in Europe and furnished sovereigns to Austria (1278-1919), Spain (1516-1700), and the Holy Roman Empire (1438-1806).

Heurige: outdoor wine taverns that serve the current year's wine, pressed from grapes grown in vineyards on the premises.

Hofball: the annual grand court ball, the high point of the Viennese social calendar, held each February in the Redoutensaal, the grand ballroom in the Hofburg Palace.

Hofburg Palace: a complex of buildings constructed over a 600-year period, architecturally ranging from 13th-century Gothic to late-19th-century Historicism. The seat of Austria and of Habsburg power for over six centuries, and home of the Habsburg Holy Roman Emperors.

Hoffähig: literally, "admissible at court." Possessing the prerequisites necessary for admittance to the imperial court, specifically, a noble paternal and maternal lineage.

Holy Roman Emperor: the ruler of the Holy Roman Empire, who, with one exception, came exclusively from the House of Habsburg from 1438 to 1806, when the empire ceased to exist.

Holy Roman Empire: the loosely federated central European political entity, successor to Charlemagne's Frankish empire (800-962), that existed from the reign of Otto I in 962 until 1806; included what is now Germany, Austria, Switzerland, the Czech Republic, eastern France, the Netherlands, and parts of Italy, most of which were also Habsburg domains.

Imperial privy councilor: any member of the group of officials and dignitaries chosen by a sovereign to participate in his advisory council.

Imperial rescript: an official announcement, order, decree, or edict by an emperor or empress.

Impressionism: a late-19th-century style of painting that attempted to depict fleeting visual impressions of a subject and was characterized primarily by the use of short brush strokes and light, bright colors.

Jause: afternoon tea.

Kipfel: a crescent-shaped roll invented in 1683 by Viennese bakers that became the inspiration for French croissants.

Kreuzer: any of several small coins of low value once used in Austria and Germany.

Künstlerhaus: literally, "Artists' House." The headquarters, meeting place, and exhibition hall of the Vienna Society of Visual Artists, Austria's leading artists' association, from which the Secessionists withdrew in 1897.

Laundry-Maids' Ball: a ball held once a year during the pre-Lenten carnival, originally intended for tradespeople but attended by Viennese of every class.

Liberal Party: formally, the National Liberal Party. A political party, active in Prussia and other German states as well as Austria, that drew its support from the wealthy, property-owning upper middle class.

Librettist: the author of a libretto, that is, the text of an opera or other dramatic musical work for the theater.

Lippizaner: a relatively small but exceptionally strong, agile, fast, and brave breed of horse, usually white, with a high-stepping strut.

Lord marshal: at the Austrian court, the person responsible primarily for the court's internal, everyday operation and regulation.

Magyars: the principal ethnic group of Hungary, a Finno-Ugric people who migrated from the Eurasian steppes beginning in about 460 and eventually settled in what was to become Hungary.

Männeken Piss: a fountain built in 1619 in Brussels, Belgium, portraying a small boy urinating.

Master of the horse: at the Austrian court, the person in charge of the stables, the court carriages, and the Spanish Riding School in Vienna.

Maundy Thursday: in Christianity, the Thursday immediately before Easter Sunday, commemorating the Last Supper of Jesus. Also called Holy Thursday.

Menorah: a nine-branched candelabrum used by Jews in celebrating Hanukkah.

Michaelerplatz: (St. Michael's Square) a plaza facing the entrance of the Hofburg.

Minaret: in Islamic religious architecture, the tower at a mosque from which the muezzin calls the faithful to prayer.

Minuet: a slow, stately, graceful French ballroom dance in 3/4 time for groups of couples, popular in 17th- and 18th-century Europe; the music for or in the rhythm of such a dance.

Morocco: soft, fine, pebble-grained leather made of goatskin tanned with sumac, used to make bindings for books.

Muslim: one who follows the teachings of Muhammad; an adherent of the Islamic faith.

Naschmarkt: a marketplace in Vienna where street vendors and farmers sell fresh produce, meats, and baked goods.

Nazarene: a member of an early-19th-century association of young Vienna Academy art students, also known as the Brotherhood of St. Luke, who believed that all art should serve a religious and moral purpose.

Needle-gun: also called the Dreyse rifle. A breechloading rifle, invented in the late 1820s, that had a long, sharp firing pin and could be fired from a prone position.

Neuritis: inflammation of a nerve, the results of which include pain, numbness or tingling, impaired reflexes, and muscular involvement ranging from loss of strength to paralysis; usually caused by an illness, allergy, or injury.

Neuropathology: study of diseases of the nervous system.

Nihilism: originally a philosophy of skepticism and a belief in scientific rationalism; later, a philosophy that totally rejected all moral truths and traditional values, laws, and institutions and that eventually further evolved into an advocacy of violent, revolutionary destruction of social and political institutions.

Nobel Prize: any of six prizes awarded annually by the Nobel Foundation for achievement in chemistry, physics, physiology or medicine, literature, economics, and peace.

Nouveau riche: literally, "new rich." One who has recently become rich, especially one who flaunts the newly acquired wealth or is uncultured.

Objets d'art: objects that have artistic merit.

Oedipus complex: in psychoanalysis, a subconscious sexual desire in a child toward its parent of the opposite sex, often accompanied by feelings of jealousy or hostility toward the parent of the same sex.

Operetta: a short drama set to music consisting of songs with orchestral accompaniment interspersed with orchestral interludes, dancing scenes, and spoken dialogue, generally lighter in subject matter and tone than grand opera.

Ostjuden: in Vienna, the name for conservative, orthodox eastern Jews who dressed in black, spoke Yiddish instead of German, and strictly followed the faith and traditions of their ancestors.

Ottoman Empire: Turkish empire founded by Osman I in the 13th century that became one of the world's most powerful states in the 15th and 16th centuries, superseding the Byzantine Empire. It eventually included in its territory southwestern Asia, the Middle East, southeastern Europe (including parts of modern Hungary, Croatia, Serbia, Bosnia, Romania, Greece, and Ukraine); the empire existed until 1922.

Pogrom: literally, "devastation." An organized, often government-condoned and -encouraged massacre of any minority group, but especially of Jews.

Poles: a Slavic, Roman Catholic people native to Poland.

Polis: a city-state of ancient Greece.

Polka: a lively couples dance of Bohemian folk origin, characterized by three quick steps followed by a hop, that, after its introduction in 1843 in Paris, became extremely popular throughout the western world.

Polyglot: multilingual.

Primate: in the Catholic Church, the highest-ranking bishop in a province or country.

Prime minister: the highest officer of a state or the head of government, entrusted with the management of the state, appointed by the sovereign or, in parliamentary systems, elected by the citizens.

Principality: a territory ruled by a prince.

Principessa: Italian for "princess."

Privy: a small room used as a toilet; an outhouse or outdoor toilet.

Proletariat: the class of workers who earn their living by selling their labor.

Prussia: a former kingdom (1701-1918) of the German Empire in north-central Europe and the largest and most important of the German states; at its height, the kingdom included most of present-day Germany, Poland, and parts of Russia, and Berlin was its capital.

Psychoanalysis: the method of psychiatric therapy originated by Sigmund Freud to discover, analyze, and understand unconscious mental processes and treat emotional disorders.

Quadrille: a square dance of French origin consisting of five figures or movements, each complete in itself, performed by four couples. The music for such a dance.

Quadruple Alliance of 1814: an alliance entered into by Prussia, Russia, Britain, and Austria for the purpose of defeating Napoleon, after which the members met at the Congress of Vienna, along with representatives of other European countries, to redraw the map of Europe.

Queue: a line of people or vehicles awaiting individual turns.

Rathaus: literally, "town hall." The town hall of any Austrian or German town or city.

Reform clothing: loose-fitting, waistless smocks similar to chemises worn by feminist reformers in the United States, Britain, and Germany.

Reichsrat: in Austria under the constitutional monarchy, the imperial parliament that, although granted legislative power, served more as an imperial council to the emperor. It held its last session on November 12, 1918, during which the Austrian Republic was formed. In Vienna, the building that housed the Reichsrat.

Rent barracks: in poor, working-class districts in Vienna, overcrowded, run-down buildings with rooms leased to tenants for outrageous sums.

Riesenrad: literally, "giant wheel." The giant Ferris wheel built in the Prater, a park in Vienna, in 1898 for Franz Josef's golden jubilee celebration.

Ringstrasse: a horseshoe-shaped series of boulevards around the old city of Vienna, built on the site of the old city's 13th-century fortifications. Public buildings and palaces in a number of different styles line the boulevards.

Rococo: a style of painting, sculpture, architecture, interior design, and decorative arts that evolved from the Baroque style in early-18th-century France and spread throughout Europe; marked by fanciful, elaborate, asymmetrical, and curved ornamentation.

Romanians: the people of Romania whose origins are uncertain but who themselves recognize the Romans as their ancestors and whose language is derived from Latin.

Romanovs: the imperial dynasty that ruled Russia from 1613 until the Russian Revolution in 1917.

Ruthenians: the name given to the west Ukrainian people who at one time were subjects of Poland, Austria, or Austria-Hungary.

Schrammelmusik: the musical genre often performed at the heurige, featuring lilting dance, march, and popular tunes played by a quartet composed of two violins, a guitar, and a clarinet or an accordion.

Secessionists: name given those artists and architects who in 1897 seceded from the mainstream artists' association in Vienna and formed their own avant-garde alliance, which became known as the Secession.

Second society: a social stratum of newly ennobled industrialists, financiers, high-level civil servants, senior military officers, and leading academics, formerly of the bourgeoisie, who were considered socially unacceptable at court.

Serbs: a Slavic, Orthodox people who are the principal ethnic group of modern Serbia.

Shah: the title of the former hereditary kings of Persia.

Slavs: the largest ethnic and linguistic group in Europe, believed to be descendants of Neolithic tribes of Asia who migrated to eastern Europe. Divided into three groups: West Slavs (Poles, Czechs, and Slovaks), East Slavs (Russians, Ukrainians, and Byelorussians), and South Slavs (Croats, Serbs, Slovenes, Macedonians, and Bulgars), all of whom speak Slavic languages derived from an Indo-European root language.

Slovaks: a Slavic, predominantly Roman Catholic people living in Slovakia.

Slovenes: also called the Alpine Slavs. A Slavic, Roman Catholic people living in Slovenia and adjacent parts of Austria and Italy.

Social democracy: a political movement advocating the use of peaceful, democratic means to move gradually from capitalism to socialism.

Social Democratic Party: the political party founded in December 1888 by a coalition of anticapitalist groups who advocated social democracy.

Socialism: a social system in which all or most of the means of production and distribution of goods are owned collectively, in which individuals may or may not own private property, and in which income distribution may be subject to state control.

Spanish Riding School: the world's oldest riding school, founded in Vienna as early as 1572 as the Imperial Spanish Riding School, and named after the Spanish horses that formed the basis of its breeding stock.

Süsses Mädel: literally, "sweet girl." Lower-middle-class single women, usually between 16 and 20 years old, who had short-lived relationships with young bourgeois men.

Symphony: a long, complex musical work composed for performance by a large orchestra, usually consisting of at least three related passages.

Szeklers: a people whose origins are not clear but who, according to their own traditions, are descendants of Attila's Huns (but who may, in fact, be Magyars), living in what was once Transylvania (now Romania); the Szekler language is actually a Hungarian, not a Germanic, dialect.

Theresianum: a school established by Jesuits in a royal palace given to them for that purpose in 1746 by Empress Maria Teresa. The school educated the children of impoverished nobility, and it became the most prestigious in Austria, specializing in training military officers.

Tsar: literally, "emperor" or "king." A term almost exclusively used to refer to the former rulers of imperial Russia.

Volksgarten: literally, "People's Garden." A large wedge-shaped park near Hofburg Palace in Vienna, laid out as a formal French garden, that opened in 1820 and became a favorite haunt of both the nobility and the general public.

Volkskaiser: literally, "People's King." Nickname given to Karl Lueger, popular socialist mayor of Vienna from 1897 until his death in 1910.

Wiener Werkstätte: literally, "Vienna Workshop." A studio founded in 1903, inspired by the English Arts and Crafts Movement, that produced numerous decorative and household objects, including jewelry, glassware and ceramics, metalwork, furniture, clothing, and paper products. The studio emphasized fine design and excellence in craftsmanship.

Waltz: a romantic, graceful ballroom dance, popular since the 18th century, developed from the ländler, an earlier, slower, but similar dance, in which (in the Viennese form) couples swirl rapidly around the floor in perpetual circles; the music for such a dance.

World Exhibition: an exhibition where examples of the best scientific, agricultural, and industrial products, arts, and crafts from around the world are displayed.

Wunderkind: literally, "wonder child." A child prodigy; a person of unusual talent or ability who achieves great success in a difficult field or profession at a very young age.

Yiddish: the language of Ashkenazic Jews of central and eastern Europe; a fusion of High German, Hebrew, Aramaic, the Slavic languages, and possibly other sources, with characters written in the Hebrew alphabet.

Zionism: an international movement, begun by newspaper editor Theodor Herzl in the late 19th century, that advocated and supported the establishment of a Jewish national state in Palestine.

PRONUNCIATION GUIDE

Adele Deutsch (ah-DAYL-uh DOYTSH)
Adelheid Dworak (AH-dayl-hite DVOHR-zhahk)
Adolf zu Sayn-Wittgenstein-Hohenstein (AH-dohlf tsoo SINE-VIHT-ghen-shtine-HOH-hehn-shtine
Alfred Nobel (AHL-frehd NOH-behl)
Auguste Rodin (oh-GOOST roh-DAN)
Baden-Baden (BAH-dehn-BAH-dehn)
Bad Kissingen (BAHD KISS-ing-ehn)
Debrecen (DEH-breh-chehn)
Der alte Herr (DAYR AHL-teh HAYR)

Die Fledermaus (DEE FLAY-dayr-maus)
Die Freundin (DEE FROYN-dihn)
Eduard Josef Wimmer-Wisgril (EH-doo-ahrd YO-sehf VIHM-mayr-VIHS-grihl)
Egon Friedell (EH-gohn free-DEHL)
Emilie Flöge (eh-MEE-lee-eh FLEH-gheh)
Erich Kielmansegg (EH-rihkh KEEL-mahns-ehk)
Fasching (FAH-shing)
Felix zu Schwarzenberg (FEH-lihx tsoo SHVAHR-tsehn-bayrg)
Feuilleton (FOY-yeh-tohn)
Franzensbad (FRAHN-tsehns-bahd)

Frauenbund (FRAU-ehn-boond)
Frau Wahrheit (FRAU VAHR-hite)
Friedrich Engels (FREE-drihkh EHNG-gehls)
Fritz Wärndorfer (FRITS VAYRN-door-fayr)
Gesamtkunstwerk (gheh-SAHMT-koonst-vayrk)
Gödöllö (guh-duh-luh)
Gorizia (goh-RIHTZ-yah)
Graben (GRAH-behn)
Griendsteidl (GREEN-shteye-dehl)
Grünne (GROON-neh)
Gyula Andrássy (JOO-lah ahn-DRAH-shih)
Heine-Geldern (HEYE-neh-GAYL-dayrn)

Helene (heh-LAY-neh)
Henriette Treffz (HEHN-ree-EHT-teh TREHFTS)
Heurige (HOY-ree-gheh)
Hirlap (HEER-lahp)
Hoch (hohkh)
Hoffähig (HOHF-feh-heeg)
Ida Ferenczy (EED-ah FEHR-ehnz-sih)
Ignatz Schnitzer (IHG-nahts SHNIHT-sayr)
Ischl (IHSHL)
Jauner (YOW-nayr)
Jause (YOW-zeh)
Katharina Schratt (KAH-tah-REE-nah SHRAHTT)
Klemens Metternich (KLAY-mehns MEHT-tayr-nihkh)
Köchert (KEH-khehrt)
Kohlmarkt (KOHL-mahrkt)
Koloman Moser (KOH-loh-mahn MOH-zayr)
Königgrätz (KEH-nihg-grayts)
Kreditanstalt (kray-DEET-ahn-SHTAHLT)
Kreuzer (KROYT-sayr)
Künstlerhaus (KOONST-layr-HAUS)
Kunstschau (KOONST-shau)
Lanckoronski (lahntz-koh-ROHN-skee)
Leipzig (LIPE-tseeg)
Linz (LIHNZ)
Lippizaner (LEE-pee-TSAH-nayr)
Ludovika (LOO-doh-VEE-kah)
Lueger (LOO-gayr)

Luigi Luccheni (loo-EE-gee loo-KEH-nee)
Lusatia (loo-SAH-tsee-ah)
Macht (MAHKHT)
Mariahilferstrasse (mah-REE-ah-heel-fayr-SHTRAH-seh)
Matsch (MAHTSH)
Mayerling (MEYE-ayr-ling)
Meynert (MEYE-nayrt)
Michaelerplatz (mee-khah-AY-layr-plahts)
Mingrelia (mihn-GRAY-lee-ah)
Mór Jókai (MOHR YOH-keye-ee)
Naschmarkt (NAHSH-mahrkt)
Neue Freie Presse (NOY-eh FRY-eh PREHSS-eh)
Neues Wiener Tagblatt (NOY-ehs VEE-nayr TAHG-blaht)
Neuschwanstein (NOY-shvahn-shtine)
Nietzsche (NEETS-sheh)
Oskar Kokoschka (OHS-kahr koh-KOHSH-kah)
Ostjuden (OHST-yoo-dehn)
Passau (PAHS-ow)
Pischingertorte (PIHSH-ing-ayr-TOHR-teh)
Prater (PRAH-tayr)
Rainer Maria Rilke (RYE-nayr MAH-ree-ah REEL-keh)
Rathaus (RAHT-haus)
Rauscher (RAU-shayr)
Recht (REHKHT)
Redoutensaal (reh-DOO-tehn-ZAHL)
Reichenau (RYE-kheh-now)

Reichsrat (RYKES-raht)
Ringstrasse (RING-SHTRAH-seh)
Rothschild (ROHT-sheeld)
Sacher (SAH-khayr)
St. Gerhardsberg (SAHNKT GAYR-hahrds-bayrg)
Sarajevo (sah-rah-YAY-voh)
Saxe-Coburg-Gotha (SAHK-seh-KOH-boorg-GOH-tah)
Schleswig-Holstein (SHLAYS-vihg-HOHL-shtyne)
Schönbrunn (SHEHN-broon)
Schrammel (SHRAHM-mehl)
Sèvres (SEHV-reh)
Steyr (SHTY-ehr)
Süsses Mädel (SOO-sehs MAY-dehl)
Szeklers (SEHK-klehrs)
Theater an der Wien (tay-AH-tayr AHN DAYR VEEN)
Theodor Herzl (TAY-oh-door HAYRT-sl)
Theophil Hansen (TAY-oh-feel HAHN-sehn)
Theresianum (TAY-ray-see-AH-noom)
Tietze (TEE-tseh)
Tyrol (tee-ROHL)
Vetsera (VEHT-sayr-ah)
Vorarlberg (FOHR-ahrl-bayrg)
Wagner (VAHG-nayr)
Waltzen (VAHL-tsehn)
Wiener Werkstätte (VEE-nayr VAYRK-shteh-teh)
Wittelsbach (VIHT-tehls-bahkh)
Wunderkind (VOON-dayr-kihnd)

ACKNOWLEDGMENTS AND PICTURE CREDITS

ACKNOWLEDGMENTS

The editors wish to thank the following individuals and institutions for their valuable assistance in the preparation of this volume:

Renata Antoniou, Graphische Sammlung Albertina, Vienna; Carlo Barocchi, Casa Editrice S. P. E. S., Firenze; Clark W. Evans and the staff of the Rare Book and Special Collections Reading Room of the Library of Congress, Washington, D.C.; Gabriele Fabiankowitsch, Österreichisches Museum für Angewandte Kunst, Vienna; Heinz Gruber, Österreichisches Nationalbibliothek, Vienna; Brigitte Hamann, Vienna; Mary Ison and Staff, Library of Congress, Washington, D.C.; Heidrun Klein, Bildarchiv Preussischer Kulturbesitz, Berlin; Sára Kulcsár-Szabó, Museum of Fine Arts, Budapest; Traudl Lessing, Vienna; Helmut Selzer, Historisches Museum der Stadt Wien, Vienna; Christian Stadelmann, Verein zur Geschichte der Arbeiterbewegung, Vienna.

PICTURE CREDITS

Credits from left to right are separated by semicolons, from top to bottom by dashes.

Cover: Artothek, Peissenberg/Historisches Museum der Stadt Wien, Vienna.

1: © Erich Lessing, Culture and Fine Arts Archive/Kunsthistorisches Museum, Gemaeldegalerie, Vienna; frame: *Elisabeth: Bilder Ihres Lebens,* by Johannes Thiele, courtesy Überreuther Verlag, Vienna. **2-5:** © Erich Lessing, Culture and Fine Arts Archive/Kunsthistorisches Museum, Gemaeldegalerie, Vienna. **6, 7:** Bildarchiv Klammet, Ohlstadt. **8-11:** Art by John Drummond, Time Life Inc., adapted from a photo from MAK-Österreichisches Museum für Angewandte Kunst, Vienna. **12, 13:** Map by John Drummond, © Time Life Inc. **14, 15:** Bridgeman-Giraudon; icon from *Jewellery Designs,* by I. Kochert, courtesy Casa Editrice S.P.E.S., Florence. **17:** With kind permission from *Peter Fendi,* by Walter Koschatzky, Salzburg, 1995 (detail). **18, 19:** Kunsthistorisches Museum, Vienna. **20, 21:** Museen des Mobiliendepots, Vienna, Foto Tina King. **22, 23:** Historisches Museum der Stadt Wien, Vienna/Bridgeman Art Library, London. **24, 25:** Kunsthistorisches Museum, Vienna/Bridgeman Art Library, London. **26, 27:** Border by John Drummond, Time Life Inc., based on a photo from Archiv für Kunst und Geschichte (AKG), Berlin; AKG, Berlin. **28:** Historisches Museum der Stadt Wien, Vienna. **29:** Museen des Mobiliendepots, Vienna/Foto Tina King. **31:** Riegele after Winterhalter, Fürst Thurn und Taxis Collection, Regensburg. **32, 33:** Bildarchiv, Österreichische Nationalbibliothek, Vienna; Heeresgeschichtliches Museum, Vienna. **34, 35:** Szépművészeti Múzeum, Budapest. **36, 37:** Border by John Drummond, © Time Life Inc.; Historisches Museum der Stadt Wien, Vienna—AKG, Berlin (2). **38:** Historisches Museum der Stadt Wien, Vienna. **39:** Jean-Loup Charmet, Paris. **40:** Historisches Museum der Stadt Wien, Vienna. **41:** AKG, Paris/Jerome da Cunha. **42:** Historisches Museum der Stadt Wien, Vienna. **43:** Privatarchiv Spacek-Cachée, Vienna. **45:** Burgtheater, Vienna/Foto Pia Odorizzi. **46, 47:** AKG, Berlin. **48:** AKG, Paris/Jerome da Cunha. **49:** © Erich Lessing, Culture and Fine Arts Archive, Vienna/Private Collection, Vienna. **50, 51:** Historisches Museum der Stadt Wien, Vienna/Bridgeman Art Library, London. **52, 53:** Library of Congress, Rare Book Collection/From *Costume of the Hereditary States of the House of Austria,* by Bertrand de Moleville, 1804; Graphische Sammlung Albertina, Vienna (2); Library of Congress, Rare Book Collection/From *Costume of the Hereditary States of the House of Austria,* by Bertrand de Moleville, 1804. **54, 55:** Graphische Sammlung Albertina, Vienna (2)—Library of Congress, Rare Book Collection/From *Costume of the Hereditary States of the House of Austria,* by Bertrand de Moleville, 1804 (3). **56, 57:** Library of Congress, Rare Book Collection/From *Costume of the Hereditary States of the House of Austria,* by Bertrand de Moleville, 1804 (2); from *Die Österreichisch-ungarische*

Monarchie in Wort und Bild, Vienna, Hugarn (VI. band), 1902, courtesy Library of Congress—from *Die Österreichisch-ungarische Monarchie in Wort und Bild,* Vienna, Hugarn Band II, 1891, courtesy Library of Congress; Library of Congress, Rare Book Collection/From *Costume of the Hereditary States of the House of Austria,* by Bertrand de Moleville, 1804. **58, 59:** Library of Congress, Rare Book Collection/From *Costume of the Hereditary States of the House of Austria,* by Bertrand de Moleville, 1804; from *Die Österreichisch-ungarische Monarchie in Wort und Bild,* Vienna, Galizien, 1898, courtesy Library of Congress—Graphische Sammlung Albertina, Vienna; Library of Congress, Rare Book Collection/From *Costume of the Hereditary States of the House of Austria,* by Bertrand de Moleville, 1804. **60, 61:** Österreichische Galerie Belvedere Wien/Carl Moll, *Naschmarkt* (detail); icon from *Jewellery Designs,* by I. Kochert, courtesy Casa Editrice S.P.E.S., Florence. **62:** Bildarchiv, Österreichische Nationalbibliothek, Vienna. **63:** Historisches Museum der Stadt Wien, Vienna. **65:** Courtesy of Spielbank, Baden-Baden. **66, 67:** Historisches Museum der Stadt Wien, Vienna. **68–71:** Border by John Drummond, © Time Life Inc. **68, 69:** © Erich Lessing, Culture and Fine Arts Archive, Vienna/Historisches Museum der Stadt Wien, Vienna. **70, 71:** AKG, Berlin; Museum der Stadt Wien, Vienna/the art archive, London. **73:** Museum der Stadt Wien, Vienna/the art archive, London. **74:** Brigitte Hamann, Vienna. **76, 77:** Historisches Museum der Stadt Wien, Vienna; Verein für Geschichte der Arbeiterbewegung, Vienna. **78, 79:** Archiv der sozialen Demokratie der Friedrich-Ebert-Stiftung, Bonn; © Erich Lessing, Culture and Fine Arts Archive, Vienna. **81:** Courtesy Mondadori, Milan DR. **82–87:** Historisches Museum der Stadt Wien, Vienna. **89:** Historisches Museum der Stadt Wien, Vienna—© Österreichischer Gewerkschaftsbund, Vienna. **90:** Wiener Stadt-und Landesbibliothek (Musiksammlung), Vienna. **93:** Historisches Museum der Stadt Wien, Vienna. **94, 95:** Border by John Drummond, © Time Life Inc.; AKG, Berlin; Peter Kumpa, Vienna. **96, 97:** Historisches Museum der Stadt Wien, Vienna; © Erich Lessing, Culture and Fine Arts Archive, Vienna. **98, 99:** Historisches Museum der Stadt Wien, Vienna—Bridgeman Art Library, London. **100, 101:** © Erich Lessing, Culture and Fine Arts Archive, Vienna/Historisches Museum der Stadt Wien, Vienna. **102, 103:** Private Collection/Bridgeman Art Library, London—Direktion der Museum der Stadt Wien, Vienna. **104–106:** © Erich Lessing, Culture and Fine Arts Archive, Vienna. **107:** Historisches Museum der Stadt Wien, Vienna/the art archive, London. **108, 109:** Direktion der Museum der Stadt Wien, Vienna—Kunsthistorisches Museum, Vienna/Bridgeman Art Library, London; © Klaus Vyhnalek. **110, 111:** © Erich Lessing, Culture and Fine Arts Archive, Vienna. **112:** The Fine Art Society, London/Bridgeman Art Library, London. **113:** Icon from *Jewellery Designs,* by I. Kochert, courtesy Casa Editrice S.P.E.S., Florence. **114, 115:** Historisches Museum der Stadt Wien, Vienna/Bridgeman Art Library, London. **116:** AKG, Berlin. **118, 119:** The Lebrecht Collection, London. **120, 121:** Bildarchiv Preussischer Kulturbesitz, Berlin/Museum der Stadt Wien, Vienna/photo by Alfredo Dagli Orti, 1990. **122, 123:** Border by John Drummond, © Time Life Inc.; Bildarchiv, Österreichische Nationalbibliothek, Vienna; DR, All Rights Reserved; Österreichische Nationalbibliothek, Musiksammlung, Vienna. **124, 125:** Historisches Museum der Stadt Wien, Vienna. **126, 127:** © Erich Lessing, Culture and Fine Arts Archive, Vienna/Historisches Museum der Stadt Wien, Vienna. **128:** AKG, Paris/Historisches Museum der Stadt Wien, Vienna. **129:** AKG, Berlin. **130, 131:** AKG, Berlin; Österreichische Galerie, Vienna. **133:** Österreichische Galerie, Vienna. **134:** Historisches Museum der Stadt Wien, Vienna/Bridgeman Art Library, London. **135:** Christian Brandstätter Verlag, Vienna. **136:** © Erich Lessing, Culture and Fine Arts Archive, Vienna. **137:** Border by John Drummond, © Time Life Inc.; Archive Photos, New York. **138–141:** Historisches Museum der Stadt Wien, Vienna. **142:** Border by John Drummond, © Time Life Inc.; AKG, Berlin/Österreichische Nationalbibliothek, Vienna. **143:** Bildarchiv, Österreichische Nationalbibliothek, Vienna. **144, 145:** Border by John Drummond, © Time Life Inc.; AKG, Berlin; Bildarchiv, Österreichische Nationalbibliothek, Vienna—Deutsche Presse Agentur/Archive Photos, New York. **146, 147:** Heeresgeschichtliches Museum, Vienna. **148–157:** Border by John Drummond, © Time Life Inc.; Wiener Werkstätte icon from *Wiener Werkstätte: Kunst und Handwerk 1903-1932,* by Werner Josef Schweiger, Copyright © 1982 by Christian Brandstätter Verlag & Edition, Vienna. **148:** Historisches Museum der Stadt Wien, Vienna; MAK-Österreichisches Museum für Angewandte Kunst, Vienna (3). **149:** MAK-Österreichisches Museum für Angewandte Kunst, Vienna. **150, 151:** © Erich Lessing, Culture and Fine Arts Archive, Vienna/Museum für Angewandte Kunst, Vienna; © Erich Lessing, Culture and Fine Arts Archive, Vienna/Galerie Galuchat, Brussels; © Erich Lessing, Culture and Fine Arts Archive, Vienna/ Hochschule für Angewandte Kunst, Vienna; MAK-Österreichisches Museum für Angewandte Kunst, Vienna—Collection Asenbaum. **152:** MAK-Österreichisches Museum für Angewandte Kunst, Vienna. **153:** Christie's Images; V&A Picture Library, London; MAK-Österreichisches Museum für Angewandte Kunst, Vienna. **154, 155:** Galerie bei der Albertina, Christa Zetter, Vienna; Österreichisches Museum für Angewandte Kunst, Vienna (4). **156:** Private Collection/Bridgeman Art Library, London; Historisches Museum der Stadt Wien, Vienna; MAK-Österreichisches Museum für Angewandte Kunst, Vienna. **157:** Österreichisches Museum für Angewandte Kunst, Vienna—Historisches Museum der Stadt Wien, Vienna.

Design Element: icon from *Jewellery Designs,* by I. Kochert, courtesy Casa Editrice S.P.E.S., Florence.

Text Credit, page 95: *Vienna's Golden Autumn,* by Hilde Spiel, Orion Publishing Group LTD, London.

BIBLIOGRAPHY

BOOKS

A History of Hungary. Bloomington: Indiana University Press, 1990.

Ara, Angelo. "The 'Cultural Soul' and the 'Merchant Soul.' " In *The Habsburg Legacy: National Identity in Historical Perspective.* Ed. by Ritchie Robertson and Edward Timms. Edinburgh: Edinburgh University Press, 1994.

Austria: The Complete Guide. New York: Fodor's Travel Publications [1995].

Bagdasarian, Nicholas Der. *The Austro-German Rapprochement, 1870-1879: From the Battle of Sedan to the Dual Alliance.* London: Associated University Presses, 1976.

Barea, Ilsa. *Vienna.* New York: Alfred A. Knopf, 1966.

Beller, Steven. *Vienna and the Jews, 1867-1938: A Cultural History.* Cambridge: Cambridge University Press, 1989.

Berkley, George E. *Vienna and Its Jews: The Tragedy of Success, 1880s-1980s.* Cambridge, Mass.: Abt Books, 1988.

Bertrand de Moleville, Antoine François, marquis de. *The Costume of the Hereditary States of the House of Austria.* Trans. by R. C. Dallas, esq. London: W. Bulmer, 1804.

Birchall, Emily. *Wedding Tour: January-June 1873 and Visit to the Vienna Exhibition.* Ed. by David Verey. Gloucester, England: Alan Sutton, 1985.

Bled, Jean-Paul. *Franz Joseph.* Trans. by Teresa Bridgeman. Oxford: Blackwell, 1992.

Blunt, Wilfrid. *The Dream King: Ludwig II of Bavaria.* Harmondsworth, Middlesex, England: Penguin Books, 1973.

Body, Pál, ed. *Hungarian Statesmen of Destiny, 1860-1960.* Boulder, Colo.: Social Sciences Monograph, 1989.

Boyer, John W.:
Culture and Political Crisis in Vienna: Christian Socialism in Power, 1897-1918. Chicago: University of Chicago Press, 1995.
Political Radicalism in Late Imperial Vienna: Origins of the Christian Social Movement, 1848-1897. Chicago: University of Chicago Press, 1981.

Bramah, Edward. *Tea & Coffee: A Modern View of Three Hundred Years of Tradition.* London: Hutchinson, 1972.

Brook-Shepherd, Gordon:
Archduke of Sarajevo: The Romance and Tragedy of Franz Ferdinand of Austria. Boston: Little, Brown, 1984.
The Austrians: A Thousand-Year Odyssey. New York: Carroll & Graf, 1996.

Çelik, Zeynep. *Displaying the Orient: Architecture of Islam at Nineteenth-Century World's Fairs.* Berkeley: University of California Press, 1992.

Decsy, Janos. *Prime Minister Gyula Andrássy's Influence on Habsburg Foreign Policy during the Franco-German War of 1870-1871.* Boulder, Colo.: East European Quarterly, 1979.

Dieman, Kurt. *Musik in Wien.* Vienna: Molden [1970].

Die Österreichisch-ungarische Monarchie in Wort und Bild, 24 vols. Vienna: K.K. Hof- und Staatsdruckerei, 1886-1902.

Egger, Margarethe. *Die "Schrammeln" in ihrer Zeit.* Vienna: Österreichischer Bundesverlag, 1989.

Engelman, Edmund. *Berggasse 19: Sigmund Freud's Home and Offices, Vienna.* Chicago: University of Chicago Press, 1976.

Fant, Kenne. *Alfred Nobel: A Biography.* Trans. by Marianne Ruuth. New York: Arcade, 1993.

Fantel, Hans. *The Waltz Kings: Johann Strauss, Father & Son, and Their Romantic Age.* New York: William Morrow, 1972.

Fenz, Werner. *Koloman Moser.* Brussels: Pierre Mardaga Editeur, 1984.

Fillitz, Hermann. *Die Schatzkammer in Wien.* Vienna: Residenz Verlag, 1986.

Fischer, Wolfgang Georg:
Gustav Klimt und Emilie Flöge. Vienna: C. Brandstätter, 1987.
Gustav Klimt & Emilie Flöge: An Artist and His Muse. Woodstock, N.Y.: Overlook Press, 1992.

Franz Joseph I. *The Incredible Friendship: The Letters of Emperor Franz Joseph to Frau Katharina Schratt.* Trans. and ed. by Evebeth Miller Kienast and Robert Rie [Albany]: State University of New York [1966].

Frodl, Gerbert. *Klimt.* Trans. by Alexandra Campbell. New York: Henry Holt, 1992.

Fugger, Nora. *The Glory of the Habsburgs: The Memoirs of Princess Fugger.* Trans. by J. A. Galston. London: George C. Harrap & Co., 1932.

Gainham, Sarah. *The Habsburg Twilight: Tales from Vienna.* New York: Atheneum, 1979.

Geehr, Richard S. *Karl Lueger: Mayor of Fin de Siècle Vienna.* Detroit: Wayne State University Press, 1990.

Geehr, Richard S., trans. and ed. *"I Decide Who is a Jew!": The Papers of Dr. Karl Lueger.* Washington, D.C.: University Press of America, 1982.

Greenhalgh, Paul. *Ephemeral Vistas: The Expositions Universelles, Great Exhibitions and World's Fairs, 1851-1939.* Manchester, U.K.: Manchester University Press, 1988.

Grun, Bernard. *Gold and Silver: The Life and Times of Franz Lehár.* New York: David McKay, 1970.

Grunfeld, Frederic V. *Vienna.* New York: Newsweek, 1981.

Hall, Peter. *Cities in Civilization.* New York: Pantheon Books, 1998.

Hamann, Brigitte:
Bertha von Suttner: A Life for Peace. Trans. by Ann Dubsky. Syracuse, N.Y.: Syracuse University Press, 1996.
Meine Liebe, Gute Freundin!: Die Briefe Kaiser Franz Josephs an Katharina Schratt. Vienna: Ueberreuter, 1992.
The Reluctant Empress. Trans. by Ruth Hein. New York: Alfred A. Knopf, 1986.

Hanák, Péter. *The Garden and the Workshop: Essays on the Cultural History of Vienna and Budapest.* Princeton, N.J.: Princeton University Press, 1998.

Haslip, Joan:
The Emperor & the Actress. New York: Dial Press, 1982.
The Lonely Empress. Cleveland: World Publishing, 1965.

Hauser Köchert, Irmgard. *Köchert Jewellery Designs: 1810-1940.* Florence: S.P.E.S., 1990.

Hausner, Ernst. *Wien.* Vienna: Jugend und Volk, 1975.

Historisches Museum der Stadt Wien. *Kaiser Franz Joseph von Österreich: Oder, Der Verfall eines Prinzips.* Vienna: Museen der Stadt Wien [1980].

Hitchins, Keith. *The Romanians: 1774-1866.* Oxford: Clarendon Press, 1996.

Hofmann, Paul. *The Viennese: Splendor, Twilight, and Exile.* New York: Anchor Press, 1988.

Hubmann, Franz. *The Habsburg Empire: The World of the Austro-Hungarian Monarchy in Original Photographs, 1840-1916.* Ed. by Andrew Wheatcroft. New York: Library Press, 1971.

Imago Austriae. Vienna: Herder, 1967.

Imperial Style: Fashions of the Hapsburg Era. New York: Metropolitan Museum of Art, 1980.

Ingrao, Charles W. *The Habsburg Monarchy: 1618-1815.* Cambridge: Cambridge University Press, 1994.

Janik, Allan, and Stephen Toulmin. *Wittgenstein's Vienna.* New York: Simon and Schuster, 1973.

Jankowitsch, Regina Maria. *K&K Eitelkeiten.* Vienna: Ueberreuter, 1997.

Johann Strauss. Vienna: Historisches Museum der Stadt Wien, 1995.

Johnson, Lonnie R. *Central Europe: Enemies, Neighbors, Friends.* New York: Oxford University Press, 1996.

Johnston, William M.:
The Austrian Mind: An Intellectual and Social History. Berkeley: University of California Press, 1972.
Vienna, Vienna: The Golden Age, 1815-1914. New York: Clarkson N. Potter, 1980.

Judtmann, Fritz. *Mayerling: The Facts behind the Legend.* Trans. by Ewald Osers. London: George C. Harrap & Co., 1971.

Kann, Robert A.:
A History of the Habsburg Empire, 1526-1918. Berkeley: University of California Press, 1974.
The Multinational Empire, Vol. 1: Empire and Nationalities. New York: Columbia University Press, 1950.

Kann, Robert A., and Zdenek V. David. *The Peoples of the Eastern Habsburg Lands, 1526-1918.* Seattle: University of Washington Press, 1984.

Kantakuzen, Julia Grant. *My Life Here and There.* New York: C. Scribner's Sons, 1921.

Keegan, Susanne. *The Bride of the Wind: The Life and Times of Alma Mahler-Werfel.* New York: Viking, 1991.

Kemp, Peter. *The Strauss Family.* London: Omnibus Press, 1989.

Kempf, Beatrix. *Woman for Peace: The Life of Bertha von Suttner.* Trans. by R. W. Last. Park Ridge, N.J.: Noyes Press, 1973.

King, Greg. *The Mad King: The Life and Times of Ludwig II of Bavaria.* Secaucus, N.J.: Birch Lane Press Book, 1996.

Koschatzky, Walter:
Des Kaisers Guckkasten. Salzburg: Residenz Verlag, 1991.
Peter Fendi. Salzburg: Residenz Verlag, 1995.
Viennese Watercolors of the Nineteenth Century. New York: Harry N. Abrams, 1988.

Koschatzky, Walter, and Horst-Herbert Kossatz. *Ornamental Posters of the Vienna Secession.* London: Academy Editions, 1974.

Kugler, Georg Johannes. *Die Wagenburg in Schönbrunn*. Graz: Verlagsanstalt, 1977.

Langer, William L., comp. and ed. *The New Illustrated Encyclopedia of World History*. New York: Harry N. Abrams, 1975.

Langseth-Christensen, Lillian. *Gourmet's Old Vienna Cookbook*. New York: Gourmet, 1959.

Levetus, A. S. *Imperial Vienna*. London: John Lane, 1905.

Lillywhite, Bryant. *London Coffee Houses*. London: George Allen and Unwin, 1963.

Magocsi, Paul Robert. *Historical Atlas of East Central Europe*. Seattle: University of Washington Press, 1993.

Mahler-Werfel, Alma. *Diaries: 1898-1902*. Trans. and ed. by Antony Beaumont and Susanne Rode-Breymann. Ithaca, N.Y.: Cornell University Press, 1998.

Mailer, Franz. *Johann Strauss: 1825-1899*. Vienna: Federal Press Service, 1999.

Marek, George R. *The Eagles Die: Franz Joseph, Elisabeth, and Their Austria*. New York: Harper & Row, 1974.

Marshall, S. L. A. *World War I*. Boston: Houghton Mifflin, 1964.

Mattie, Erik. *World's Fairs*. Princeton, N.J.: Princeton Architectural Press, 1998.

May, Arthur J. *Vienna in the Age of Franz Josef*. Norman, Okla.: University of Oklahoma Press, 1966.

Merriam-Webster's Geographical Dictionary (3rd ed.). Springfield, Mass.: Merriam-Webster, 1998.

Mraz, Gerda. *Elisabeth: Prinzessin in Bayern*. Vienna: Brandstätter, 1998.

Murad, Anatol. *Franz Joseph I of Austria and His Empire*. New York: Twayne, 1968.

Nebehay, Christian M. *Gustav Klimt: From Drawing to Painting*. New York: Harry N. Abrams, 1994.

New Grove Dictionary of Music and Musicians: Vol. 16: Riegel-Schusterfleck. Ed. by Stanley Sadie. London: Macmillan, 1980.

Palmer, Alan:
Metternich. New York: Harper & Row, 1972.
Twilight of the Habsburgs: The Life and Times of Emperor Franz Joseph. New York: Grove Press, 1994.

Partsch, Susanna:
Gustav Klimt: Painter of Women. Munich: Prestel, 1994.
Klimt: Life and Work. London: Bracken Books, 1989.

Popp, Adelheid:
The Autobiography of a Working Woman. Trans. by E. C. Harvey. Westport, Conn.: Hyperion Press, 1983 (reprint of 1913 edition).
Jugend Einer Arbeiterin. Berlin: J. H. W. Dietz, 1977.

Prater, D. A. *European of Yesterday: A Biography of Stefan Zweig*. Oxford: Clarendon Press, 1972.

Das Pratermuseum. Vienna: Museen der Stadt Wien, 1993.

Rickett, Richard. *Music and Musicians in Vienna*. Vienna: Georg Prachner, 1973.

Robertson, Ritchie, and Edward Timms, eds. *The Habsburg Legacy: National Idenity in Historical Perspective*. Edinburgh: Edinburgh University Press, 1994.

Romania: A Country Study. Ed. by Ronald D. Bachman. Washington, D.C.: G.P.O., 1991.

Rothenberg, Gunther E. *The Military Border in Croatia, 1740-1881: A Study of an Imperial Institution*. Chicago: University of Chicago Press, 1966.

Rudolf: Ein Leben im Schatten von Mayerling. Vienna: Museen der Stadt, 1990.

Schivelbusch, Wolfgang. *Tastes of Paradise: A Social History of Spices, Stimulants, and Intoxicants*. Trans. by David Jacobson. New York: Pantheon Books, 1992.

Schorske, Carl E. *Fin-de-Siècle Vienna: Politics and Culture*. New York: Alfred A. Knopf, 1980.

Schraff, Anne. *Women of Peace: Nobel Peace Prize Winners*. Hillside, N.J.: Enslow, 1994.

Schubert's Vienna. Ed. by Raymond Erickson. New Haven, Conn.: Yale University, 1997.

Sked, Alan. *The Decline and Fall of the Habsburg Empire, 1815-1918*. London: Longman, 1989.

Sorell, Walter. *Three Women: Lives of Sex and Genius*. Indianapolis: Bobbs-Merrill, 1975.

Spiel, Hilde. *Vienna's Golden Autumn: 1866-1938*. New York: Weidenfeld and Nicolson, 1987.

Spitzer, Leo. *Lives in between: Assimilation and Marginality in Austria, Brazil, West Africa, 1780-1945*. Cambridge: Cambridge University Press, 1989.

Spitzer, Rudolf. *Des Bürgermeisters Lueger Lumpen und Steuerträger*. Vienna: Österreichischer Bundesverlag, 1988.

Stefan Zweig: Leben und Werk im Bild. Frankfurt: Insel, 1981.

Steffahn, Harald. *Bertha von Suttner*. Hamburg: Rowohlt, 1998.

Strauss, Johann. *Leben und Werk in Briefen und Dokumenten*, Vols. 3, 4, 6. Tutzing: Hans Schneider, 1996.

Suttner, Bertha von. *Memoirs of Bertha von Suttner: The Records of an Eventful Life*, Vol. 1. New York: Garland, 1972 (reprint of 1910 edition).

Szeps, Berta. *My Life and History*. Trans. by John Sommerfield. New York: Alfred A. Knopf, 1939.

Tannahill, Reay. *Food in History*. New York: Three Rivers Press, 1988.

Taylor, A. J. P. *The Habsburg Monarchy: 1809-1918*. Chicago: University of Chicago Press, 1948.

Toman, Rolf. *Wien: Kunst und Architektur*. Cologne: Könemann, 1999.

Traubner, Richard. *Operetta: A Theatrical History*. Garden City, N.Y.: Doubleday & Co., 1983.

Trollope, Frances. *Vienna and the Austrians*, Vol. 2. London: Richard Bentley, 1838.

Varnedoe, Kirk. *Vienna 1900: Art, Architecture & Design*. New York: Museum of Modern Art, 1986.

Vergo, Peter. *Art in Vienna: 1898-1918*. London: Phaidon, 1975.

Vienna: 1890-1920. New York: Rizzoli, 1984.

Vienna: The World of Yesterday, 1889-1914. Ed. by Stephen Eric Bronner and F. Peter Wagner. Atlantic, N.J.: Humanities Press, 1997.

Völker, Angela. *Wiener Mode + Modefotografie*. Munich: Verlag Schneider-Henn, 1984.

Wandruszka, Adam. *The House of Habsburg: Six Hundred Years of a European Dynasty*. Trans. by Cathleen and Hans Epstein. Garden City, N.Y.: Doubleday & Co., 1964.

Wandycz, Piotr S. *The Lands of Partitioned Poland, 1795-1918*. Seattle: University of Washington Press, 1974.

Wechsberg, Joseph:
Sounds of Vienna. London: Weidenfeld and Nicolson, 1968.
The Waltz Emperors: The Life and Times and Music of the Strauss Family. New York: Putnam's Sons, 1973.

Wegs, J. Robert. *Growing Up Working Class*. University Park: Pennsylvania State University Press, 1989.

Wheatcroft, Andrew. *The Habsburgs: Embodying Empire*. London: Viking, 1995.

Wilkinson, Philip, and Robert Ingpen. *Encyclopedia of Events that Changed the World: Eighty Turning Points in History*. New York: Viking, 1991.

Yates, Jill. *Coffee Lover's Bible: Ode to the Divine Brew in Fact, Food & Fancy*. Santa Fe: Clear Light, 1998.

Zweig, Friderike. *Stefan Zweig*. New York: Thomas Y. Crowell, 1946.

Zweig, Stefan. *The World of Yesterday: An Autobiography*. Lincoln: University of Nebraska Press, 1964.

PERIODICALS

Gay, Peter. "Sigmund Freud." *Time,* March 29, 1999.

Koepp, Andreas. "Viennese Soul Music." *Austria Kultur,* Vol. 9.

Simon, John. Review of *Diaries: 1898-1902*, by Alma Mahler-Werfel. *New York Times Book Review,* March 28, 1999.

OTHER SOURCES

"A Night in a Viennese Heurigen." Vocal and instrumental recording. Capitol Records.

"Wiener Heurigenlieder." Vocal and instrumental recording. MHS Stereo.

INDEX

TIME® LIFE BOOKS

Time-Life Books is a division of Time Life Inc.

TIME LIFE INC.
CHAIRMAN AND CHIEF EXECUTIVE OFFICER:
Jim Nelson
PRESIDENT AND CHIEF OPERATING OFFICER:
Steven Janas
SENIOR EXECUTIVE VICE PRESIDENT AND
CHIEF OPERATIONS OFFICER: Mary Davis Holt
SENIOR VICE PRESIDENT AND CHIEF FINAN-
CIAL OFFICER: Christopher Hearing

TIME-LIFE BOOKS
PRESIDENT: Joseph A. Kuna
PUBLISHER/MANAGING EDITOR: Neil Kagan
VICE PRESIDENT, NEW PRODUCT
DEVELOPMENT: Amy Golden

What Life Was Like ®
AT EMPIRE'S END

EDITOR: Denise Dersin
Deputy Editors: Trudy W. Pearson, Paula York-Soderlund
Art Director: Alan Pitts
Text Editor: Robin Currie
Associate Editor/Research and Writing: Stacy W. Hoffhaus
Copyeditor: Leanne Sullivan
Technical Art Specialist: John Drummond
Editorial Assistant: Christine Higgins
Photo Coordinator: David Herod

Special Contributors: Ronald H. Bailey, Michael Blumen-thal, Ellen Galford (chapter text); Christina Huth, Susan V. Kelly, Jane Martin, Norma Shaw, Marilyn Murphy Terrell (research-writing); Lina Baber Burton, Meghan K. Blute, Connie Contreras, Sarah L. Evans, Rena Kakani, Karen Kinney, Patricia Nelson (research); Constance Buchanan, Janet Cave (editing); Barbara E. Cohen (index); Barbara L. Klein (overread)

Correspondents: Christine Hinze (London), Christina Lieberman (New York), Maria Vincenza Aloisi (Paris); valuable assistance also provided by Elisabeth Kraemer-Singh, Angelika Lemmer (Bonn)

Separations by the Time-Life Imaging Department

NEW PRODUCT DEVELOPMENT:
Director, Elizabeth D. Ward; Project Manager, Barbara M. Sheppard; Director of Marketing, Mary Ann Donaghy; Marketing Manager, Paul Fontaine; Associate Marketing Manager, Erin Gaskins

MARKETING: Director, Pamela R. Farrell; Marketing Manager, Nancy Gallo; Associate Marketing Manager, Erin Trefry

Senior Vice President, Law & Business Affairs:
Randolph H. Elkins
Vice President, Finance: Claudia Goldberg
Vice President, Book Production: Patricia Pascale
Vice President, Imaging: Marjann Caldwell
Director, Publishing Technology: Betsi McGrath
Director, Editorial Administration: Barbara Levitt
Director, Photography and Research: John Conrad Weiser
Director, Quality Assurance: James King
Manager, Technical Services: Anne Topp
Senior Production Manager: Ken Sabol
Manager, Copyedit/Page Makeup: Debby Tait
Production Manager: Virginia Reardon
Chief Librarian: Louise D. Forstall

Consultant:
Arthur Herman currently is Visiting Associate Professor of History at George Mason University and Coordinator of the Western Heritage Program at the Smithsonian Institu-tion in Washington, D.C. He completed his Ph.D. at Johns Hopkins University, where his dissertation won the pres-tigious Brittingham Prize. Dr. Herman's book, *The Idea of Decline in Western History,* was published in 1997 and has since been translated into German, Spanish, and Por-tuguese. He also has published numerous articles in peri-odicals such as *The Journal of Modern History* and *Cahiers du Dix-Septième.*

First printing. Printed in U.S.A.
School and library distribution by Time-Life Education, P.O. Box 85026, Richmond, Virginia 23285-5026.

TIME-LIFE is a trademark of Time Warner Inc. and affiliated companies.

Library of Congress Cataloging-in-Publication Data
What life was like at empire's end ; Austro-Hungarian Empire, AD 1848-1918 / by the editors of Time-Life Books.
 p. cm. — (What life was like)
 Includes bibliographical references and index.
 ISBN 0-7835-5467-2
 1. Austria—Civilization—19th century. 2. Aus-tria—Intellectual life—19th century. 3. Austria—Social life and customs. 4. Arts, Austrian. I. Time-Life Books. II. What life was like series.
DB80 .W47 2000 99-462123
943.6'04—dc21

10 9 8 7 6 5 4 3 2 1

Other Publications:
HISTORY
Our American Century
World War II
The American Story
Voices of the Civil War
The American Indians
Lost Civilizations
Mysteries of the Unknown
Time Frame
The Civil War
Cultural Atlas

COOKING
Weight Watchers® Smart Choice Recipe Collection
Great Taste~Low Fat
Williams-Sonoma Kitchen Library

SCIENCE/NATURE
Voyage Through the Universe

DO IT YOURSELF
Custom Woodworking
Golf Digest Total Golf
How to Fix It
The Time-Life Complete Gardener
Home Repair and Improvement
The Art of Woodworking

For information on and a full description of any of the Time-Life Books series listed above, please call 1-800-621-7026 or write:
Reader Information, Time-Life Customer Service, P.O. Box C-32068, Richmond, Virginia 23261-2068

This volume is one in a series on world history that uses contemporary art, artifacts, and personal accounts to create an intimate portrait of daily life in the past.

Other volumes included in the
What Life Was Like series:
On the Banks of the Nile: Egypt, 3050-30 BC
In the Age of Chivalry: Medieval Europe, AD 800-1500
When Rome Ruled the World: The Roman Empire, 100 BC-AD 200
At the Dawn of Democracy: Classical Athens, 525-322 BC
When Longships Sailed: Vikings, AD 800-1100
Among Druids and High Kings: Celtic Ireland, AD 400-1200
In the Realm of Elizabeth: England, AD 1533-1603
Amid Splendor and Intrigue: Byzantine Empire, AD 330-1453
In the Land of the Dragon: Imperial China, AD 960-1368
In the Time of War and Peace: Imperial Russia, AD 1696-1917
In the Jewel in the Crown: British India, AD 1600-1905
At the Rebirth of Genius: Renaissance Italy, AD 1400-1550
Among Samurai and Shoguns: Japan, AD 1000-1700
During the Age of Reason: France, AD 1660-1800
In Europe's Golden Age: Northern Europe, AD 1500-1675
In the Lands of the Prophet: Islamic World, AD 570-1405
In Europe's Romantic Era: Europe, AD 1789-1848